ATTITUDE

ATTITUDE

wanna make
something of it?

the secret of stand-up comedy

TONY ALLEN

GOTHIC IMAGE
publications

First published in Great Britain in 2002 by Gothic Image Publications,
PO Box 2568, Glastonbury, Somerset BA6 8XR, England.

ISBN 0 906362 56 3

A CIP catalogue record for this book is available from the British Library.

Cover photography by Peter Woodcock.
Cover design by Bernard Chandler and Peter Woodcock.
Design and layout by Bernard Chandler (Graphics), Glastonbury.
Printed by HSW Print, Tonypandy, Rhondda, Wales.

For my Mum, who throughout my childhood, told me freshly improvised bedtime stories about a boy called Tonky who got up to endless mischief and always got away with it.

CONTENTS

Acknowledgements

Thanks to everyone who helped me get this volume together:
Richard Baker, Tony Bennett, Ishmael Blaygrove, Gervais Currie, Matt Harvey, Den Levett, John Miles, Brian Montague, Rory Motion, Andy Porter and John Studholme. Frederique Cassan for digging out the Alt Cab Album, Anna Clayden for locating a copy of Rough Theatre Plays, and Mike Braybrook for research and help with transcribing.

Helen Cherry and Peter Rigg for cartoons.

Gia Giavanni, Sean Hignet, James Laritz, and Philip Wolmuth for photos.

Dale Ashman, Ruth Davies and Anna Davin for feedback and proof-reading essays.

Peter the Tape and Radio Pete Edmunds for the 1979 audio tapes. Giles Auckland Lewis for the 1990 videos of the Cabbage Patch.

New Agenda Arts Trust for their continued support and the feedback website: newagenda.org.uk

The Robert Armin / Will Shakespeare piece was originally brainstormed in the early eighties with John Connor.

I'd also like to thank those who have contributed feedback and material for my stage act over the years, but more pertinently for input and support in the period 1979-80, especially Karin Monte.
Also: Mary Jane Anderton, Sallie Apprahamian, Steve Balogh, Helen Berringer, Tom Costello, Tom Dunill, Tony Dowd, Paul Durden, Sarah Grieves, Malcolm Hay, Mary Ann Lysaght, Vernon Magee, Brian Montague, John Phillips, Andy Porter, Annie Potter, Ken Robinson, Linda Saunders, Roger Selves, Judy Simon, Pippa Smith, Sam Smith, John Unwin, John Williams, Heathcote Williams and Mik Zetlin.

The late Max Handley for all the lateral thinking.

Foreword

Tony Allen is a seminal figure in the history of British comedy. Along with more famous contemporaries like Alexei Sayle, he initiated the alternative comedy scene, which challenged the cheap bigotry with which 1970s comedy was thoroughly raddled, and massively extended the possibilities of the stand-up format. Suddenly, instead of sticking to old gags which confirmed audience prejudices, comedians were allowed to be confrontational, wild, and absurd. Tony founded a group of comics and musicians, called 'Alternative Cabaret', which toured round pubs and students' unions, laying the ground for the comedy clubs which are now scattered liberally across London and beyond, in which the vast majority of today's biggest comedy stars cut their teeth. Without the efforts of Alternative Cabaret, there would be no Jo Brand, no Eddie Izzard, no Jack Dee: quite simply, there would have been nowhere for them to develop their talents in such a way.

Furthermore, listening back to recordings of the acts in the first wave of alternative comedy, Tony was arguably the most influential in establishing a style of stand-up which still dominates today, albeit in a disastrously watered-down form: in among sharp comic digs at the police, multinational corporations and doctors' class bias, he had well-crafted observational routines about wine bars and hedgehogs which could slot reasonably comfortably into the act of many comics currently working the circuit.

The difference is that, unlike present day circuit comedians, Tony is capable of much more. Besides his historical significance, he is a brilliant stand-up comedian. More than anybody else I can think of, he is capable of tackling subjects which seem quite unsuitable for comic treatment, and making them funny. His act has delved into such unlikely topics as Heisenberg's Uncertainty Principle, the workings of the Stock Exchange, and Amazonian rainforest tribes. The bravery and inventiveness of his work led *City Limits* to describe him as 'the master', while *The Independent* called him 'a sell-out alternative who has not sold out'.

Tony's writing is a highly readable blend of autobiography and analysis, and both aspects are equally appealing. The autobiographical side appeals because his life has seen him play so many roles: anarchist, fringe theatre practitioner, comedian, street clown, regular at Speakers' Corner, university teacher. I don't know exactly which of these roles he was playing when I saw him take on the legendary Dario Fo in a heated debate about the nature of performance at an academic conference at the University of Wolverhampton.

The analytical side of his writing appeals, not just because he is opinionated, witty, incisive and occasionally scabrous, but also because of his deep understanding of the nature of performance. There is a vast body of theoretical work on acting, dating back to Stanislavski and beyond, which attempts to make sense of the craft of the actor. No such body of theory exists on the work of the stand-up comedian, and little serious work has been done on the subject. This makes Tony's writing particularly valuable. Sections of this book on specific topics - Trevor Griffiths' *Comedians*, street clowning, or the wry and inventive review of a mobile phone conversation overheard on a train - offer specific analytical insights. Better still, the section on Attitude offers a distinctive, overarching theoretical approach to stand-up comedy, which will be useful to both critics and teachers of the form.

This book, the reflections of a unique comedian, is an important contribution to what I hope will be a growing debate about the nature of comic performance.

Oliver Double, 24 April 2002

*The feminist who makes
fun of the feminist movement ...
now*

Introduction

The secret of stand-up comedy is Attitude

This book is an exploration of comic attitude in the art of stand-up comedy. It contains the sort of information I could have done with twenty-five years ago when I was dying on me arse struggling to MC sporadic Rock Benefits. I don't suppose it would have changed anything for me overnight. The ritual public humiliation would have continued, but at least I might have had an inkling of what was going on.

Facing the beast of a live audience, without the theatrical convention of a fourth wall, is a pretty scary situation. It appears to trigger a sort of strategic identity crisis. Somewhere in this complex process is the clue to more than mere survival; it can also lead to the discovery of a performer's comic attitude.

The target audience for this book is primarily performers, tutors and interested parties, and the next new wave of live solo artistes - stand-up comedians, performance poets, spoken word exponents, lyrical street traders, celebrity politicians, ambitious demagogues and wannabe messiahs - in fact anybody that's got something to say and wants to give voice to it and might choose to learn from my mistakes.

There are basically four plots: the nuts and bolts of stand-up performance, a rough history from the village idiot to contemporary spoken word, my own development from street actor to stand-up comedian, and a deconstruction of the art and attitude of various performers past and present. It also comprises a selection of essays, examples of my solo stage act, including a complete transcript: _The Grim Reapo Man_ is _at the Door_, 1990, plus previously unpublished fragments, reviews and tidied-up journal notes that managed to survive my various technology upgrades.

Those who can, do. Those who can't, teach. But we all of us like a good laugh.

Enjoy.

In his biography of Lenny Bruce, Albert Goldman suggests that what Lenny did in his stage act echoed the ritual performance of a tribal shaman. He took drugs, got himself into a trance-like state, and then walked on stage and catharted the tribe's stuff.

I thought, 'I'll have some of that'. So at my next gig, just before I went on, I skinned up a fat one of homegrown local produce - Ladbroke Grove window box, (who said it has to travel across two continents to give it potency?) and then I went out on stage and catharted all over the audience.
One problem - wrong tribe.

Have we got a show for you tonight!
Have we got a show for you tonight!
Have we got a show for them tonight?

It's a performance
Be funny
Be yourself
Always give one hundred percent

Once more with Attitude

Gushy, showbiz, pazazz	*Have we got a show for you tonight!*
Sincere, cloying, luvvie	*Have we got a show for you tonight!*
Clueless, to the wings	*Have we got a show for them tonight?*

THE SECRET OF STAND-UP COMEDY

February 2002

I'm sat up the back of the Laughing Horse Comedy Club, in the upstairs function room of the Coach and Horses, Soho, London. There's fifteen people present; most of them are L plate comedians psyching up for their five and ten minutes of valuable stage time. It's an open spot night and it's about to start, but I'm not stopping. I'm here to check out the room for my solo show and to have a meet with Alex the promoter.

I've been writing solidly for the previous day and half. I haven't slept, spoken to anyone or hardly eaten for 32 hours and I've walked the four miles here from Ladbroke Grove. As I strolled through Hyde Park smoking a spliff of organic skunk, I had a good think. I'm now on my second pint of Guinness and I'm feeling a bit light-headed. Oh and one other thing - at about six o'clock this morning I discovered the secret of comedy again. Third time this year and it's only February.

There's no getting away from it. The secret of comedy is good timing. Unfortunately, it's not a technique that can be learned in front of the bathroom mirror; it's an intuitive state of grace that has to be discovered, an elusive abstract lubricant that exists in the eternal now and can only be found by taking risks and playing around with a live audience. Stage time and lots of it - there's no substitute. Good timing oils the works and it's the first thing to fail when the performance goes wonky. Like most things in the old stand-up comedy game, it's all in the doing of it.

There's no getting away from it; the secret of comedy is attitude. Unfortunately, it's not a technique that can be learned in front of the bathroom mirror. It's who you are on stage: the sum parts of your personality that flourish and demand expression or come to your assistance when you are stood in front of an audience trying to communicate. How do you discover your own unique comic attitude? Same old treadmill - stage time, taking risks and playing around. Stand-up comedy? It's all in the doing of it.

There's no getting away from it, the secret of comedy is simply - repetition, the rule of three and always leave them wanting more.

Alex leans across and has a word with each of the other three people sat at my table, giving them details of the running order. These sort of slots are often booked three months in advance; six months in the bigger clubs.

'Second half,' moans the skinny lad who's been poring over his set list and silently muttering to himself since I sat down. 'Don't worry,' says the chunky bloke with ginger hair sat next to me, 'you'll be able to critique everyone else's material.' No one says anything. It was meant as a joke, but it doesn't qualify as one - nobody laughed. But there's no loss of face. Nobody knew it was intended as a joke either. We're just looking at each other, wondering if a conversation has started. 'Critique?' asks the skinny lad. 'Er,' says Ginger. 'Analysis.' I suggest. 'Oh!' he says. It all goes awkward again.

These people clearly don't know each other. They don't even want to talk to each other. They are performers about to go on. They know they should be doing something pertinent to prepare, but they don't know quite what. I can't help them with that one. I haven't solved it myself yet. Each to their own on preparation, is my current thinking. Nevertheless, they are a very particular niche audience. The words 'Material', 'Critique', and 'Analysis' hang in the ether.

'It's not a matter of material,' I say with professorial certainty, good timing, and probably slurred diction. The smart young woman, who's also been checking a set list, looks up again and pays attention. I've got an impromptu audience of three and I'm seriously on-message. 'The secret of comedy has all to do with h'a'tti-tude.' I say 'attitude' in my best Dickensian cockney.

'Oh yeah?' says Ginger tentatively for all three of them.

'Yeah. You have to recognise the essential complementary facets of yer personality that thrive when yer 'up there doing it'. Then it's just a matter of juxtaposition.'

'I've got to introduce a rock band tomorrow night,' says Ginger, by way of a challenge for me to prove my thesis.

I'll tell you my favourite gag for that audience:

Lemme hear you say 'Yeah!'
'Yeah!'
Lemme hear you say, 'Y-Yeah!'
'Y-Yeah!'
Lemme hear you say 'Baaaahh!'

He laughs at that. He'll be using it tomorrow. It's a great gag that renders the cliché redundant, exposing it as a cheap unimaginative compering ploy. I deconstruct it for him in terms of attitude. 'Yadder yadder yadder! Yadder yadder yadder!' - hackneyed, clichéd and rabble rousing. 'Nah nah n-naah nah!' - impish, tricksy and too clever by half.

'Rule of three.' says Ginger correctly but actually missing my point.

'Yeah that too, the rule of three. Establish, Reinforce...'

'Surprise.' He interrupts correctly. He's been humouring me. But then I've been patronising him. Sod it. I haven't spoken to anyone for two days and I do need to blurt all this out to somebody.

Aggie Elsdon, the MC for the night, starts to warm up off-stage with a bit of playful singing. 'Two minutes to show time!' she warns.

'Aggie Elsdon for instance,' I continue, 'what are the complementary facets of her personality essential to her comedy?' Ginger thinks, but I don't let him answer.

'Plucky and exuberant? Yeah? Juxtaposed with jaded and world weary.'

He thinks briefly and agrees. It's actually much more subtle than that, and Aggie's a perfect

example of that subtlety.

A few more people have arrived. 'Address the now.' I say. 'Ergonomics! If we move our table back eighteen inches and create an aisle, these people here can go and sit down over there and won't have to walk across the front of the stage. No house manager - very slack.' We move the table and two touristy couples smile and pick their way through.

Show time. The taped jazz in the background fades with the house lights and Aggie appears in a spotlight behind the mic. It focuses the room. Simple textbook techie stuff, but so many little clubs fail to make it happen.

Aggie Elsdon, previously Wacky Aggie Elsdon, is an eccentric forty-something with dyed red hair and too much jewelry. She wears an oriental denim shift with matching kung-fu slacks and looks more like a dodgy tarot reader than a stand-up comedian. All eyes and teeth, she launches unaccompanied into an up-tempo Sophie Tucker-style opening number. She clearly can't be serious, but she's a trooper and it's a spirited rendition - it grabs them. That much achieved, she hits a beautifully timed bum note and the whole facade cracks, the false bonhomie collapses into crest-fallen resignation and she starts coughing. After her final wheeze, she looks up and gives us a brief glimpse of death warmed up. Exhausted and fed-up, she takes the mic. Now for the stand-up comedy.

It's spot on. Our table has been leading the laughter. I exchange nods with Ginger. Aggie continues to illustrate my thesis with example after example in a cracking little ten-minute opener. Every set-up is invested with a measure of light, which is extinguished by complementary dark in the punchline. Fragile optimism dashed by throwaway pessimism. Good news followed by bad news; good news followed by more bad news; good news interrupted by brief unhinged anger anticipating bad news. Then she rings the changes. Spirited acceptance of the way things are, juxtaposed with belligerent pleas for resistance. Blatantly envious descriptions of youth, success and beauty confronted by vicious calls for revenge. Finally, when the anger offers no respite or resolution, she gets delightfully bleak and surreal. All this is by way of an introduction to the evening plus a little bit of 'What a crap day I've had.'

I've known Aggie for five years and she's always been a better writer than performer, but lately all that has changed. She's really got on top of it, toned down the raucous extremes and now seems to be enjoying the subtlety of what she's doing. The audience loves it, particularly the closing lines, which comprise a very special sort of joke - the unvarnished truth. No longer the victim, she says with a hint of bravado, 'I'm not doing this anymore. I'm going off to run a residential hotel in Pahnang, Laos. God! I'm tired of fucking London!'

It's the best I've ever seen her. They'll love her in Pahnang. Attitude is universal.

The Performance Imperative - October 29th, 1999

2.15pm. I arrive late to deliver my paper, *The Art Of Stand Up Comedy*, at a conference entitled Whose Theatre Is It Anyway? at the Arena Theatre, Wolverhampton University. In the foyer there are hushed tones and why? Because some poor sod is trying to deliver a paper to an attentive audience of fifty a few yards away in a ludicrous sunken area within earshot of the entrance and reception desk. This is probably the Arena. Thirty seconds in, and already I want to shoot the architect. An efficient young woman in a navy blue uniform on the desk signs me in and introduces me, in whispers, to my guide - another female also in navy (perhaps Hertz or Tesco are sponsoring the event). The guide leads me off through a maze of corridors where I notice other papers being delivered, mostly in classrooms, to more attentive groups.

I've never delivered a paper before and I am brooding on how difficult I've made it for myself. One of my arguments is that the central difference between performing stand-up comedy and acting, is that a performer directly acknowledges the audience whereas an actor acknowledges a permanent fourth wall. Consequently, any public speaker performing to a live audience, be they poet, rock star, politician, barrow boy, teacher or someone delivering a paper at a conference, is a performer using the same set of tools. It's essential that I deliver my paper as a performance. The stuff of my paper is the first kickings of a Performer's Handbook. I've got the itinerary for that set of tools. I know it pretty well because it serves as the framework for the workshops that I devised and have been running for years. Only trouble is, as a stand-up comedian, I'm used to choosing from a whole bunch of tried and tested routines organised in various fairly familiar sequences, but today I have a sheaf of accumulated notes - reams of them - my personal strategy and schedule for a six-session workshop that I've hardly ever given public voice to in its entirety. I've spent the last few weeks, days and hours preparing a précis, but I've not read it through fully since the last major update (completed as we were parking the car). Every time I start, I stop and add new bits. I've never had to explain it all in one go before and now I'm about to be called on to deliver at any moment.

My guide stops at a door. I look in through the glass panel. This is the gig. I'm shown into the room and sit down at the back as quietly as I can. Oliver Double, ex-stand-up comedian, now Professor Double of Kent University, is talking confidently to twenty people. He acknowledges me with a nod without breaking his rhythm - he's on it. He's a performer.

The classroom has three rows of fifteen chairs arced around Olly in one corner - the other two thirds of the room are empty - creating an echo. There's a continual drone - someone is chatting somewhere.

There's a smart looking young woman, again in navy blue, seated beside a table behind Olly. He's using an epidioscope and a video screen and moving between the two while projecting his voice without a mic. I'm not listening to him; I'm working out the dynamics of the room. The drone is close by - a young translator leaning into the ear of a distinguished looking old geezer who is also putting in his two penny worth. Irritated, I move to a seat on the other side of the room and discreetly consult the précis of my notes. I've got a very pertinent opener - it's a new addition scribbled in biro at the top of page one: 'Vuk Drascovic'. I'm not sure now whether I'll be able to walk straight on and go into it because I have decided to re-organise the performance space first.

The two droners move across behind me. Annoyed, I get up, give them the eye 'large' and return to my original seat. I'm gonna have to sort them out, and also I'll be moving that woman off the 'stage'.

Olly is talking about the development of stand-up and comparing the stilted cartoon-style of patter

acts and variety artists to the more naturalistic approach of contemporary comedians. I know his take on this stuff. It was in his book *Stand-Up: On being a Comedian*. It's a perfect set-up for what I want to say. I've always liked Olly's work, even before I read his book with the chapter documenting a brief history of Alternative Comedy and recognising (nay, celebrating) my contribution in a way that modesty demands that I never could.

My creative comedy pal Den Levett arrives. She's been performing and co-workshopping with me for two years and knows my work. Our ensemble of eight, The Performance Club, has been booked as the conference cabaret later on tonight. Den is very good at picking me up for being unnecessarily aggressive on stage. She sits at the back with Tom our techie.

Anger can be a very useful tool to me although, after all these years, I'm still learning how to grab hold of it and run on its energy. As a rule it only works when I have got it harnessed, when I'm aware of why I'm angry in the first place. Today. Now. I am angry with myself for not getting my shit together. I know I'm quite capable of performing that anger if needs be - admitting it to the audience and even getting a laugh out of it. So why is my blame machine still flailing around looking for targets to dump on? I've got all sorts filling my head, from the Wolverhampton inner ring-road system to the burblers in the back row.

Olly concludes and announces that there are two other speakers. I gesture for him to let the other guy go on first, giving me more time to consider what I'm doing.

Chris Ritchie makes no attempt to perform and sits behind the table and commences to read from his notes. He's short on charisma but seriously on-message. He is proposing that stand-up be 'legitimised' and has his own ideas for a set of tools. I'm immediately on the defensive and anxious when he starts deconstructing stand-up in a totally different way to me and suggesting his own categories. My body language becomes hostile and I deliberately look daggers at him. He catches my eye and looks a little nervous. I immediately regret what I'm doing and attempt to inhabit a less neg-head space. I look on supportively while trying to think in Den's mode. 'This is a very interesting event and I'm quietly delighted that there's other comedy nerds out there and twenty of them are here willing to listen to our ideas.' Huh! Even if two of them are disrupting the event by continually burbling. I mean how can you listen to the speaker and talk, all at the same time? What is he - some sort of novelty act? God! I'm sat thinking up one-liners to censure the rowdies and I still haven't précis'd my notes or edited all the stuff in my head. Yes, this is just like a gig.

Ritchie says that there is less reason for comedians to be political nowadays because there is less to be political about. Just where's he been hiding? Rather than get into stroppy heckling I'll just have to do some tasty political material and answer this statement by deed. (In fact, he said nothing of the sort, but I'm getting increasingly stressed-out and that's what I heard.)

Eventually it's my turn. Deep breath. Be yourself. Be funny. Always give a hundred percent and, if possible, without referring to your notes. I step up and attempt to grab the room by looking round at the situation and acknowledging the task ahead of me with a vaguely optimistic sigh. I ask the woman (who turns out to be Cathy Mcgregor, the person who booked me) to sit in the audience. She complies amicably. Then I confront the burblers.

'So what's the relationship here?'

'I am translating for him,' replies the youngster.

I've presumed too much here. I didn't reckon on having a translation taking place through my set. Some of my anger is focused on them. But, to be fair, it's not their fault. The more I think about it, the more likely it seems that this could well be common practice at an international conference.

I pause and give a thoughtful if disgruntled, 'Hmm!' without being overtly xenophobic, and then

mug to the room - weighing up the situation and its ramifications in my head. This is real - I'm performing reality. I give a shrug of acceptance with as much grace as I can muster.

I explain (before I'd planned to) the stuff about this being a performance situation. I personally need to hear myself say this because I'm not sure whether I believe it any longer.

The burblers take the burbling down a couple of notches as I slide into my set conversationally with a brief bit of chat about the traffic on the motorway explaining why I was late, which seamlessly leads into a choice wrong footer of an opening gag...

> *...and you know them bastards - one minute they're in the middle lane doing about thirty mph because they're driving with their elbows, trying to roll a spliff? And then they pull across into the outside lane, foot to the boards and suddenly they realise that they're doing eighty and end up on the inside lane doing fifteen miles per hour and causing all sorts of chaos? Do you know them bastards? Do you? D'you know the ones I mean? Yeah? Well, I'm one of them, right!*

This gets a laugh and then the laugh builds as other people realise it's alright to laugh at a lecture on comedy and then they think back to the joke and they laugh at it. I wait for them to catch up and as the laughter starts to subside - that's the time to resume talking - it quells the tail end of the laughter. Start any sooner and they can't hear you over the sound of their own laughter; any later and you've got an unnecessary pause - bad timing. Now that I've set up the performance expectations, I get a flash of panic as I consider the great wodge of unstructured material I'm about to lay on them.

I hadn't resumed talking; I'd paused unnecessarily. Timing? It's an easier horse to ride than to mount. On with the show.

> *...I was watching Tony Blair the other day on the telly addressing a conference. He walked on beaming and waving and then, while the crowd were still applauding, he 'apparently' recognised someone in the audience, pointed at them and made like he knew them, and clearly hadn't seen them for some time. I saw Clinton do the same thing a few days earlier. I've got my version of the same thing. It's a ploy. What comes across is 'Hey! Good to see you. Glad you could make it. How's the family? Nice one. Catch up with you laters.' What is really going on is, the performer is demolishing the fourth wall and bonding with the room - 'I don't know you, I've never met you before and let's keep it that way. But hey, I'm an opportunist and you are my way of establishing a connection with this audience.' Politicians are learning the skills of the live performer. No big surprise there, until I saw news footage from Serbia and Vuk Drascovic was using the same technique. What next? The Indonesian Generals? 'Hey! Good to see you. How's the family? Do you want to see them again?'*

Thirty minutes later I've proposed my theory differentiating performers and actors. And hopefully proved it by giving a performance with plenty of appropriate 'now' and 'attitude'. I've also kept it lively by

adding a fair sprinkling of relevant bits of my material throughout. I even managed to slip in a topical political joke for the innocent Ritchie.

> *'And why are the Allies dropping just about every bomb they've got on Serbia? Cos they're junking all their non y2k compliant ordnance before its past its shell by date.'*

But it was like a gig in other ways. I allowed myself to get into endorsing and elaborating on one of Chris Ritchie's other topics by having a good moan about theatre and acting being institutionalised in the higher education system, whereas stand-up comedy and performance have no equivalent. Stand-up is self-taught apart from a small sub-culture of independently-run workshops and the odd enlightened university drama department giving the likes of me and Olly a few tutoring hours. I also point out that performers write, update and present their own material whereas actors interpret a third party's set script through a director. So who's the real artist?

I've left little time to detail my main set of ideas and only mention a rough framework of categories and the order I believe they should be taught in: starting with a whole bag of fundamentals for the first session that includes the relationship with the audience - mimicry, mugging, and corpsing. Basic presentational techniques, the joys and importance of timing, and identifying attitude - who you become on stage in front of a live audience. An introduction to irony. Then applying attitude to material, including experience, opinion, observation, imagination and information. An exploration of cliché, stereotype and taboo. Joke structure - rule of three. A comparison of wit and pun. Texture. A range of secondary techniques for embellishing material. And finally identifying personal technique and consolidating individual strengths and existing skills.

It's a bit of an ideas salad. I've given too many examples and followed up too many tangents, but I've kept the aggression to a minimum. I've dealt with the burblers by subtly leaving silences when they are talking. Embarrassed, they censure each other. I've sustained a performance and had me moments. I'm not happy with it, but people have been making notes and now I'm running out of time. I hardly mention any workshop exercises or a million other things I'd like to have said and suddenly it's 'questions from the floor'.

There is a fractured discussion about several topics common to all three speakers: recognising and legitimising stand-up, organising a discipline, deconstruction and language, defining stand-up by the 'Now' agenda… but this is the wrong forum - not everyone is up to speed. The distinguished foreign gent stands up with his translator and makes a contribution which is both fascinating and wide of the mark. When he has been going for what seems like five minutes, talking about how the comedian in Greek classical theatre usurped the tragedian and took on the weighty subject matter, I become frustrated and want to return to our discussion so I interrupt him and inform him that he's missing our point about modern stand-up comedians operating 'in the now'. When he ignores me, I tell him he is supposed to be making a point, not delivering his own paper. It's fairly easy to heckle someone with a translator because there's two sets of pauses. I don't feel right doing this so I shut up. Also I'm none too clear about Ancient Greek theatre. Den then interrupts him with a salient point on the same 'now' subject; only she makes it relevant to 'yer actual' here and now. He stops soon after.

Later, in the large, crowded bar, over a beer, someone says they'd heard that I'd been arguing with Dario Fo. Fo! Fo of all people! Dario 'Accidental Death of an Anarchist' Fo. Fo is a bit of a hero of mine. It'd be good to meet him; I would like the opportunity to explain and discuss our difference. So I go looking for him, and find him and muscle in on his conversation. Immediately I'm introduced to the five people at his

table. I sit down and after some cursory chat in English, they resume their conversation in Italian and ignore me. After a few minutes I realise I've been rightly had. But I can't let it go. So I sit there and I wait. I wait until the master is holding court and in full flow and then I start burbling to myself quietly in fluent tape-backwards. As soon as he notices and stops, I smile a wordless plea of 'ring any bells?' He doesn't get it. Or does he? Because spot on, he is in performance mode and simply looks across at his translator, and expresses an exaggerated clown gesture of utter bewilderment, and gets the last laugh.

Working the Carriage - February 2000

I board a fairly busy Glasgow to London train at Carlisle and sit across the aisle from a chunky black guy dressed in expensive soft dark leather. He is sat occupying almost two seats and wears a headset with the mic hovering a few inches from his mouth. In front of him on the table are an open address book, a small keyboard and some notes on scraps of paper. He taps a few keys, waits briefly and then, loud and clear in an American accent, he starts a conversation with, 'Hi John. Yeah. I'm on the train.' Great modern clichés have to be heard with an American accent for the full impact. There was a high wince-factor among my fellow passengers.

As it happens he was a pleasant enough guy, Dean, or was it Dane - DB anyway. A gentle, good-humoured musician who was... 'on the road with a band - decent bunch of guys - Jo'burg next week and then on to Australia, not back home to the States and the wife and two kids until March. Renting a flat in London - the East End - Bethnal Green - right side of town for the recording studio. Problems with the backing singers - the ones in the studio, not the three on tour - they're fine. Agents taking a percentage of the travel expenses but management are checking that out.' I got that much, and more, in the four calls he made before we reached Lancaster and then I just had to move. I had a review to write.

On reflection, this was one of the most sustained and ambitious 'on the phone and on the train' performances that I've experienced. It also exposed a profound flaw in the current approach to the form itself, be it a single or multi-call set. Although DB was attempting some interesting developments with narrative and attitude - introducing fresh threads with each new call, embellishing material already established and displaying broad emotional range - he failed to convince. DB and all his fellow practitioners have yet to come to terms with their artistic identity. They are clearly involved in delivering a semi-improvised script to an audience - their voices are raised above and projected beyond personal space and private conversation; but they're not actors - they are not in character. They are playing themselves in the here and now, although they do tend to ignore their audience and operate behind a fourth wall. So they must either be 'performance artists' - a modern extension of fine art where the artist becomes living art or somesuch excuse for obscure excess. Or (more likely) they are hobbyist performers, supposedly operating within the same parameters as stand-up comedians. Until they sort it out and understand what they are doing, 'on the phone and on the train' is dead in its tracks as a form of creative expression.

Presenting a live performance involves demolishing the fourth wall and acknowledging the audience. It also requires a few basic techniques - mugging and mimicry, timing the laughs, even manipulating applause, while at the same time anticipating hecklers and being prepared to deal with them. You have to

work the carriage. Where this became crucially apparent with DB, and where he really failed to convince, was when it got personal. Sure the Joe at the other end of the line was convinced, but how many times did we, the audience, have to hear his concerned avuncular tones asking yet another close buddy: '...and you? How's this ol' life treating you, man?' before it sounded trite, perfunctory and, dare I say it, transparently dishonest? All we needed was a shared aside or a raised eyebrow, but no, we got nothing. Witnessing that unacknowledged and obvious deceit was the final turn-off for me. That, and of course the fact that the whole episode was a fucking imposition in the first place.

Performance Dynamics

Myth has it that the art of the raconteur / comedian is a natural gift, despite the fact that any deconstruction reveals it to be honed, heightened and carefully selected re-runs of normal speech and behaviour. The oft-repeated statement that you can go into any public bar and find a natural comic holding court may be apparently true.

Most of us employ a limited range of performance skills in social situations in our everyday lives. Our audience, whether or not they are actually paying us any attention, are those around us. On a roll: we make the right choices and sustain the consequences, know when to boldly speak up for ourselves, when to be conciliatory and when to listen patiently. This involves orchestrating our emotional behaviour. We've all probably got at least one good performance in us.

Nevertheless, to elevate even the most seasoned pub raconteur to the level of a solo performer capable of delivering a sustained cabaret act, requires a construct of considerable sophistication.

The deliberately public comments, quipped asides or looks of exasperation of a complaining punter in the bank, bus queue or betting shop, may involve performing; they do not necessarily constitute a performance.

On stage, halfway through scene one of the school pantomime. Oompah stripper music and lights. Enter two fourteen-year-old boys playing the ugly sisters. They come on to immediate hoots of approval, catcalling and wolf whistles. They are dressed in drag and represent extreme caricatures of their female contemporaries. The white kid has a black wig of spiraled telephone cord, the black kid, a platinum wig of a blonde bombshell. They both wear ridiculous OTT make-up. They have balloons stuffed inside bras inside boob tubes. One has hotpants with a padded bum, suspenders, stockings and sexy boots; the other a Ra Ra skirt, baggy ill-fitting panty hose and sling-back high heels. This is their audience and they are dressed to kill.

They play to the crowd with a mixture of embarrassment and bravado, making glorious hay while the licensed sun shines. Their promenade is a lewd show of stumbling about, playing with their boobs and adjusting their dress. They share their glee at what they are doing with the whole school but especially their immediate peer group. The sub-text is: 'Look at me. I'm up here doing this Nyaahh! And this Nyaaahh! And I'm getting away with it. Nyaaaaahh!' When they eventually come to deliver their lines, it's with robust intuitive distance - always as themselves, aware of enjoying the grossness of their parody and constantly feeding off and inter-acting with the rowdy crowd. The fourth wall has been demolished. It is a performance by performers.

A studio theatre. Darkness. *Autogeddon* by Heathcote Williams performed by Roy Hutchins. It takes 20 seconds to gradually illuminate the down stage centre. The audience settles into focussed silence. The performer walks into the spotlight. He introduces himself and briefly explains that he is going to recite a poem. He is serious, engaging, and likeable; he clearly has reverence for the piece he is about to interpret. The poem lasts almost an hour and he serves the integrity of the text throughout. Occasionally by way of nuance - a smile or a raised eyebrow - he shares in the audience's delight at a particularly witty line, astonishment at the litany of outrageous facts, or appreciation of the quality of the writing. At one point a late-comer enters and interrupts the flow. He smiles, acknowledges their embarrassment, allows them to settle and continues. At the end he thanks the audience for their attention and bids them goodnight. It is a performance by a performer.

Relationship to the Fourth Wall

A stand-up comedy performance involves direct communication with an audience. Performing rather than acting.

The actor is playing a role. The deceit is known. The actor and the audience have a contract - the actor plays a role and the audience suspends its disbelief and agrees to be transported to the time and place of the play and watch the action through an imaginary fourth wall. As soon as the play is over, the contract ends and everybody applauds and waves at each other.

A raconteur comedian walks on stage relatively naked. He speaks directly to the audience in the first person. There is no contract, only a nebulous agreement that the performance is spontaneous and authentic. Even though the set-piece jokes, skits and monologues may be learned word for word, the audience will overlook any deceit so long as they get to laugh and feel included.

Stand-up comedians, when telling a story or describing an event, may choose to erect a temporary fourth wall and inhabit their musings, memories and imaginings by acting out a character, short scene or conversation. But whatever the frequency and duration of these fragments, they will constantly return to directly addressing the audience by briefly sharing the implications of what's being said, with passing comments, rhetorical questions, and facial muggings. The audience are spoken to, conferred with and confided in, and more importantly their responses are acknowledged. Consequently the timing, placing, or even the inclusion of some of these asides to the room will vary from gig to gig, as will the amount of additional material and the moments of pure improvisation.

Now and Then

Stand-up comedy therefore has two agendas - performing prepared material plus all the business of delivering it to this audience on this particular occasion.

This double agenda has been described by comedian Ken Dodd as 'Then and Now'. 'A funny thing happened to me on my way to the theatre (Then). Oh yes! You can laugh, Mrs. And I wish the rest of you would.'(Now).

The 'Now' agenda defines stand-up comedy. To deal with the 'Now' and assist with just about everything else, it's important to have at least a competency badge in two basic clown techniques.

Mugging and Mimicry

The outrageous costume and antics of a clown create a range of immediate reactions: adults point and smile, children laugh, and toddlers are traumatised or burst into tears. Clowns thrive in this state of affairs. They happily drop their token business and start to improvise, switching playfully between two distinct modes of

expression. Mimicry: aping, ridiculing, and generally sending up their subjects. Mugging: sharing exaggerated little cameos of their own feelings with the audience via looks, double takes and visual asides. The greater the response, the more opportunity for creative play - re-working the familiar and experimenting with the immediate. Juggling and riding a unicycle need be no more than an intro - an excuse to perform.

Christmas Party at Loweswater Hall, Cumbria. 1995

Lilli Landau is nine years old. She stands up and announces that she will now perform a card trick. The dozen or so guests have had prior warning. They stop what they are doing and indulge the kid for a few minutes. She explains, with some aplomb, that we are about to witness a very difficult mind-reading trick and that she has nothing up her sleeves and there will be no collusion with any member of the audience. At this point there are smirks and people look at her mother Sharon, who has been in a constant confab with Lilli and a pack of playing cards for the previous half-hour. Lilli censures the room with a high-minded stare and a hint of a smile. She shuffles the pack with mock gravitas, asks for them to be cut and then ceremoniously lays out five, face up, from the top of the pack. She then briefly goes back into a huddle with Sharon again. More giggles. Another delightful censure. 'I will now leave the room. One of you - but not Sharon - will pick a card.' More giggles and censure. Then with authority, 'I will return and identify the card.' Lilli leaves, someone picks a card and Lilli returns when called. She enjoys muttering some magic gibberish, holds her hands above the cards as if feeling their energy, and looks round the room at everyone, but especially at Sharon. Then with the room hanging on her every word, she announces with a flourish, 'The ten of diamonds.' There is a marked silence. It's the wrong card. Her facial expression and posture are still in triumphant magician mode, but she is crumbling inside.

We are in uncharted dangerous territory now. For three long lonely seconds she ponders her narrow range of options. Will she burst into tears and run out of the room? Fall into her mother's arms hiding her face? Throw a tantrum? Or slump into a sulk? She takes the performance option. Her lips tighten and a smile forces its way onto the corners of her mouth. She then corpses and breaks into giggling laughter joined by everyone else in the room.

Although Lilli had options, her emotional impulse was bound to act before she could think clearly, so her line of behaviour says as much about Lilli's character as it does about any performance skill she might have. That she has the makings of a talented performer is in little doubt.

Lilli had in fact made it a lot easier for herself to corpse her way out of the hole she'd suddenly dug for herself, because her performance was always 'in quotes' - she was never wholly the serious magician; she was always Lilli playing the serious magician. Her final corpse was one of a sequence of asides and muggings used throughout to distance herself from the magician and remind us that she, Lilli, was only playing.

Timing the Corpse

Corpsing is a simple 'Now' technique that can assist a performer in all sorts of situations. While introducing a joke or funny story, the well-timed corpse can build expectation: 'I'm laughing just thinking about telling you this story.' After a punchline, a corpse can mark time while the audience laughter subsides: 'Yes. That is so funny I can understand why you're still laughing.'

Clearly it's a deceit at the edge of reality and should be used sparingly, although not everyone believes that. There's always one, isn't there? Billy Connolly has developed an infectious corpsing style of delivery which he indulges continually to the extent that it is an important element of his core stage persona.

Attitude: giggling, gregarious stage-Glaswegian oik. You'd have to see his stage act three times to make a decent guess as to how much of it is random. My reckoning would be that it's well over 90% embedded in routine and varies only in degree. Its effect, however, is to establish and sustain a very engaging 'now' performance.

Corpsing

Historically, in low-budget touring Shakespearean theatre, the actor manager (usually a barnstorming old ham) playing the lead role, would be left standing in the last act, down stage centre, booming out the final speech. Strewn all round him were his cast, in the minor roles, slaughtered, playing dead, bored, thinking about last orders down the pub and suppressing fits of giggling. Hence corpsing.

Much taboo about laughing

When performers employ devices like corpsing that involve switching personas and shifting from one seemingly authentic emotional state to another, and manage to extricate themselves from embarrassing situations, they inevitably expose the entire performance for what it is - a performance, and not the authentic communication it pretends to be. This aspect of the performer's art, with its echoes in our own often deceitful emotional behaviour is, I believe, the seedshit of a blossoming taboo against the deconstruction of stand-up comedy, epitomised by the myth that 'you can either do it or you can't do it, but you certainly can't learn it or teach it.'

Kay at Hood

At Hood Fayre in the early eighties, I watched in awe as the Fool, Jonathan Kay, was introduced on to the main cabaret stage. It was a long walk from the wings to the mic and it took him several minutes. He stopped on entering and waited for the spotlight to find him. He grinned and acknowledged us and the situation. He was then drawn to the edge of the stage by someone giggling in the front row. He mimicked them and mugged his thoughts to the rest of us. He mimed questions, translated answers and suggested scenarios - all without saying a word. By the time he'd reached the mic and finally spoke, he had us believing that some of those in the front row were half asleep having danced all night, some were stoned, one was sulking because their tent had collapsed, another was shy, one was coming on to him and several were up for anything because they'd been drinking competitively. We laughed at every gesture and expression and at every familiar reference. We laughed at his delicacy, daring, lightness of touch, impishness, sense of mock propriety, and we laughed because we were being reminded of the simple joy of creative play.

Frankie Howerd mugging

All successful performers use scaled-down versions of these basic techniques. Mugging is an elegant shorthand for expressing who you are and what you feel. At his best, Frankie Howerd's mugging was masterful - attitude encapsulated in a veritable armoury of salacious lip-puckering glances, eyebrow-raising asides, pleas for sympathy and looks of world-weary resignation to the room.

'Addressing the Now' can sometimes require more than just a cursory 'working the room'. There are those occasions when an external event so demands attention, that a failure to deal with it reveals the deceit and nullifies the potency of the live performance. For the comedian this amounts to a dereliction of duty.

Good Friday at the Irish Centre, Camden. 22 May 1998
Ardal O'Hanlon, John Molony, Bob Boyton, Mary Burke and Kevin Gildea

There are gift moments in stand-up comedy when the audience have something on their collective mind and all that is required to get them laughing is to acknowledge it. Do it with attitude, explore some of the detail and they are yours for as long as you want them. Replying to a heckler, commenting on a dropped drinks tray, the state of the venue, the price of the beer, the weather, the big news story, the death of a celeb, the local taboo revealed. All are such gifts. Among the comedy nerds, we call it addressing the Now. The Now agenda defines stand up comedy. It's the difference between the performer and the actor, between improvising without a fourth wall, or scripted and with a fourth wall. When an audience is addressed directly about something shared but unexpressed, stand-up comedy can get very interesting, dangerous even, and depending on the accuracy of the comment, and the potency of the subject, these occasions can turn shamanic.

The Irish Centre, Camden, packed to capacity for an evening of comedy on the night of the referendum on the Good Friday Peace Agreement. The previous night's telly news bulletins have shown David Trimble and John Hume appearing on a Belfast rock stage with Bono and U2 supporting Tony Blair's 'Yes' campaign. The likes of Gerry Adams and David Irvine and their respective armed wings are also on message, but if that sounds like a motley crew, the 'No' campaign boasts Ian Paisley, half of Trimble's Unionists, Conor Cruise O'Brien plus several Loyalist and Republican hard-line para-military splinter groups and the National Front. The old George Bernard Shaw one-liner still stands: 'If you understand Irish politics, then you've been misinformed.'

The majority of the 600 audience are London Irish of Catholic origin and presumably 'Yes' supporters. Some, not many, even sport badges and T-shirts and even before the show starts, there's the odd shout of 'Yes' from the crowd. Nothing particularly triumphalist, but clearly it's something this community has been concerned with for many a month. Recently, on the London comedy circuit, I've heard the odd good gag on the subject but tonight, in such a setting and with five comedians on the bill, my expectations are high. I feel as if I'm in the right place at the right time - one of those 'you should have been there' gigs.

I've got my own thoughts on the media fest that's been going on for the past goodness knows how long in Northern Ireland. For instance, is it me or does David Irvine seem like a decent bloke? Someone who's done a bit of thinking while he's been in clink and thought, 'Shit man, it's about time I grew up', and similarly Gerry Adams. Do you reckon there was a moment when Gerry took Martin McGuinness aside and said, 'Listen pal, we're not as young as we were, I can't keep this up any longer, we been responsible for killing people, I ain't sleeping too good. There's new kids on the block as daft and as scary as we were. Well, as you were, anyway. What say we mellow out?' And Martin's going ape-shit calling him all the fuckwit-Judas-traitorous-Michael Collins' under the sun and Gerry's had to slap him about a bit and say, 'Hel-lo! Martin. Get a life.' Or is it simpler than that? Has some MI6 sweet-talker just taken them both aside and said 'Oi Paddy! Wise up. You're welcome to this shit hole. We want outta here. Know it! Now just let us leave quietly with a bit of dignity and we'll try and persuade the silly Unionists that it's cool. And let us all try and make Paisley look like some turkey bible puncher from the 17th century.' Wide of the mark? Probably. It's not really my subject, but what do the locals think?

It's a Works canteen of a venue, the Camden Irish Centre. The crap lighting goes down and the show starts. The crowd is up for it. I'm not the only one with expectations. Kevin Gildea, a boisterous, if unmemorable compère, struggles a bit at first, and although he has them laughing and participating, he only really manages to appear like a professional MC when the night is two acts old.

31

First up in the graveyard slot is Mary Burke whose decidedly lightweight patter concerning primary school teaching, nursing, and middle-class friends, is pretty dull stuff, but her occasional shafts of wit on being Irish and over here are enough to earn a warm reception even if she has little to offer on the issue of the day. Next!

Bob Boyton, the only non-Irish act on the bill, has never been one to mince his words or dodge an issue, but tonight he's doing the gig as part of a tentative comeback, his mind's on survival and he's far from his best. More recently Bob's been reading his gritty short stories of London low-life in the quieter clubs and studio theatres, where the diamond geezer side of his personality has shone through to the audience brighter than it ever did on the intimidating stage of stand-up comedy.

His blustering delivery is a touch too relentless and the shock value of his class-war political material predictable and not that funny. But it's going down well enough, until he re-introduces Lady Di - just to have yet another pop at her. It sounds gratuitous and it is; the audience aren't so easily rabble-roused and decline the group stereotype they are being asked to adopt. 'Have I gone too far?' asked Bob. He had, but it was the presumption 'too far' that restrained them. He got off unscathed. Lucky Bob.

By contrast John Molony is the first comedian on the bill to appear relaxed and consequently to relax the room. He has genuinely funny material and can deliver it with a lightness of touch and a range of technique, which keeps the laughter flowing. Unfortunately, he has long since purged his act of anything relevant or political and he isn't about to make tonight an exception, no matter how risk free and appropriate the occasion. His fleeting remarks on the historical vote back home are sadly content-free. As he moves into his accordion finale, I wonder what thoughts Dave Allen or Tom O'Connor, Terry Wogan even, would have shared with this gathering.

Headliner Ardal O'Hanlon was plucked from obscurity a couple of years into his career and given instant fame in a cult sit-com. It was left to him to deal with the odd friendly, and by now drunken heckler shouting 'Yes' from the back of the room. Like the other acts before him, he fails to express any feelings on the subject which everyone else in the room must have an extended set. He jokes that he has nothing much to say about anything, and mercifully doesn't waste that much of our time in telling us. His stage persona, like theme pubs and *Riverdance* is a commodified cliché of Irishness - inoffensive, innocent and mildly quirky - Father Dougal without Father Ted. And like so much stand-up comedy, irrelevant and such a disappointment. I really must stay in more.

Attitude: Starting Out

Those who copy the innovator do exactly the opposite of what the innovator did. They inevitably take one step to the side and one step back. At best they are the front line of the new old guard.

Most fledgling comedians on the London comedy circuit start out by blagging stage time in makeshift clubs in pub function rooms often run by fledgling entrepreneurs or other comedians. Here, at the very bottom end of the market, they perform five and ten minute open spots in front of audiences of seldom more than a few dozen. This is an appropriate chance to experiment and it may be their last. As soon as they get their first

STAND-UP COMEDY
– LESSON ONE –
ATTITUDE
CREATING A RAPPORT

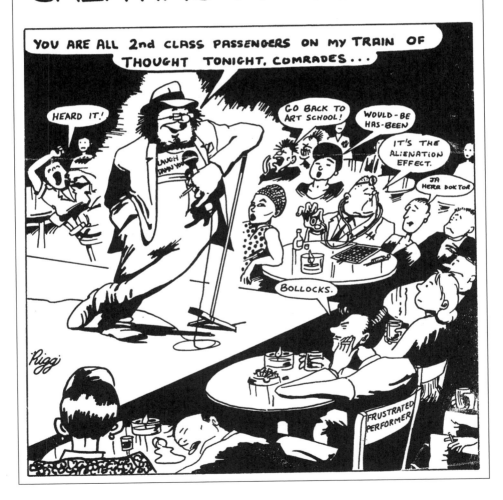

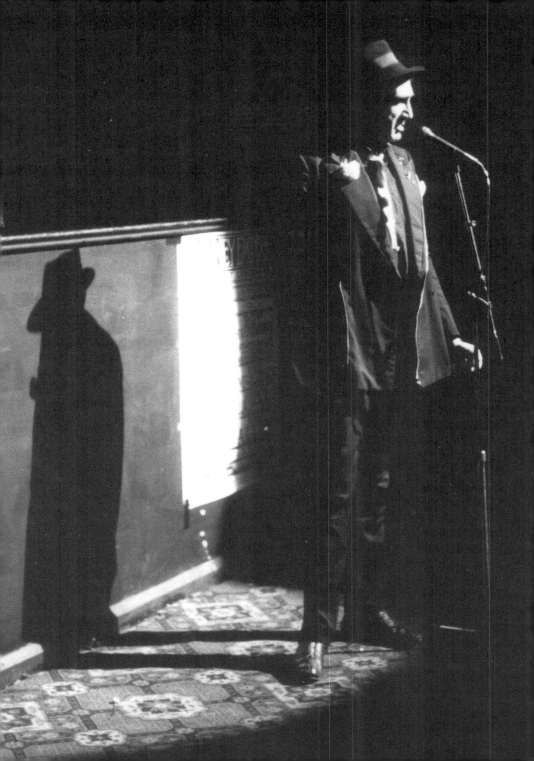

'paid ten' in an established room, their opportunities to take risks and make the inevitable mistakes start to decrease. The pressure to conform and succeed is obvious and the impetus to cut the clever stuff and stitch together a 'tight twenty' as good as the next guy's is almost overwhelming; but it's also soul-destroying. The household names of a few years hence are currently waiting in a four-to-six month queue to perform ten minutes of stand-up stress at the Comedy Store. If they have talent and are competent they will reach the over-populated under-paid plateau of perpetual semi-professionalism. There, along with several hundred other hopefuls, they will play in clubs where it's possible to be spotted by someone who might know someone, and where their role models are the regular headliners - slick, efficient and on £500 a week.

It's a pretty inadequate apprenticeship and given the competitive service-industry environment, it's not difficult to understand why so many contemporary comedians have such a limited range of attitude and mostly conform to a narrow range of generic types.

Stage Time and Making Mistakes

Stand-up comedy's peculiar route to professional status has similarities with other potentially get-rich-quick vocations like football, acting, or pop music. One fundamental difference, however, is that stand-up comedians gain precious little from training and rehearsal. They have to be out there in front of an audience larking about and experimenting. There is no other way for a stand-up to discover the essential attitude that will inform their unique stage persona. It's all in the doing of it.

Discovering and expressing attitude is not something that can be approached like an acting role and mastered by technique. It cannot be selected off the peg and successfully donned or adopted. Attitude is a peculiar expression of personality under pressure. It is integral. It needs to be owned by the original owner. Someone else's attitude or one borrowed from the local gene pool will be highly inappropriate in times of crisis.

If any theatrical analogy is to be drawn, then it comes from the understanding that the essential driving force of a play is the dramatic conflict based in character; similarly the essential impetus of a stand-up comedy act lies in the juxtaposition of expressions of attitude.

Every performer has to be aware of the previous role models and find their own way of dealing with all the influences and ubiquitous clichés in the cultural archive.

Identity Crisis

Standing on stage in front of a live audience is a situation that appears to trigger a sort of strategic identity crisis. In order merely to survive, various sides of our personality come to our assistance. However idiosyncratic or inappropriate these minority personalities appear to be, they should all be given an audition. How we recognise and then express these sides of our personality, how we assemble an individual palette of available emotional states, how we learn to switch seamlessly from one to another, and how we laugh at ourselves and the world around us, is the stuff of discovering our own unique range of Attitude.

For some (bless 'em) this is a task never consciously undertaken; stood in a spotlight, they intuitively inhabit a part of themselves with a range of attitude that works. They switch from perky innocent into hapless loser or opinionated pedant into belligerent psychotic with enviable ease and timing. For the rest of us it takes a little longer and some of us will be banging our heads against a brick wall decades into our careers.

Often comedians will give each other feedback on material, but rarely mention attitude. Maybe to discuss attitude is to get a bit too personal? In a workshop situation when we ask a group to give feedback on an individual's performance, the first question is always, 'Who are they up there?' There is always a

reticence from the group. But we are not asking what are they like in the bar or in private conversation, but who are they under pressure? Who do they become when they are faced with an audience? What revamped parts of themselves do they show us? This is not a wholly personal question. It is distanced by the act of performance. Be honest with each other on a need to know basis.

Defensive Traits

Some comedians display defensive personality traits which they don't recognise, or if they do, they refuse to investigate. Although this sort of self-deception can complicate real life, on a comedy stage it can be a long-term snarl-up and waste valuable time and energy (tell me about it). A performer who is not owning and exploring parts of their defensive personality is really doing things the hard way. Discovering your comic Attitude can be having the nous, humility and imagination to do it the easy way.

Every apologetic wince, intimidated nervous tick, or pedantic repetition might just be the personality trait that leads to the discovery of a unique comic attitude. The essential curl from one expression of attitude, voice, sub-self, minority personality, call it what you will, into the next.

The Essential Curl

In his 1997 book, *Stand-up: On Being a Comedian*, Oliver Double makes a concluding statement that 'the secret of good comedy is jokes.' Jokes being defined in the broadest terms as any device or trick that creates laughter. But Olly, jokes are merely the vehicle of stand-up comedy. The actual fuel, the perfect blend juice required to get the joke up and running - is attitude. The secret of the joke with its familiar set-up and punchline exists in the blend - the juxtaposition of two complementary expressions of attitude, dormant in the first instance and consummated in the second. The essential curl of 'comic' attitude from one to the other reveals the individual's performance truth. How subtle or blatant the revelation is a matter of style and of personal choice.

> *And it's only while speaking to you here tonight, that I have realised just how interesting I am.* - ARNOLD BROWN
> Engaging and mildly patronising into quirky and egotistical.

> *I shouldn't really be here tonight, not with my material.* - RORY MOTION
> Lack-lustre and distracted into honest and self-deprecating.

> *How are you all? Enjoying yourselves? As if I give a fuck!* - IAN COGNITO
> Brash and perfunctory into blunt and provocative.

A comedian's favourite joke (one that they insist on keeping in their act) may often be a key to their comic attitude and an expression of their essential performance truth.

> *How d'you get a nun pregnant? Fuck her!*
> Larky and blatant into gratuitously obvious.

An anti-joke, with a stark truth, demolishing our expectation of something cleverer. It says a lot about the blunt, cynical throwaway, 'what you see is what you get' attitude of comedian Malcolm Hardee. That

he continues 'not to give a toss', and tells this joke regularly even though his audience have been shouting out the punchline ahead of him for the last ten years, only underlines the point.

Workshop

Den Levett and I have developed a very useful workshop exercise, which explores two if not more fundamentals of stand-up comedy - timing and attitude. It involves standing up in performance mode and exposing your inner nerd to the rest of the group. You just have to go on about something you know thoroughly or intimately. It doesn't necessarily have to be something useful like 'how to apply a tourniquet'; it can be something you have never given voice to before like a bunch of brief cameo descriptions of all your aunts on your mother's side. The idea is to get on a roll with it and lose yourself in it. In Exeter this February we had our first train-spotter and he was a corker. Over a period of three days and without much encouragement, he seized the opportunity and delivered the goods. In the initial exercises he was seen as amiable, earnest, honest, pedantic, slightly awkward and prone to bluster when excited. When 'a bit of a mad professor' was mentioned, he took it on board and started performing as if he was giving a lecture. Gregory had never been on a stage before and he may choose never to again, but in a ten minute showcase performance, he took a studio theatre audience of thirty people giggling through the history of Britain's railways on the 12.08 from Kings Cross to Edinburgh (with a 17 minute fuel stop) and imparting more esoteric information than any of us could handle. The curl of his comic attitude - that his serious facade could never contain his passion and enthusiasm - revealed him as intelligent, endearing and intriguingly dotty. We ended up loving him almost as much he loved his subject.

Discovering Attitude

Many successful comedians can remember a moment of enlightenment when they discovered the key to their comic attitude and like all personal quests, the Holy Grail is just as likely to be stumbled upon accidentally as it is by dogged experimentation.

Jack Dee

A well-documented case in point is of the door to door salesman Jack Dee, who spent his first six months on the streets of South London trying to sell insurance with a cheeky buoyant and wide-eyed attitude. He was getting nowhere. He was feeling depressed and miserable with the way his sales pitch was going and the slow rate he was developing new business. Eventually he decided to quit. With nothing to lose, he made the remaining few calls in his diary in a decidedly surly tone and then by way of a fillip, he pushed a shooter underneath people's noses. Immediately he started getting the commissions.

Ronnie Rigsby

Some performers have a comic attitude based in a very limited range of personal voices; some adopt characters - a type they know well and can inhabit with ease or invest with irony and perform with a broad-brush stroke of a style. Comedians can often reveal bizarre alter egos experimenting with character.

Logan Murray is a good-looking thirty-something comedian, engaging, witty and with a penchant for the outrageous and left field image. For many years he has worked as a jobbing stand-up comedian plus doing occasional seasons of playing one half of the double act Bib and Bob with Jerry Sadowitz. His best work though, is in the character of Ronnie Rigsby, a cynical foul-mouthed MC from hell, with fifty years at the bottom end of showbiz behind him and nothing to show for it but utter contempt. What makes Ronnie Rigsby the funniest character act on the London circuit, is Murray's control over the character's excesses and the intelligence of his continual deconstruction of what he's doing. Ronnie Rigsby is an ageless, media-savvy, post-mod creation just as likely to sneer and quote Chomsky as slag off a minor variety hall artiste. The curl of the comic attitude starts with half-arsed efforts to present a professional face, degenerates quickly into hollow apologies and ends with lewdness, insult and couldn't give-a-fuckery. With this dynamic, Logan Murray has developed considerable space to improvise and explore further, as well as expressing alter ego Ronnie Rigsby's feelings about the state of show business.

Attitude informs Material

Performers can access a wealth of material by simply applying attitude to any chosen subject matter: observing the world about them, relating their own experience, letting their imagination run riot, expressing their opinions, imparting familiar information or simply playing with whatever comes up. Material that is informed by a strong, well-defined and consistent range of attitude will also be owned, and consequently easier to remember.

List and Curl

I would just like to take this opportunity to thank...

If you are a semi-resting comedian waiting for two weeks until your next gig, then try this as an exercise to pass the time. Write a thank-you list. You don't have to show it to anyone if you don't want to. Do it for yourself.

Thank anyone who has ever influenced you in any way and give the briefest of explanations why or none at all (you can witter on forever but that's another plot). Thank them with love, thank them with irony, thank them with humour, bewilderment, disdain, hero-worship, anger or best wishes. Spit out their names, drool at the very thought of them, salute them, shout at them one last time, delight at their memory, corpse at the very thought of them. Family, friends, lovers, comrades, politicians and celebs, obscure people known only to you - neighbours from hell, neighbours from heaven, bass guitarists of forgotten punk bands, kids you went to school with and who disgraced or excelled themselves, teachers who helped, hindered or humiliated you, priests, publicans, probation officers, shopkeepers, show-offs and shit-stirrers, and all those people that must exist because somebody must to have written that ad or road safety jingle that drove you insane or designed that tower that blocks your view of the setting sun.

Mention at least one unfortunate who, there but for the grace etc., and at least one talentless chancer who represents everything that is right or wrong or whatever about the appalling and / or wonderful society in which you live or scrabble about on the fringes of. Get surreal with it, silly with it, serious, seditious and scatological with it. Regress, pontificate, condemn, celebrate, but keep it personal, make it all about you and your loves, hates, likes, dislikes, fantasies and predilections. Enjoy yourself with it.

Include yourself in relation to each of them. Use the excuse of distance of time to diss yourself and your bad behaviour and thank those who must have overlooked it, forgave you and loved you despite it.

Read it out loud to yourself, improvising any thoughts along the way. Express your feelings towards

them with emotional emphasis as you speak their name, adding the secondary stuff and extras as you would asides or throwaway background information.

Tick anything that tickles you.
Cut out the stuff that just helped the process.
Don't analyse it too much but put it in some sort of order
Give a quirky personal reason for making the list.
Repeat it again and remind yourself that it is funny.
If you like what you've written, go perform it somewhere, soon.
You can even refer to your notes.

This is not a comprehensive 'how to' book, but here's a couple of examples of attitude being revealed in workshop sessions:

Arse-about-face

The arse-about-face exercise never fails to get a good response or generate some brilliant piece of business. The audience all turn with their backs to the performer. The rule is that they turn round only when they've been made to laugh. Or when they are overwhelmingly interested in what's happening behind them.

Gary spent all of two minutes exploring a range of tut-tutting and incomplete expressions of disgust and disbelief - 'Jees...' 'For the love of...' 'I don't believe...' 'Would you ever.' He builds up a room full of expectation before coming out with:

'Jesus. Don't they just get away with murder? Hairdressers?'

After what has been noisy exercise with a sequence of lewdness and dirty joke telling, Gail comes on stage and says absolutely nothing. After about thirty seconds she gives the vaguest of internal sighs. Three people laugh and turn round. She then silently shares with them her real-time authentic feelings of frustration of waiting - nothing so obvious as checking her wristwatch - just a minimal, yet totally focussed performance comprising the merest flickerings of facial expressions, apologetic shrugs and occasional changes of posture. It has them giggling infectiously, causing others to turn round to watch. She greets the newcomers with faint looks of 'what kept you?' disdain. It's a fine display of attitude and working the room - every nuance in the 'now' and all of it spontaneous. Never once does she consider thinking up funny lines away from the business in hand. Eventually, two of the last three turn round. All but Paul have succumbed. As soon as she sees it is him, she silently shares her lack of surprise and gives an exasperated glance to the heavens, swearing under her breath. There is a big response. As the crescendo of laughter dips, she speaks aloud emphatically for the first time, as if behind his back, 'I knew he'd be the last.'

Hot seat - Performance mode

'An Audience with...' (based on the telly programme)

The group asks one person questions on any aspect of life. Interesting areas should be encouraged with 'more about that' or as Den Levett would say, 'double click on that.' The idea is to get the performer on a roll. To up the ante, questions can be repeated and pursued (which also says something about the questioner), and the performer can refuse to answer. Other than the usual range of attitude, the exercise explores an individual's boundaries and finds out who they become when they are on the defensive - who's on border patrol.

Katerina playfully answers questions from the others but refuses to tell Dave anything at all. Every time he asks her a question, she is evasive and increasingly clams up. Eventually, when he pushes it and gets personal, she stares at him and then very clearly and curtly rattles off two detailed lists of unrequested personal information - one headed 'feminine hygiene' and the other 'medical history'. For a moment it gets serious, and then she finishes with: ...'contraception arrangements. No, not on a first workshop.' While everyone falls about laughing, both Katerina and Dave are also pointing at each other and repeating 'performance mode!'

Structure - Giving it Form

An anecdote, opinion, or even a snippet of information told in conversation and then honed, heightened and embellished in the re-telling can structure itself without any deliberate design. Fragments lifted from a performer's personal conversational cannon are often, with minimal tweaking, ready-made material for the stage act. Material improvised on the spot can also, surprisingly, be elegantly structured. But beyond such quirks of serendipity, structuring potentially funny ideas into a form where they actually get laughs is a matter of personal discovery and trial and error. The best guide is to express yourself in the language and manner that comes easiest and feels most enjoyable - make the whole thing a pleasure to do. Know who you are. Know what you've got to say and get on with it.

For those who share my penchant for nerdy deconstruction, the following few pages may offer more about joke structure.

Word play - Puns and Wit
There is a qualitative difference between the word play of a raw pun and the word play of sophisticated wit. It is a spectrum rather than two distinct categories. At one end is the pun - a meaningless construction that unites two ideas or concepts that have nothing in common other than the fact that they share or have been allocated the same or similar sounding words. A joke that bends over backwards to point that out is no big deal.

Why are there no aspirins in the jungle? The parrots-eat-em-all. (Paracetemol)

The word play of a witticism, however, unites two ideas or concepts and often adds to the understanding of one or even both.

Skit Shared!
Concise title for a performance ensemble workshop

Attitude! Wanna make something of it?
Grabby title for a book about comedy. Enough said. More deconstructed wit. See pages 43, 76.

Puns

I've got an aversion to puns. I'm a pun snob. They are the joke form of the intellectually arrested, of those who are still struggling to understand the basics of language. I shun them. Den Levett says I'm victimising an innocent and valid joke form. She's quite happy to deal with them - she has a song of unrequited love that is full of puns and calculated to make the audience cringe:

> *If I were baker, I'd look at you with doughy eyes*
> *If I were a cobbler, I'd give you my sole*
> *If I were a soldier, I'd wrap my arms around you*
> *If I were a roofer, I'd tell you how I felt*

Once she's got them cringing, she gets them laughing at the witty way she plays with the puns. It concludes:

> *If I was a telephone operator,*
> *I'd give you a ring - we'd be engaged.*

I can see the method in it and the final wit gets me laughing, but I still don't like puns. It has doubtless got something to do with my inferiority complex about the quality of my education - I am self-taught.

Children's comics, like the *Dandy* and the *Beano*, rely solely on puns and eschew wit because it's too complex for their readership who are still learning the language. Similarly the comedy of Chico Marx's screen persona (an immigrant to the US coping with learning a second language) depends almost entirely on puns. If you or your friends have proffered a pun around 'Hat he chewed' on the title of this book, then we are talking about you. No stigma, but puns alone do not make good comedy. It's only with careful structuring or the re-interpreting of a cliché that puns begin to appear funny. We laugh at the trickery.

> *Friend of mine has called his puppy 'life'. Cos life's a bitch.*

In jokes with a victim, a pun is often a mistake made by someone who is either stupid, innocent, or unsophisticated.

> *Did you hear about the Irish blonde...?*

No, let's not even go down there. You can only laugh wholeheartedly at those jokes, if you accept that the Irish or blondes or whatever are congenitally stupid. Dyslexic jokes work better. At least the dyslexic pun joke describes dyslexia. Consequently there is an onus on conjuring up a funny image rather than any old slack.

> *Did you hear about the dyslexic devil worshipper who sold his soul to Santa?*

I laughed. It passed the time, but it would have passed anyway. Pun jokes about (or repeated by)

children can be the exception and are often delightful.

Why did the biscuit cry? Because his mother had been a wafer so long.

And a visual pun loved by kids:
What did the 0 say to the 8? Nice belt.

On hearing a weak pun, a sophisticated audience will recognise, not the butt of the joke as stupid, but rather the joke teller as stupid. The familiar groan response usually comes when they recognise that the joke is actually on them for having listened in the first place.

I've also got a theory about groaners which involves the rule of three. Even a relatively low-brow audience will groan when there is no surprise or spin on hearing the third particularly bland pun-joke in a row.

Rule of Three

A laugh, a song, a demonic possession.*

Establish, reinforce, surprise!

The rule of three pervades joke structure and also advertising slogans - there's probably marketing seminars dedicated to it. Avoid four; always go for three. The reason why Neil Kinnock was once such a windbag - he used five and without a surprise at the end.

A laugh, a joke, a can of worms.

My hobbies are smoking, drinking and keep-fit.

Troops out of Ireland. Troops out of England. Troops out of the Army.

You thought it was over. You thought it was safe. You thought wrong.
(Blah for Speilberg's *Lost World*)

He gave me chocolates, flowers and multiple bruising.
(Advertising campaign for a women's refuge)

French cooking is not only frogs' legs and snails. They eat insects as well.
(Anticipated three)

I'll give you three seconds to come out - one, two, two 'n' half.
(I overheard a kid say this in the back garden)

*Aggie Elsdon's by-line in 1999.

I was on the tube recently and a student of language started to explain to me that all jokes could be deconstructed in terms of major premise, minor premise and conclusion. Or thesis, anti-thesis and synthesis. Or... I never got the last bit because I didn't want to miss my stop.

Clichés

The currency of most joke structure involves re-interpreting cliché. By cliché I mean any well-known phrase or saying - song titles, graffiti, advertising slogans, news headlines, quotations. In fact, many clichés are already re-interpretations of previous clichés.

On a simplistic level, you can select a few current clichés, change the wording slightly to mean something different, then work backwards and create a set of jokes. Listening to some comedians, it's what I assume they must do, and it shows. The subject matter is arbitrary and the joke structure is obvious and eventually monotonous. Given a space cadet attitude with timing to match, it's an act. But it's joke writing by numbers.

Most clichés are not just simply familiar phrases in neutral short-hand; they also express received ideas, popular myths and stereotypical thinking, as well as long-standing truths. Clichés can therefore degrade and corrupt with time. 'Sound as a pound'. 'Safe as houses'. 'Plenty more fish in the sea'. Every day we wake up in a world informed by yesterday, our language and ideas encapsulated in cliché reinforce the habitual thinking of yesterday. Fashions pass, the tenets of science are subject to re-appraisal; even what were once understood to be universal truths are periodically overturned and pass into history.

Comedy that accepts the dubious cliché as a given, must be bunged in the recyc. The dumb blonde and the thick Paddy are obvious examples of yesterday's slack, but every other sentence we utter may contain clichés that reinforce lies and stereotypes that can translate into potential pain for some of us. The job of the artist and of the comedian is to challenge, confront and expose the redundant clichés of yesterday, not to go projecting our own defensive stuff onto others.

I'm gonna give up smoking if it kills me. (TA)

Money talks - it usually says 'goodbye'. - ANON

Money doesn't talk, it swears. - BOB DYLAN

Therapy has taken the place of religion. Once you'd go and talk to the priest. Now you go and talk to the therapist. About the priest. - SINEAD O'CONNOR

A woman without a man is like a fish without a bicycle. - 70s FEMINIST GRAFFITI

The Queen Mother. Now there's a really dull national holiday just waiting to happen.

This was a very perceptive joke that Tony Hindle first cracked shortly after Lady Di's funeral. Why it's funny is because it is the truth. And the truth stripped bare of any mush. At the time, the image of the

Queen Mum (the accident waiting to happen) was of her on live telly picking her way between racehorses and looking decidedly fragile. It also revealed that as a nation we had watched the Queen Mother's funeral arrangements and paraphernalia swing smoothly into action, the only difference being, it was Lady Di's name on the box. The whole shebang was actually waiting in the wings for another three years.

Some jokes are simple statements of truth - new clichés:

Sex. If I'd known it was going to be the last time, I'd have paid more attention.

And this beautiful observation on ageing from John Mortimer, or more likely George Burns:
At my age, when I bend down to tie up my shoelaces, I always ask myself, 'Is there anything else I could be doing while I'm down here?'

A good heading in a comedian's notebook* is 'I've never seen that before'. It's a way of identifying fresh subject matter and new clichés. In October 2001, Rory Motion and I walked out of a pub in the Balls Pond Road and fell about laughing when we read the blah on a hoarding, advertising the flats in a new luxury block. It finished on the legend '…plus Armani suited concierge'. We'd never seen that before.

A comedian's approach to cliché can often say a lot about their attitude.

When men make love, they can fantasise about being with somebody else. Huh! When women make love, they can fantasise about being with anybody else! - JO BRAND - one-upping men in the war of the sexes

I was at an impressionable age when I overheard one woman say to another woman, 'A good man is hard to find.' So I hid.
MATT HARVEY - compliant and self-deprecating

Justice must not only be done. It must be seen to be believed.
PETER COOK's mix of two clichés - clever, manipulative and insightful

Know Thyself

Thou hypocrite, first remove the log from thine own eye; and then thou shalt see clearly to remove the spec from thy neighbour's eye. - MATTHEW 7. 3-5

Self-deprecation - drawing attention to your own faults, admitting to your own bullshit and presenting a gentle (or not so gentle) parody of self - is a refreshing trait in anybody, especially a comedian, and it can lead to the creation of highly original comedy.

*On the subject of notebooks. Never, repeat never, refer to a joke by its punchline. At moments of stress on stage, you might just blurt it out when reminding yourself of what comes next. Similarly, always finish a joke with the weight of the punchline on the last word.

We're the sort of people who fantasise about refusing to appear in the Royal Command Performance. PAULINE MELVILLE

Getting into the habit of confronting clichés and stating awkward little local truths can also lead to the discovery of bigger unstated truths.

Taboo

Whenever anybody tells me there are no taboos left, I ask them how they know. Surely taboos are never talked about, not even acknowledged - they're taboo. In a liberal society, to suggest there are still taboos is almost a taboo. Put it this way. Think of something about your personal life that you would never admit to anybody. Now if you can't think of anything, then you probably can't even admit it to yourself. But don't worry, you're not alone. We all have them. It doesn't necessarily stop you being a nice person. They can, of course, become a problem when we, all of us, as a society, share the same taboo. Be vigilant - Don't let your unconscious select your metaphors.

Terry Alderton's Essex Man - Comedy Store 1998

There's a rough rule of thumb in contemporary stand-up comedy that says if you're going to slag off other people and other communities, then at least give you and yours a good drubbing first. The logic is flawed, and unless the self-scrutiny reveals an awareness of the motives, it can't morally exonerate a comedian from being mean-spirited or downright offensive. It is not the state of comedic grace that Tony Hancock once suggested when he said, 'Look at me. I am absurd. I am you.' A brief spate of self-deprecation as a preamble to a litany of hate mongering has little to do with exploring personal pain and extrapolating beyond to some universal truth. At best, it confuses and wrong foots the audience, buys a reactionary comedian a bit of time to inflict some camouflaged slack on them and then get off stage unscathed. Such is the moral ambiguity and underlin-

ing act structure of many performers on the London Comedy Circuit.

Terry Alderton was an apolitical innocent, strong on physical clowning when he learned his trade in this climate. Nowadays the sheer flamboyance of his comedy technique is intoxicating - a wild gamut of mugging, mimicry and snapshot impressions. Although his talent is impressive, it is also deceptively limited and conceals a dismal lack of substance. His opening 'knock thyself' routine is a relentless and hilarious cartoon take on yer average Essex man as a mindless Neanderthal. But, for all its flair, it hardly qualifies as self-deprecation, so little is revealed of the man or his tribe. It's the same broad brush-stroke characterisation that he daubs across all his targets, be they Urban West Indian or Home Counties Gentry.

As if to avoid the wrath of the PC police, Alderton has replaced what by now, in comparison, seem like the subtleties of traditional racial and regional stereotypes, with a universal blanket stupidity - a whole world peopled by morons. Defined only by accent, tabloid cultural reference, and occasional product placement, every caricature that Alderton inhabits displays the IQ of his thicko from Basildon.

This combination of seemingly inoffensive material and awesome technique is clearly a formula for a measure of success. At the London Comedy Store he regularly leaves the audience exhausted and howling for more. There are few acts who can, or dare follow him, but without any real content, he is an unlikely headliner and will find it increasingly frustrating always having to play second billing to any competent comic with a hint of originality. Like a sensational circus skills or novelty act, Alderton is condemned to a career of closing the first half of the show, albeit with an impressive bang.

Favourite Joke

There's a few gems among all the street jokes and club jokes that do the rounds and people endlessly re-tell each other. Contemporary stand-ups quite rightly avoid them because they don't much like punchlines being shouted out. I love altering and adding my own lines to them. Sometimes I'll change the genders, nationalities or even whole settings before I pass them on. I get a particular kick out of hearing them retold back to me years later including some flourish of mine that I'd forgotten about. This is my favourite. I added the charcoal moustache and the misleading homosexual story-line. Given the quality of laughter the joke receives, I reckon that its simple statement about male sexuality is close to a universal truth.

A classic clichéd setting - a shipwrecked geezer sitting alone on a little desert island with a couple of palm trees. One day he's looking out to sea and he spots a ship on the horizon and he starts shouting and waving but the ship sinks and he can't do anything about it. Then he spots someone - a woman splashing about in the water and she's not waving, she's drowning. He dives in, swims out and saves her. Back on the beach he performs mouth to mouth and brings her round. It's Pamela Anderson or Catherine Zeta Jones. Whatever. It's a joke - you choose.

'You've saved my life,' she says. 'How can I ever repay you? I'll do anything you want.'

The next few days they spend screwing every which way. I'll spare you the details. After a week of this, she picks up on the fact he's not happy and she says to him, 'Listen, just tell me what I have to do to satisfy you. You saved my life. I'll do anything.'

And he says, 'There is one thing that I'd like.'

'Name it,' she says.

He's a bit embarrassed and then he says, 'It involves cutting your hair short and putting on this suit.'

She's a bit wary but goes along with it, cuts her hair, puts on a baggy old khaki suit.

'And?' she says.

He puts his finger in the remains of last night's campfire, then leans towards her and draws a moustache on her face.

'Now what?' she says.

'Go down on the beach and walk past.'

She goes down to the beach and as she walks past, he's waving at her excitedly, 'Here mate! Guess who I'm shagging?'

November 2001

Personal Argot

'Tings ickle bit a pear shape innit.'

Performing with attitude - even if the range of self-expression is limited - will always benefit from the use of personalised argot - the language and mannerisms peculiar to the minority personality being expressed. The voice of self-deprecation is particularly ripe for embellishment. There are no rules. Use whatever's appropriate. Relish and celebrate it.

In the summer of 2000 I started writing a journal of my weekly stint at that melting pot of cultures - Speakers' Corner. More than ever before I was aware of people's delight in playing around with language. I've found myself picking up and adopting fragments from both those recent arrivals to the country still struggling with English and from various other mates who are best described as post-ironic parodists.

There's a large minority of mini-cab drivers, for example, who, fresh to Blighty, can't help learning a most advanced form of pidgin English. They spend half their time hanging out with a cross-section of other recent immigrants and the other half driving around with a similarly broad cross-section of locals and tourists. It was a mini-cab driver who responded to my 'How are you then, alright?' with the legend 'Tings ickle bit a pear shape innit'. That wonderful statement could just as easily have come from an arch parodist.

Post-modernist lingo, as it was explained to me by a heckler at the Park, is all about sampling anything and everything, past and present - whatever.

Whapping Sirrah! Yon rozzers just liberated me top-bud reefers and bunged me a caution. Ungood or what?

All manner of stuff is increasingly finding its way into people's vocabulary and into my stage and park performance. Some of it is just an extension of lazy Ladbroke Grove dopehead talk - y'mun sweetaz Noah'imene - but personally some of it is readily presenting itself fresh from my deepest yesterdays.

At thirteen years old I identified not with the ambitious working class life-style I'd been born into, but with the gambling milieu of the local billiard hall where I'd skive off and hang out. Here, as well as learning the local slang hybrid that had a smattering of racing slang, rhyming slang, Jewish slang, and back slang, I also picked up the mannered language and speech patterns of gamblers, con-men, ageing spivs and that odd strain of working class poseurs who spoke in h'affected tones just short of camp polari. And just like its best known exponent, Kenneth Williams, it would always degenerate into 'common'.

In performance I'm always interested in what I'll come up with next. Recently, as well as performing the meat of my act on mic, my brief larky asides (off mic to the ring-siders) have become extended flurries of

verbal doodling - targeted at no one in particular. Well, they know who they are.

> 'No, not you Mrs. Ms. Mate. No, Mrs. Cos when I say 'Mrs' Mrs, I'm using the
> h'appellation as a generic term. So I'm including you lads as well. Mrs. And you
> know what? If I was gay, and I'm not, well not properly, but if I was, I wouldn't
> let 'you' out of my sight. Mrs. Noah'imene? Stream of consciousness? Nah, just
> wacky slack with arbitrary creative intent, but what do I know about it?
> Currently I'm speaking a pick and mix patois of pidgin English and
> contemporaneous post-mod cockney bollocks. I'm well aware that it sounds a
> bit h'affected and up it's own h'arse 'ole. So I'll try an' keep it to a minimum.
> Alright Mrs?
> I don't have to do this, you know. I'll soon be well flush. I'm about to
> launch me own financial currency. Done the design - instead of the thin metal
> strip, it's gotta single silver strand of my barnet. I've got problems with the
> geneticist and the printer on that one, as it 'appens. But be prepared - today
> Argentina, tomorrow Doodah-in-the-Wold. Tings ickle bit a pear shape innit.
> Noah'imene? Wonky economy - coconut mat securely under the h'arse 'ole,
> 'elter skelter, Yankee dollar, downhill spiral. Bosh! Buddy can you spare a
> dime? Don't lose yer rag - you'll need it to clean yer marbles.'

When Stanley Unwin died, they ran a few of his bits on radio and telly; I caught several different bits two or three times. I was reminded of seeing him as a kid, and how, although I was always glad for him to pop up in a variety show or whatever, he always left me frustrated and disappointed. It was as if a really larky old uncle had come round, promised to stay, but then went AWOL before he'd warmed up even. Reading some of his transcripts - online - where else - Google can find anything, I was inspired to concoct an obituary.

Obitulobe - Stanley Unwin, comedian. June 1911 - January 2002

Grief-feely of the deepest catchy throat-load.

Nonsense? Gobload? Gibber Gibber? He called it Unfunny-easy-money and now he kick the proverbilly bucketload.

Stanley Unwin, butter knobe as Professor Stan Bollocks the very oddly speaking comedling died today at the ripe old chestnut of ninety thunderbold, after a lifeline of giving a deep joy of the throatlode to generalisations of the Brittle peoplee. Oh yes.

Bored in South Africal, he learned to talk utter bollodes at his mother's kneecapped after a minor roadload taxi dent. In nineteen thirtle end he immelgrated to Brittle Blighty just in timely for the second worst warble.

Stan the Unhinged became populode in the late fordels after spendling the hostilityloads in the Royal Airy Forecast ENSA, talking utter bollodes to the frontline trouploads - just what's needling after a hard dayload of nasty nazi fighty. Put out that lightload! Don't you know there's a bore on? Top heckload!

Stan the Unfunny preferred to workle (if you can call it workle) in radi-yodel and on the telly goggle box of BBC Auntie, although he did do a liddle biddle on the comercialode and also a bid of Channel Folly.

Not a lot of live workle though, due to a serial lacko material - three minute set top wackle. Who's gonna queue round the blocky for that little load? botty botty on seaty seaty I hardly think droves. Oh no.

Showbiddle contemperyloads have been expressing their grief-feely of the deepest catchy throat-load.

Des O'Cornered said, 'Professor Stan was nothing less than a comedy Thunderbold. Is that enough? I haven't got any more.'

A TEFL Will Self-full (Be-spoken wordle ex-patient and Standing-up novelless,) claim that Professor Stan the unfunny, was a bigly influence on John lemons of the Beatlodes book 'own all the rights' and liken him to the Revver Spoonload, and Mrs. Spike Millingprop. Him went on saying, 'Stan had a deeply Joycean flair for pigeons with healthy dollops of Hilarious Bollodes. Or was he justly rippling off Edbold the Lear?'

Ken Doddle said to daydle, 'Oh yes Mrs, Stanlow had a wonderly wave with the wordles. He gave deep and lastingly joy to the average male thunderbold on the clapped-out omnibotty. Any more outstanding fees plead? How tickled I amlode . See! I can do it as wellington. How long have you got? I can go on all nightly you know?'

Bernard Meaning was typically outspokled, 'I neville knew what the daft cunt was on about.'

And Tommylee Trouper said, 'Don't ask me Pal I'm alreadlee deadlee - just like that - kicked the proverbillee bucketload yonks back.'

In the late early seventyloads Prof. Stan became surprisley hip cool and dadio with the populode singing ensemblode Small Faeces - Big Thunderbold, with the hit allbum Oddball But Flakey Talent - wouldn't it be nicely nicely to get on with your neighbloads.

Professor Stan the unfunny was an acquirey tastelode. And not everybotti experience the deep joy of the fifth thunderbold when they heardled him talk utter bollodes. Some too-clever-by-halfload peoplee said that he was taking the piddle and getting away with murdle and that Benny Hunt with a bit of cottle could do it. Oh yes.

A spokespeddle for the Beeblee C said, 'In an alreaderly overcrowdfull industrophy, a vacant lot existing for a comedling to talk meaningless bollodes and bring a deep joy of the afore-mentioned and oft-quotee thunderboldsix to the Brittle peoplee'.

Lonely Talon. 15 January 2002

THE HISTORY OF STAND-UP COMEDY

Whoever writes history will probably get it wrong, especially in the eyes of the actual participants. For every news item ever broadcast, there's probably some Jo who was on the spot with a clear view, saying, 'Well it didn't look like that from where I was standing.'

Writing history out of your own time is a matter of diligent research unless you're lazy like me. Then it's mostly about interpreting previous interpretations and the occasional first-hand subjective account.

Modern history is a bit different. I can make up my own mind about how important I think Lenny Bruce or Max Miller is to the development of stand-up comedy, because I can listen to the tapes of live gigs and watch some ragged film footage. I can check the dates, research the context and read several contemporary accounts. Then I can write my own interpretation. But it's harder to go back 100 years and do that with Dan Leno and the development of 'patter' in the Music Hall, because there's less to go on. There are no recordings performed in front of a live audience, only some very primitive studio stuff and a few selected scripts, reviews and photos. Meanwhile, some of Leno's contemporaries have been left out of the more recent interpretations and the context is getting mistier. 200 years back in the fogs of time, only the performances of Joey Grimaldi are documented. And four hundred years back?

The Storyteller, the Fool and the Shaman

All form tends toward the archetype.
The archetype itself has no form. - MAX HANDLEY

The storyteller serves the story.
The fool serves the moment.
The shaman serves the tribe.

The Storyteller

Taking a stroll through the camping area of a summer festival around dusk, you'd be hard-pushed not to find a storyteller sat in front of a fire surrounded by kids gradually nodding off in their sleeping bags. Not all performers have to go for the big finish. But then not all storytelling audiences lie down with their eyes closed or sit staring into the flames of an open fire.

For the storyteller, part of her art lies in selecting the right story for the occasion. The rest is in the telling. A good storyteller will rarely repeat the same story word for word, and the same story from a different storyteller can often be unrecognisable to the lay listener.

The storyteller / writer, as a general rule, selects the bare bones of an existing story and then customises it to suit her own style. The process can involve describing and interpreting each scene and character through all five senses and in terms of a choice of passing or pervading moods. The whole text can be enriched and decorated using a personal repertoire of mnemonics, schematic sequences and structural devices. In the actual telling, she can inhabit and personify just about anything she chooses, investing every detail, every phrase and every word - verb, noun and adjective, every vowel and syllable, with energy or meaning. She can do sound effects, sing, sniff, snort, spit and gargle. Characters and their actions can be described in their own particular language, rhythm and sentence structure.

> *And the BIG monks, in the BIG hats, looked under the BIG stones. KERR...RUNCH! And-all-the-little-monks-in-the-little-hats-looked-under-the-little-stones-crinch-crinch-crinkly-crinch!*

A purest-strain storyteller has no first person voice and expresses herself through all the creative choices she has made in the 'writing', and continues to make in the telling. She is a cipher but does more than simply serve the text; she becomes it; she is the text. Her story exists not so much in her physical performance, but more in her ability to feed the imaginations of the listeners. There are no moments in between - the radio's on - there is a version of the fourth wall in place but it mainly concerns the soundscape. If it is broken, then the story embraces the intrusion. At a festival a story can include:

> *...and in the distance they could still hear the very silly goblins and the very sad goblins pretending to be at a party.*

The Fool

The traditional fool operates with a similar set of creative options to the traditional storyteller, except that with the fool there is no text being served because none exists. While the fool can call on a vast repertoire of technique and comic business, his performance serves only the moment. Like the storyteller, the fool avoids the first person. He expresses himself through selfless play. Beyond that there are no rules and the options are endless - it's playtime.

Ask a fool to express an opinion; he will play at expressing opinions. Ask a fool to make a choice; he will play at making choices. Ask a fool to tell a story and he'll ask you for the plot and the characters.

In the tarot pack, the fool is card Zero of the Major Arcana - the beginning and the end. We start off as a fool knowing nothing and we end up as a fool knowing nothing.

The Shaman

The shaman is a storyteller fool.

The shaman serves the tribe. He has a similar creative toolbox to the storyteller and the fool, plus a few extra options of his own.

He serves the story but there is only one story. He serves the moment and the moment goes back a long way and that's the story.

The shaman takes risks and investigates the dark side. He speaks in the first person only as a cipher to serve the tribe. The shaman can be outrageous and provocative. He may even be feared.

The shaman asks the audience:

Who are we? What are we doing? And is this the interval?

The First Joke

It's a good bet that the first joke was a combination of schadenfreude and toilet humour. When the first group of punters gathered around the original village idiot and started laughing at him, it was probably because he was exposing himself or eating turds or bellowing obscene nonsense.

The first inter-action was probably mimicry - them pointing at him and laughing, and him excitedly pointing back at them and imitating their laughter. It escalated from there - shameless behaviour and mimicking the peculiarities of his tormentors, sometimes earning him a scrap of dinner and sometimes landing him in the stocks for the afternoon.

To cut a long story very short: soon his uninhibited antics and complete lack of guile gained a modest reputation and he attracted the attention of the local chieftain who came riding up and said, 'That is funny! Hose him down and bring him back to my place, I've got the King coming to dinner at the weekend.' And so it was that eventually the village idiot, with his innocent lewd show and untutored piss-taking, gibbered, dribbled and masturbated his way to the table of the monarch and eventually into the job of Court Fool.

Didn't last long of course: 'Is that all he does - insult my guests, fart and play with his dong?'

'He pisses himself occasionally.'

'Get me a different one. One that doesn't smell quite as bad.'

Soon the word was out that you could get regular board for the night and eat at the King's Table and all you had to do was pretend to be interestingly deranged.

The Fool became the Feigned Fool, cleaned up his act and became Court Jester with his own regular chat show. Meanwhile, back on the village green, a new grotesque was learning three-ball juggling using two cowpats and a small child.

May 3rd 1993

The Danga to Archy

The parasites of Ancient Greece also blagged a free meal at the table of the great and good in exchange for their provocative and witty banter. Buffoons, wits and fools, with varying degrees of license and success, have done much the same across most cultures and throughout history.

The first recorded mention of a fool is of an all-singing all-dancing African pygmy, the Danga, in the Pharaoh's court in ancient Egypt, 2000 BC. He was said to have mimicked the 'Dance of the Gods' - probably tagged on the end of the chorus line and by pure juxtaposition, rendered it ridiculous.

The rich, famous, and powerful throughout ancient history appear to have surrounded themselves with unusual and eccentric specimens of humanity. Although many of them were kept simply as freak show exhibits, they were part of a culture of otherness that included everything from philosopher fools to half-wits and contortionists.

The best documented is the cult of wise fool dwarves who served the warlords of ancient Ireland. The Celtic tradition is full of the exploits of a broad spectrum of dwarf fools versed in the creative arts, many of whom were warriors, all vested with alleged magical powers, and if not, then at least the talent to trick, amuse and mesmerise.

One suicidal performance by a warrior fool probably changed the course of history. Taillefer was a joculator of William the Conqueror. The story goes that on the morning of the Battle of Hastings, when the two armies were lined up against each other, Tailleffer rode out into no-man's land singing a rousing song of French chivalry. He dismounted and began juggling a huge sword, throwing it high into the air and catching it in rhythm with his singing. The English frontline troops were gob-smacked and even more so when he charged them, making a killing before being killed himself. It is presumably quite difficult to defend yourself while applauding. The French, of course, were roused to great deeds and the rest is the cliché of history.

Much of the information relating to English fools comes from the writings of Christian clerics who were clearly unhappy with the irreligious feigned innocents who had the ear of the king. If fools were not 'the devils work', then what were they? In the cleric's interpretation of events, warrior fools in particular, even though they martyred themselves in battle with lateral behaviour that changed the course of history, were either demonised or left out of the official recorded story of the victors.

The idealised view of the jester is of a licensed fool - the king's eyes and ears in a potentially traitorous court; more pertinently, a confidante and personal playmate, a wordsmith-cum-psychotherapist skilled at reinterpreting the king's own words back to him and capable of inhabiting an alter-ego to mirror the man's folly. Such are the luxuries and necessities of absolute power.

In reality, medieval monarchs, just like modern cabaret audiences, probably got the comedians they deserved. For every jester who lived dangerously and dared to speak the truth, there were those who did little more than competently MC the royal command performance. Doubtless many more ended up in prison or what passed for the madhouse.

What is less well known is that the fool had no status whatsoever, and depending on the etiquette of the particular court or mood of the moment, may well have been ignored entirely by all but his lord or master. Existing only on the fringes of reality, the fool was officially non-existent - a nobody, with less actual status than a pet or even a piece of furniture.

In modern film interpretations of English history, the Monarch's fool is all but absent. Will Somer, the last of the English innocent fools, never features in the films depicting his master Henry VIII. Even Elizabeth I, who recognised and dignified her fools, is never seen with either her two female dwarf fools or her jester, Tarleton. Like most of their kind before them, they are still being written out of history.

In the paranoid court of James I, Archibald Armstrong was more than a jester to the King; he was James's closest friend and personal aide. When James fell seriously ill, he refused to see anyone other than Archy. The court jester was the only one privy to the seriousness of the situation, and for a period of 3 months, perish the thought, a fool probably ran the country. Archy is also credited with a string of outrageous stunts, including assuming the role of a foreign diplomat and ridiculing members of the Spanish court. He eventually had to be pensioned off and was given an estate in Ireland where he retired in colonial decadence with his own court jester. Or did he?

Commedia Dell'Arte

'Commedia dell'arte - comedy of the professionals - was an irreverent, knockabout style pantomime which evolved from the carnivals of Southern Italy and spread across Western Europe via France in the late sixteenth century,' it sez here.

It's hard to imagine a culture with the sort of artistic freedom and high concentration of talent that could give birth to something as elegant and as basic as the commedia dell'arte. But it clearly happened and without any perceptible interference. In fact it was initially sanctioned and sponsored by the wealthy courts of Florence.

The actors involved were dedicated professionals who committed their careers to extending the working archive of one character while exploring new riffs and licks in a tight ensemble set-up. These universally recognisable stock characters, with their deeply human flaws and foibles, provided the bedrock of the dramatic conflict. The flexible knockabout style with its fights, deceptions and intrigue was aimed directly at the common people. The plot always reflected the downtrodden servant's perspective of the perennial subjects of love, sex, wealth and power.

Imagine an improvised Goon Show (including women) performing unsentimental Charles Dickens scenarios in the theatrical equivalent of a live rock group format. It was a concept that toured Europe for 200 years.

Commedia was highly stylised theatre, strong on mime, with the actors wearing half masks that accentuated their physicality. They probably expressed themselves verbally in a pan-European theatrical pidgin language, and with every blow, bump and knockabout exchange accompanied by an ensemble backing of sound effects and music.

Any given commedia troupe would have a core group of actors playing the familiar stock characters; essential were two servants and their employer. Harlequin, the young male lead - tricksy, agile and often too clever by half, Columbine, sometimes his lover, torn between love and security or duty, and the wealthy Pantaloon, her sometimes suitor, husband or father, always cuckolded or robbed. There were also other rich and decadent characters: a Doctor-cum-Lawyer - greedy and lecherous, and The Captain - a swaggering boaster often revealed as a coward. But most important was the comic chorus of Zanni - various servants, mischievous oiks and scheming low life - notably Brighella, a wily wheeler dealer gang leader, Pedrollini a love-struck melancholic, Punchinello, a grotesque yobbo.

With an agreed rough scenario and denouement, and a disciplined code which allowed for plenty of spontaneous solos, they improvised their way through a sequence of scenes - the familiar stock character inter-action often having a stone - scissors - paper logic to the outcome.

A solo mime exercise used by modern commedia exponents illustrates the theatrical style and context of bottom-line street life survival perfectly. It's got the makings of tight ten-minute routines dependent on attitude. Every nuance and every thought process is played large and repeated to the audience:

Enter character in half mask. He mimes hunger. He sees some dog shit, considers it as a meal, reflects on the grossness, reminds himself of his hunger, ponders, makes a decision, and relishes eating the dog shit, feels sick, regrets doing it, throws up, feels better, is still hungry, sees the vomit, and eats it.

The history is sketchy, but commedia companies could number anything from 10 to 20 and included several other women characters. The actors, who spent their lives playing one stock character, improvising speeches, reciting poems, quipping asides and customising their roles, need not have been playing themselves, but they certainly must have brought much of themselves to their roles. Consequently, throughout the two hundred years of commedia's existence, the stock characters gradually developed and subtly changed, as did their relationships and their status within the troupes. In various cultures across Europe, characters combined and new characters appeared, leading to the establishment of national variations under new names.

In France in the early 1800s the mime actor Debareau developed Pierrot, originally the melancholic Pedrollini, into a national institution. In *Les Enfants Du Paradis*, the classic French film about his life, Debareau too is portrayed as a deeply sad character hopelessly in love with an unattainable woman.

In 1642 when Oliver Cromwell's Puritan regime banned all theatrical performance, commedia companies must have scrubbed England from their gigging schedules. But the Punchinello character appears to have hung in. Cross-pollinated with the local Vice character - originally the trickster fool of the Mystery plays - Punch utilised Harlequin's slapstick bat, took a wife and resurfaced in the Punch and Judy puppet show.

In England commedia dell'arte eventually morphed into the Harlequinade and then the English Pantomime - but more of that later. First the Bard.

Robert Armin - a speculation

That bear is bleeding! It's injured! Either chain it up outside or kill it,
but you're not bringing it in here.

I've always wondered how Elizabethan actors dealt with the groundlings - the rough crowds who paid a half-groat concessionary rate to stand for hours, five feet immediately below the stage. The influence of the energetic commedia dell'arte troupes and how they worked the crowd can have only upped the ante further. My guess is that in both styles, the actors not taking part in a scene, must have remained on stage or at least within the view of the audience. Here they operated like any good performance ensemble - as a role-model for the audience: focussing on the action of the play, always taking part in, but never quite leading the general appreciation and, through their own 'performed' sense of occasion and expectation, subtly censured any disruption. It still must have been an awkward gig. There must have been tension between the serious actors and the comic performers, who had the skills to work the crowd. The temptation must have been irresistible.

Back around 1600, Robert Armin landed a residency as principal comic actor with The Chamberlain's Men - scriptwriter Will Shakespeare. Top of Armin's CV was the fact that Tarleton, Elizabeth's Jester, was once his mentor. He'd also played fool leads with the best theatre companies, had written a successful comic satire, and was publishing a book of jests. He was a top comedy attraction and took up his new post probably just in time to play the original first gravedigger in the original version of *Hamlet* plus some chorus bits.

Robert Armin was groomed as a fool and then as a comic actor / performer. His creative process

must have involved a lot of working the crowds in big alfresco town centre venues. Then suddenly he's landed a ten-minute bit part in a four-hour tragedy. My interpretation of Armin makes him the subject of Shakespeare's irritation in a sub-plot of Hamlet's speech to the First Player. Still with me?

> *And let those that play your clowns speak no more than is set down for them; for there be of them that will themselves laugh, to set on some quantity of the barren spectators to laugh too, though in the mean time some necessary question of the play be then to be considered; that's villainous, and shows a most pitiful ambition in the fool that uses it.*

Forget the plot of Hamlet. What Shakespeare is indirectly saying to Armin (and the other comedians and of course to the audience) is...

> *This is a new theatre and you are the new comic lead in this company. Your predecessor Billy Kemp was always going off script and working the riff raff in the crowd and wrecking my best lines. And now you're at it. This isn't some Latin knockabout romp. This is my show. So stop it. Now! And consider this a public warning.*

Was Shakespeare censuring the early development of stand-up comedy? I think so. He wasn't stupid. He will have witnessed the commedia actors improvising long comic speeches and could see that his job, and the jobs of his twenty actors, could all be done by one comic performer and he wasn't taking any chances. If the Bard hadn't been so vigilant, Elizabethan theatre might well have gone the same way as the Edinburgh Fringe Festival - dominated by solo comedians.

If Armin did play the first gravedigger, what did he make of his lines in Act V Scene 1? He is required to pick up the skull of the royal jester Yorrick and utter the words, 'this skull hath lain in the earth three and twenty years,' and, 'a whoreson of a mad fellow...' and '...a pestilence on him for a mad rogue...'

Hamlet picks up Yorrick's skull and explains further with, 'Now get you to my lady's chamber, and tell her let her paint an inch thick, to this favour she must come; make her laugh at that.'

Someone, who knows about these things, once pointed out to me that the Bard was referring to Elizabeth, now an old woman, and her jester Tarleton, who had been dead 13 years. Tarleton was of course Armin's mentor. Why would the Bard put such words in Armin's mouth? Surely as a wind up.

Whatever the nature of the tension between them, and the plays of the Bard are peppered with clues, they continued to work together. Most notably Armin was the original Fool in *King Lear*. How much of Lear's Fool can be attributed to Armin and how much to Shakespeare is a question worth posing, but not one central to the history of stand-up comedy. There was other, darker stuff about to happen later in the seventeenth century that would match any tragedy the Bard could write.

Fools in High Places

During the English Civil War 1642 - 8, both the Royalists and Parliamentarians described their adversaries as 'fools'. The subsequent Puritan regime of Oliver Cromwell closed down all the theatres and banned public performances. During this dark period the word 'fool', which had previously been applied to a sympathetic comic innocent or comic performer feigning innocence, now had an ominous connotation. 'Fools in high places' was a phrase used only to describe politicians. A rhetorical question like 'what sort of a fool would ban comedy and laughter?' suggested a far greater madness than any comic pretence a mere fool show could offer. The appellation 'fool', like the fools themselves, was rendered redundant. The actual Fool performers with no professional identity and ostensibly nowhere to perform, had to re-invent themselves as Jack Puddings and Merry Andrews playing in illegal drolls (rough theatre farces) on the country fair circuit.

It was, however, very difficult to legislate against what went on in a market-place or a fairground. Descriptions of Bartholomew Fair at Smithfield make it sound like a long-running seasonal Glastonbury Festival in the middle of London's East End. The jester / cleric Rahere is said to have had the original idea in a vision in 1100.

Throughout the two decades of the police state, 1642-1660, Bartholomew Fair ran almost to schedule. The only time the Puritans did threaten to close it down, they were pre-empted and it opened early and, once up and running, was unstoppable.

For the previous fifty years many a fool performer had earned a living as one of the dupes and fool accomplices in a mountebank's medicine show. These shabby commercial ventures had evolved over the years into an entertainment form using the sale of the elixir only as a means of collecting an entrance fee to what had become a popular fairground attraction. From the 1640s, what was once the very lowest gig a comedian could play, became overnight one of the few shows in town.

It is difficult to comprehend the depth of the social upheaval during this period. The monarch was not only head of the Church and head of the English state, but had ruled (it was believed) with divine authority from God. In January 1649 when Cromwell beheaded Charles I, the political and religious radicalism that was already rife, increased. A year later he put down the leftist Leveller mutiny in the Army and this act unleashed a further spate of utopian sects. Most flamboyant were the Ranters, who eschewed all authority and believed that God existed in all creatures and that men and women were incapable of sin. Ranter prophets and their followers were reported to be roaming the countryside spreading heresy and endlessly partying. This early exotic blossoming of English anarchism was gradually hunted down and its exponents tortured and forced to recant at their trials before being imprisoned.

Meanwhile, and against this backdrop, there existed a sub-culture of professional comic actors and satirical pamphleteers touring the country fair circuit in small troupes, offering news bulletins and the medicine of raw satire to heal the body politic. There is understandably only scant evidence about the nature of these mountebank shows (or the droll shows, which also dabbled in satire). The fact that it did happen was revealed when a semblance of normality was reinstated in 1660 with the restoration of Charles II. Mountebanks with Jack Pudding (fool) assistants emerged as a popular satirical ensemble style doing the rounds.

The world of conventional theatre in England never quite recovered from the Puritan period. Actual spoken word became the designated prerogative of the serious actor and was confined to a handful of theatres, mostly in London. Other venues were required to produce various styles of musical entertainment.

This code of niggardly censorship would remain in place with minor tweakings until the turn of the twentieth century. To this day England's licensing laws make it illegal to have three or more musicians on a stage in a regular pub. And as for closing times! What are we? 12 year olds? But I digress... In the decadent Restoration period, the law was arbitrarily administered and it barely extended to the popular theatre of the masses.

Joe Haines

By the 1680s, a rogue actor, called Joe Haines, was getting himself a bad name as a comic mountebank by hawking a cure-all elixir of seditious satire aimed variously at the sickness of the church, the state, and certain of his fellow actors. Haines, as well as being an accomplished Harlequin and a comic actor, was also a prankster and practical joker - he was once imprisoned in France for impersonating an English peer. In fact Haines' career is better documented by magistrates' reports and the complaints of those whom he wronged or affronted, than by any theatre reviewers. He toured England with a Jack Pudding fool troupe in tow, masquerading as a professor of medicine, his satirical diatribes and spontaneous mock sermons often landing him in trouble with various authorities and on a number of occasions with audiences too. He explained himself on stage and from the dock, but invariably his pleading and recanting was tongue in cheek and designed to add further confusion.

The escapades of Joe Haines, with his delight in notoriety, suggest he was fearlessly satirising the blatant double standards of his time. In its short life as a stock comic character, the mountebank had always been tarnished by the deceptive show of its real life double-dealing counterpart, selling moody medicine. Haines' contribution deepened the crimes of the mountebank from minor hawking infringements to something close to treason.

The only 'recent' example of a mountebank talking witty social politics I gleaned from the biography of Bonar Thompson - Hyde Park orator. He sold pamphlets on birth control with his customary flair in the street markets of 1930s London, most notably in Electric Avenue, Brixton.

Joseph Grimaldi and English Pantomime

By the first half of the 18th century commedia dell'arte in its original form had spread very thin, although its influence was everywhere. Its harshest critics described it as 'an excuse for staging the spectacle of public brawling'. In the established theatres the Harlequinade pantomime became the English hybrid of commedia dell'arte, with the addition of Clown, a minor English stock character, to the line-up of fall guys for Harlequin to trounce and best. The influential mime actor and dancer, John Rich, silenced the character of Harlequin and moved him away from broad comedy into an eccentric mute romantic hero, and subsequent players continued the trend. The Harlequinade pantomime became a fantastical fairy story - an hour's entertainment at the end of a long evening in the theatre. Meanwhile, Clowns and Pierrots had discovered a little earner away from the theatres, and were developing their broad knockabout comedy skills in the new Equestrian tent shows (the beginnings of Circus) which started from 1770. This potted history is by way of introducing the idea of a comic void to what happened next.

By the end of the 18th century, a Clown of French birth, name of Dubois (the first performer in

England to use white face in the circus), was influencing a Clown of Italian extraction, name of Joseph Grimaldi. The Clown character had been steadily growing in comic status with the work of various players, including Grimaldi's father. In 1806, at Covent Garden Theatre, Joey junior junked Clown's traditional rustic smock and ruddy face and dressed himself up in a customised version of servant's livery that also parodied the strutting peacocks of high fashion, and of Harlequin too, no doubt. He added wild startling make-up - white face, red contoured cheek triangles and exaggerated eyebrows. It was all designed to project his actions and expressions to fill the theatre. It would also fill the vacuum left by Harlequin's virtual abdication from the role of top comic lead.

Joseph Grimaldi must have been on a 'moment' at the turn of the 19th century. When his father had last played the role of Clown, he was a dummied-down bumpkin of a character, the bumbling butt of Harlequin's slapstick. Almost overnight Grimaldi Jnr had leap-frogged over and out of the part-time double act and landed Clown downstage centre as an all-knowing urban trickster, adding a tougher satirical edge to the content of his fooling.

Joey Grimaldi had become the first star of the new English Pantomime with customised vehicles written to display his talents. He developed various solo spots within the Panto plot-line and showcased what was generally acclaimed to be his comic genius. As well as establishing the comic song, he also performed high-energy acrobatics and performance stunts. Whatever it was he had, the impact was phenomenal. The next generation of clowns and funny men, particularly in the new circuses, were Joeys, not 'were known as' Joeys. This was beyond generic. They 'were' Joeys. They did him. The full tribute act. Every other Light Ents act in the biz was a tribute act to Joey Grimaldi. Long after his death, his influence was still felt beyond theatre and circus, in the robust satiric approach to costume, make-up, and comic song in the Music Halls.

Any description of Joey Grimaldi's varied talents always includes his unusual skill of lampooning popular figures of the day by apparently re-arranging fruit, vegetables and cooking utensils and other everyday items on a barrow. It wasn't a one-off joke; he was known for it and he rang the changes. For example: upper class dandies, King George III included, had made the hussar uniform high fashion. Now, just how Grimaldi arranged a coal scuttle, a muff and a full-length coat into a primitive cartoon sculpture that had a Covent Garden audience of 2500 rolling in the isles night after night, was beyond me. I assumed that an allusion to royalty was dangerous and his comic genius must have been in the execution, leaving the joke, therefore, lost to us.

Then, in the early 1990s, I was sat in the middle of 2000 people in a tent at the Campus Festival in Devon watching the theatrical maverick and spoken word performer, Ken Campbell. He had brought a little shopping trolley on stage with him, holding several books which he referred to occasionally. He started talking about the meaning of life and took off his jacket and casually dumped it on top of the books. Then he read out something about physics, replaced the book, took off his glasses and placed them on top of his jacket. It was a hot day and, while he talked, he mopped his brow, took off his cap and put it with the rest of his stuff. He started talking about paying a visit to Prof Stephen Hawking to discuss Grand Unified Theory. He gave the trolley a half turn and started talking to it. No one saw it coming and no one expected it. But there, on stage, was the unmistakable icon of Stephen Hawking - his crumpled little body, with a book on his lap, and his face, lost as usual behind his glasses and under the peak of his cap. Uncanny? I think so. Grimaldi was clearly a comic genius. And Ken Campbell is worth a mention too.

A Brief History of Burnt Cork Minstrelsy

There were white actors blacking up and playing black comic characters in the British Theatre as early as the 1760s - Charles Dibdin, the actor who wrote Joey Grimaldi's first major Panto, *Mother Goose*, 1808, had toured England in his youth with a black-face solo comic recitation. It was an acquired taste of the English upper classes who also kept black servants as fashion accessories. The English 'comedian' Charles Mathews played Philadelphia in 1820 as a comic slave character performing a recitation.

Jim Crow

In 1828, during an interval spot in a New York theatre, a white actor named Daddy Rice appeared as a black character, 'Jim Crow', and sang a song of the same name. His skin was darkened with burnt cork; he was dressed up as a crass black stereotype. The song and the man were an overnight success. Rice was touring Britain within two years.

The Musicians

In 1843 a bunch of white musicians did some serious ear-wigging and learned a whole repertoire of black songs and performed them under the name 'The Virginia Minstrels'. Their example was soon taken up and given a more theatrical format by the Christy Minstrels and very quickly the whole tawdry show was on the road. It became a national pastime and spread throughout America and Europe. While the blacks were still at work, many whites spent their leisure time blacking-up in hobbyist bands portraying blacks as all-singing, all-dancing, grinning hedonistic buffoons. We'd slipped back 4000 years.

The Format

While many of the early songs and music were stolen from the blacks by whites, and customised to suit their own style and prejudice, it was a white man who originated the format for the spoken word interludes. Steven Forster was the writer / director behind the Christy Minstrels. Not only did he write many of the original songs, he is also credited with the concept of the semi-circle of musicians with Mr Interlocutor the MC in the centre, and the two 'end men', Brudder Tambo (on tambourine) and Brudder Bones (on bones or spoons). These three players performed short comedy interludes of cross-talk repartee, riddles and jokes in between the song and dance numbers, plus an extended musical sketch where the stock characters, 'Jim Crow', a stupid country bumpkin, along with his skiving, work-shy urbanite counterparts, Jim Dandy and Zip Coon, explored and exaggerated the cross-talk further. In another context, this wholesale denigration of a defenceless race would have been the acceptable and familiar stuff of developing stock character foolery.

The terms 'Jim Crow', 'Dandies', and 'Coons' became used as racial slurs with a whole entertainment genre to perpetuate them and the bigotry behind them. Eventually, as the abolition of slavery became a major issue, 'Jim Crow' became the word applied to the laws and customs which oppressed blacks. By then the garish simplicity of the burnt-cork minstrel style and its oeuvre of often outstandingly catchy songs, energetic dance routines, and cross-talk comedy formats, had become endemic across the Atlantic in the Victorian Music Hall.

There had always been featured 'genuine Negro' minstrel performers working the English Halls and they had long since set a precedent for what seems in retrospect one of the bizarre ironies of 'emancipation'. For American blacks, it must have been a rare early equal opportunity to form their own minstrel shows and

black-up with burnt cork (with a touch of white on the eyes and lips), pretending to be whites pretending to be blacks. By the time they got on the circuit forged by the whites pretending to be blacks, and toured the English Music Halls, they were blacks pretending to be whites pretending to be blacks, replacing whites pretending to be blacks. Had nobody heard of whiteface? It was that style of confusion (but not that one) that was the stuff of the cross-talk repartee of Minstrelsy.

There is still much denial and embarrassment around the documenting of Minstrelsy. I discovered more information on a website about the history of the banjo than on sites or in books devoted to the history of Pop music, Vaudeville, or Music Hall. I find it hard to believe, but supposedly the black minstrel troupes hardly deviated from the existing formats of their white predecessors and did little more than continue to confirm the stereotypes.

However offensive it appears to us now, the burnt-cork minstrel of the late 19th and early 20th century was an acceptable home grown American stock character - an available option for any performer, regardless of race, to inhabit and explore all manner of eccentricity.

Centenary

When Al Jolson (previously an endman with Dockstader's Minstrels and, incidentally, Jewish) 'immortalised' blackface and sang 'Mammy' in the first talkie, *The Jazz Singer*, in 1928, he gave the solo Minstrelsy of Daddy Rice a new lease of life.

All the stock characters of fooldom had their battles with language, and it's a fair assumption that the fast cross-talk misunderstandings of Abbot and Costello and the Marx Brothers all owe much to the endmen of Minstrelsy.

> *'My wife's gone to the West Indies.'*
> *'Jamaica?'*
> *'No, she went of her own accord.'*

Victorian Music Hall

Sing-a-long

Victorian Music Hall evolved from backroom tavern entertainment - so-called Penny Gaffs. The first customised Halls were built in the late 1840s and were licensed for smoking, drinking and music, but not spoken word dramas. So the modern history of stand-up comedy seems to have started in an institution where sustained talking to the audience was actually illegal. The comedians of the Music Hall sang mostly robust comic songs with a fair sprinkling of sentimental ballads and were devised for mass community singing and without a PA system. It's no surprise that fragments still live on in the sing-a-long choruses and chants from the terraces of football grounds: *My old man said, be a city / town / united fan. Fuck off! Bollocks! You're a cunt!* being a particularly charming re-working of 'Don't dilly-dally on the way' which, had she heard it, Marie Lloyd may well have approved of. The song seems to be a variation on 'Polly Wolly Doodle' which was one of the very first songs of Minstrelsy and also has a range of football terrace adaptations.

The Influence of Panto

Music Hall also had deep roots in Grimaldi-style English Pantomime which developed and occupied many theatres as well as most of the Halls for several months of the year. The convention of cross-dressing was endemic and the costume, make-up, and performance style of Panto all added to the projection of image to fill the room. There were as many solo women artists strutting around the stage in top hat and tails as there were men making the most of their pantomime dame routines. Panto was (and remains) predominantly a performer's, rather than an actor's medium, and long runs in Panto doing knockabout comic characters performing monologues with musical accompaniment was a major influence and training ground for the Halls.

Gus Elen

While many of the wide range of skills and novelty acts in the general Music Hall melting pot were picking up influences and finding their own comic rapport with the audience, the singers of sentimental comic songs were developing in another way. Gus Elen was one of the leading 'Coster comedians', a sort of barrow boy-cum-pearly king, a popular London character 'type' of the time. He was less of a rowdy carouser than his contemporaries and the long lyrical verses of his songs resembled the reflective content of much later stand-up routines. Songs like 'it's a great big shame' and 'ouses in between' were rich in lines about poverty and textural jokes about the cockney dialect.

If you saw my little backyard, 'Wot a pretty spot!' you'd cry,
It's a picture on a sunny summer day;
Wiv the turnip tops and cabbages wot peoples doesn't buy,
makes it on a Sunday look all gay.
The neighbours finks I grow 'em and you'd fancy you're in Kent,
Or at Epsom if you gaze into the mews.
It's a wonder as the landlord doesn't want to raise the rent,
Because we've got such nobby distant views.

Oh it really is a wery pretty garden
And Chingford to the eastward could be seen;
Wiv a ladder and some glasses,
You could see to 'Ackney Marshes,
If it wasn't for the 'ouses in between.

Dan Leno, Harry Champion and Patter

A further advance came from Panto Dame and King of the Halls, Dan Leno, a cross-dressing clog-dancing expressive comic mega-talent, who was reckoned to be the first to introduce long sequences of patter tacked on to the verses of his songs. His contemporaries developed it further and it's hard to imagine now how this actually worked in practice. At the turn of the 20th century new customised Variety theatres were being built that held up to 3000 people, double the capacity of most music halls. The patter-style cockney bollocks verse to a music hall song like Harry Champion's 'Any old Iron' requires much the same motormouth delivery as a modern rap offering.

Just a week or two ago me poor old Uncle Bill
He went and kicked the bucket and he left me in his will,
The other day I popped round to see poor Aunty Jane
She said, 'Your Uncle has left to you his watch and chain.'
I put it on, stuck it across me chest
Thought I looked a dandy as it dangled on me vest.
Just to flash it off I starts to walk about
A load of little kids began to follow me and shout:
Any old iron etc...

Without amplification, just how did the audience, sat in the back of the Hackney Empire upper circle, hear the jokes and appreciate the subtleties? My understanding is they were probably singing the chorus at the time and that patter started off and developed as asides to the front stalls and those within earshot. Either that or Champion had impeccable diction, excellent projection and the sort of charisma that demands total focus. He had none of these; he was a loveable blustering rabble-rouser.

This is no idle speculation. When I was in Rough Theatre in the mid seventies, I re-wrote several of his songs and while the choruses worked fine, I never managed to keep the rhythm and project the verse lines beyond the front few rows:

And to protect their racketeer karma
they've got this extra character armour
Corrugated iron corrugated iron etc...

Rough Theatre performing Squat While Stocks Last *in Trafalgar Square 1976. L-R: Philip Wolmuth, Tony allen, Maggie Ford and John Miles.*

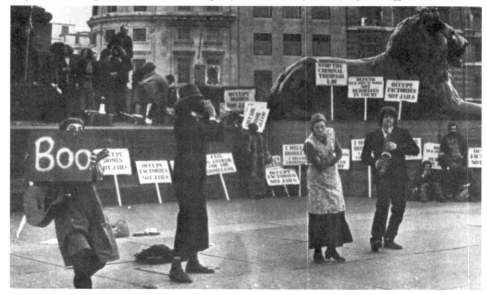

Patter became one of the comedian's creative options and although it may have been officially described as music, with regular piano chords punctuating the spoken word, it was undoubtedly the beginning of modern stand-up comedy. Patter's leading exponent, Dan Leno, was still ostensibly wedded to character comedy until the end of his career, and would tick the same box as Dame Edna Everage or Harry Enfield. Others used the costume and make-up of character only as a way of projecting their image.

Marie Lloyd needed no character costume to stamp her good-time girl identity on the back row. Although she may have exaggerated her make-up, she sang her bawdy songs, and doubtless worked the stalls, without the facade of character. She, like many others, was performing a bold and heightened version of herself.

Variety

After World War One, eccentric comedians, as opposed to character comedians, were more in evidence. George Robey (the Prime Minister of Mirth) wore a dark smock-like coat and had enormous eyebrows set against a tides-out receding hairline, and Billy Bennett (almost a gentleman) wore a crumpled dinner suit and hobnailed boots. Both recited set-piece rhyming monologues with accompanying patter, short sections of which were single idea jokes.

If it was only for want of a PA system to project their voices in the larger venues, what then was happening in the smaller venues? Did stand-up comedy actually get started away from the big Variety theatres? Audiences of the time were also listening to a range of alfresco public orators in parks and market places, many of whom were far from serious speakers and joked about everything under the sun. Alongside them was a sub-culture of racing tipsters - big characters who relied on entertaining crowds with prolonged mountebank-style witty spiel. It's hard to imagine that there wasn't some crossover of styles happening in the more intimate entertainment venues. It's an unfashionable thought, but maybe stand-up comedy, in terms of a sustained act of nothing more than just talking to the audience, first got going in the more up-market supper club circuit, where comedians like Arthur Askey learned his trade sharing the bill with after-dinner speakers.

By the time decent PA systems were eventually installed in the early 1930s, sustained joke-telling and short anecdotes were part of the comedian's options. The official restrictions on spoken word were now delegated to the theatre managements who enforced stringent codes concerning good taste. It became a matter of choice whether to cut out the songs, ditties, and monologues and go for a wholly stand-up set. It is Ted Ray who is credited with dumping his white suit and bowler hat, and walking on stage in much the same Saturday night togs as the other young blokes in his audience. He performed an act comprising jokes and short first person anecdotes, saving his violin solo only for the all-important big finish.

Max Miller - Comic Attitude and Beyond

I saw Max Miller play the Chiswick Empire in 1957 when I was twelve. My Dad took me one evening out of the blue - doubtless as a rite of passage. All I can remember is that there was this geezer, and I mean 'geezer' on stage wearing a suit made out of jazzy curtain material with the baggy trousers stuffed neatly into his socks - 'plus fours'. I asked my Dad afterwards. I'd recently become obsessed with clothes. On the way to the gig, Dad had said, 'So you wanna suit? I'll get you a suit like Max Miller's.' He said nothing else. I knew it was going to be a joke. That was my only expectation and my only lasting image of Max Miller. I can't remember any of his jokes, only my Dad's daft joke on me about Miller's suit.

Clearly I was bonding with my father and not paying attention, but what I did recall of Miller is fascinating: a packed darkened room, with the crowd hanging on his every word. The pervading mood was of something illicit happening, like at any moment we might be found out and all asked to leave.

Later, as an adult, listening to the tapes of his gigs, I seriously started to wonder what sort of repressed adolescent I must have been to have had a chance to listen to so many saucy jokes, and not to have taken it. Maybe I was simply embarrassed and chose not to hear. But that's not the point. Whatever else I missed, I clearly clued into what was going on.

When he was peaking in the late thirties, he must have cut the same sort of figure as Joey Grimaldi. Working class geezer dressed up like an over-the-top toff - on anyone else it'd look silly - but Miller's so full of himself, he's carrying it off. A cheeky charming swaggering narcissist. He's travelled, he's gambled and he's certainly 'one for the ladies' and, given half a chance, he'll tell us all about it.

As soon as Miller is on, he establishes a conspiratorial dynamic with the audience concerning the whereabouts of the theatre manager who wants to check his material. He keeps glancing into the wings:

> *'He's still there. He wants to look at my stuff, you see. I don't show him,*
> *but he wants to see it.'*

Miller, and he must have been 65 years old when I saw him and well past his best, was still creating a mood of furtive disclosure and the audience were still colluding with him. He presumably still had his comic attitude of 'cheeky and conspiratorial' curled into 'devilment and mock denial' with its 'will he or won't he get a chance to tell us' hook of expectation into the audience.

It's a device that served him well over four decades and there must have been times when it was

very real. Miller's career is dotted with periods when he was out of favour and banned outright from the stages of employers who were committed to promoting a 'decent' show, aimed at a broad popular cash return.

There has never been a period when such a device was not relevant. A contemporary comedian could make it work today on the Miller-lite Jongleurs circuit, where the current taboo is one of creativity with its possibility of causing discomfort by hinting at the evil of service industry failure. 'If he gets a chance, will he or won't he go too far and be an individual and serve his own truth instead of a generic approximation?'

When Miller did put down the approved white book and delivered his 'blue book' material, it was merely a taster of the sort of jokes doing the rounds in the public bars. Hearing Miller tell it again, publicly and in front of the ladies, was the actual gag. Contemporary comedians like Jenny Eclair and Jo Brand (who women take their twelve-year-old daughters to see) are leading exponents of a modern variation, with a range of awkward female subject matter. When I saw the Milleresque Roy Chubby Brown live in Skegness in 1998, he had a neat twist on the theme, which involved a tacit conspiracy with the women in the audience to tell detailed cunnilingus jokes to embarrass the lads.

Max Miller, the Cheeky Chappie, is remembered for his risqué comic songs and the jokes he shouldn't have told, but the other element of his performance that consolidated his attitude and assured his longevity as headline act, was his sparkling rapport with the audience and the fluency of his 'patter' between the gags.

> 'You can't help liking him, can you? Miller's the name, Lady, there'll never be another, will there? - They just don't make 'em any more, Ducks. Good job I was a boy. If I'd turned out a girl, I really would have been in trouble. No! Listen. He's gone. Here's one...'

Who Killed Variety?

Variety wasn't killed off by television; it just failed to adjust its set. From the mid-fifties everything got a lot grubbier in Variety; whether or not Max Miller was supported by a series of nude tableau acts, I can't recall, but that's what started to happen. It was the wrong response aimed at the wrong generation and when it became obvious that rock 'n' roll was the new Music Hall, Variety couldn't compete. The first wave of rock audiences were tearing up the seats because they didn't want to sit and watch; they wanted to get up and dance. In retrospect, an astute Variety management should have ripped out the front six rows in a couple of the tattier theatres and booked a trial season of raunchy comedy rock packages. The Coasters headlining, Lonnie Donegan in support, and Screaming Lord Sutch, for openers. I'd have gone. Instead, their last ditch attempt was to try and incorporate it in a traditional bill 'and introducing popular new recording star Cliff Richard'. That sort of approach.

Lonnie Donegan did actually play Variety but with much the same treatment. They missed their chance there; his comic songs were in the tradition of the Music Hall. If anybody could have saved Variety, it was probably him.

It was three years later, in 1960, when I was fifteen, that I next recall seeing live entertainment - Gene Vincent and Eddie Cochran - at a scruffy cinema in Ruislip. By then, the new generic role model of rock had narrowed to young, cool and mildly delinquent.

> Well I'm gonna raise fuss
> And I'm gonna raise a holler

Variety was dead by then and live stand-up comedy was virtually in hiding.

Why are Eric and Ernie so Loveable?

In the autumn of 2001, I was on my way to Amsterdam and arrived in the crowded departure lounge at Luton Airport to learn that the flight had been delayed for two hours.

About a third of the three hundred or so people waiting were sat watching the telly on an overhead screen. Back to back Morecambe and Wise TV shows. I stashed the book I was reading, found myself a seat in the middle of them and let it wash over me. There's a lot worse ways of spending two hours. The youngish lively crowd were focussed and loving it. Every time there was a break from Eric and Ernie, people chatted to each other and I soon picked up on the fact that most of them were Dutch with a fair sprinkling of other nationals, mostly Europeans, but only a few English.

So what was it about Eric Morecambe and Ernie Wise that made them so universally loved?

Ernie Wise was working the Northern Club circuit when he was six-years-old. His father would black-up and sit him on his knee and sing 'Little Pal' as the finale to a cross-talk comedy double act, Carson and the Kid. Eric Morecambe was almost as precocious - winning talent contests in his early teens, staged by a professional 'blacked-up minstrel' troupe in the local seaside resort of Morecambe. He, like Ernie, was an all-round song and dance comic. They teamed up as a double act in the mid 1940s when they were both still in their teens. By sheer hard work and dedication, they became a headline showbiz attraction by 1960. In all that time they'd never had an original thought in their heads. They did what almost every other act did in their profession - they nicked material off other acts or rummaged in the archive and appropriated whatever suited them. It was the demise of live Variety and their decision to concentrate on television that forced them to finally take on scriptwriters and pay for using other people's material. No judgement. That's the way it was. Interesting to note that Hills and Green, the scriptwriters for their second TV series, were paid more than them.

In a profession where the bland were leading the bland, Morecambe and Wise got creative. Their double act evolved and gradually became less dependant on scripted gags and more on the subtle inter-action of their personas. For the rest of their careers (until 1983 when Eric died of his third heart attack) they stayed at the top. Their most creative period was their time at the Beeb from 68-77. In the final five years they appeared to be coasting.

In a double act, the two expressions of attitude echoing the set-up and punchline of joke structure are obvious. In their early work there was little or no attitude involved beyond the fact that Ernie was charming and sensible (the feed) and Eric was wacky and comical (the gag man). They would stand or fall on the quality of the gag and the business of putting it over to the audience. The whole thing was in inverted commas and very stagey. Often the set-up was cumbersome and required a prop that was then discarded. Eric walking on with an apple on a string tied to a stick.

> Ernie: *What are you doing?*
> Eric: *I'm going fishing.*
> Ernie: *Fishing? You don't catch fish with an apple. You catch fish with a worm.*
> Eric: *The worm's in the apple.*

Boom boom! And it was a 'boom boom!' or 'tarrah!' to the audience on the punchline. A dozen more gags, a couple of songs and a dance routine. Such was the stuff of double acts. After twenty years with

regular updates and ringing the changes, Morecambe and Wise knew their business intimately.

When they subtly reversed the roles with Ernie Wise still providing the set-up but by expressing ambition, vanity or pomposity, it's his attitude that is the set-up more than what he's actually saying. And it's a perfect set-up. Eric also gets to express attitude. Eric need only register the fact that he's heard it. A simple turn to Ernie and a corresponding raised eyebrow to the audience or camera can get the laugh. His attitude is a complexity of rising status, mock pity or mild derision and of course playfulness. From there he can embark on humouring Ernie to encourage him to make further egocentric statements.

A further sophistication involved Ernie Wise catching on to the fact that he was being humoured or that Eric was sharing something with the audience and going behind his back. When Ernie started standing up for himself and making efforts to turn the joke back on Eric, it got curlier still. Eric's mugging to the audience became double-takes, which required a look of knowing amusement acknowledging what was going on - (Whooee! get him!).

The final deepening of the plot assured them an undeniable place in the heart of the nation's Christmas viewing habits.

When Ernie's backchat starts scoring the odd point, Eric is forced to notionally stop the game and remind Ernie of some salient facts. He points at Ernie, warning him to lay off the clever stuff. These threats never amount to anything more than playful reminders that Eric is twice Ernie's size - a look of censure, a firm arm around the shoulder, and very occasionally briefly holding Ernie's face between his hands and glancing at the audience.

But Eric never takes it any further. He may still glance at the audience, but he never goes so far as to ask them, 'Shall I give him the slap he deserves?' He always desists. They are friends and Eric is not about to betray the friendship any more than he already has.

And that was the beauty of it. Their on-stage relationship became a well-observed reflection on the unwritten rules of any long-term relationship. Eric has reached the boundary. Whatever his problem is with Ernie, he'll have to live with it, grin and bear it and close ranks.

Ernie of course is oblivious to all this and full of himself. Eric can only gently snipe, even playfully sulk, or better still, get Ernie off his ego-trip and on to another agenda where they can both mess about and enjoy themselves. Cue for a song. Two of a kind? They definitely weren't that.

In their performance, Ernie Wise is a vain, ambitious, penny-pinching, bumptious, flawed little know-all - a showbiz monster; Eric Morecambe a big, warm, endlessly playful man, who expresses a complexity of largesse and patience in a look and a minor adjustment to the tilt of his glasses. His only flaw is that he loves Ernie unconditionally. Every Morecambe and Wise sketch is a little homage to the tolerance of friendship.

Lenny Bruce

I never saw Lenny Bruce perform. I was vaguely aware of the news items about his short run of gigs at The Establishment Club in 1963 and his subsequent exclusion from the UK. Shortly after this, I heard his first album 'Sick Comedian'. It was recorded in the fifties. I didn't know it, but by then he'd moved on to a far more adventurous style of comedy. It was 1968 and Lenny Bruce had been dead for two years when I first

heard what I now consider to be his three seminal albums - the concerts at Berkeley, Carnegie Hall, and the Curran Theatre.

America in the fifties

In the period following World War Two, the development of good quality microphones, and the advent of television contributed to more intimate and less robust approaches to live comedy.

In America, the post-war generation of comedians were playing a circuit of cabaret clubs with occasional TV chat show appearances. They began to drop the razzmatazz of vaudeville styles (the equivalent of Variety and Music Hall) in favour of something far more relaxed and sophisticated. By the late fifties, one strain of this style eschewed familiar gag-telling in favour of extended skits and thematic routines. The early albums of Bob Newhart and Shelly Berman helped establish and popularise this style. Its most adventurous exponent, Lenny Bruce, explored subject matter previously deemed unsuitable as mainstream comedy material, performing extended raps about religion, drugs and sexuality. While Bruce's admirers celebrated him as a taboo-breaking social satirist, he was dubbed 'sick comedian' by journalists representing the conservative silent majority.

Lenny Bruce clearly became tired of doing the well-rehearsed comic 'bits', as he called them, and he began endlessly experimenting with ways of sustaining improvisation beyond the simple honing, heightening and embellishment of existing material. As early as 1960 his preferred approach was to 'free-form' - go out there, kick a few ideas around and give voice to his stream of consciousness, keeping his existing set-piece 'bits' in reserve to, if need be, pull the gig round.

By the early sixties, Lenny Bruce and his more politically motivated contemporaries, Mort Sahl and Dick Gregory, were performing their material as if they were holding an intelligent spontaneous conversation with the audience. The joke structure employed was subtle and not immediately apparent; their stage personas, the experiences related and the opinions expressed, had the ring of authenticity. The subject matter was real and relevant. Even their costume was casual everyday wear. We had entered the era of the serious raconteur comedian, although it would be another twenty years before this style of stand-up established itself with any grace on a live stage in the UK (Dave Allen being a notable exception).

The sensational side of Lenny Bruce's career has been well-documented. But there is an artistic legacy made of subtler stuff. Lenny Bruce's most important contribution to the art of stand-up comedy has less to do with breaking taboos around choice of language and subject matter, and more to do with the risks he took with himself on stage. Unsurprisingly, Lenny was into be-bop - he wanted to 'blow', 'wail' and 'cook' like a jazz musician, but having a flair for language and a head full of outrageous ideas, didn't bear comparison with 'being at one with your axe'. Performing stand-up seemingly without artifice, he started to discover range and variety in the light and shade of his own on-stage personality - his performance 'attitude'. More than any other comedian before or since, Lenny Bruce intuitively understood, used, and oozed attitude. He performed in a style of such flair and intimacy and expressed himself so eloquently, it is hard to think of any comedian since who has done anything vaguely comparable.

It was the American legal system that provided him with the impetus which would ironically liberate his artistic style, and tragically also be the death of him. First, in 1961, came an unnecessary drugs bust for the possession of methadone for which he had a doctor's prescription. A few weeks later, there was an equally pointless and vindictive obscenity bust for use of the phrase 'cock-sucker' in his stand-up act at the first house at the Jazz Workshop, San Francisco. He was out on bail and back on stage for the late show, with a whole

wodge of potent material and the urgency and opportunity to share it. Rapping out his experiences with the law and updating his audience with his latest take on the current situation became a central theme in his work.

The busts (eight in all) and the police harassment continued; preparation for the lengthy trials and appeals began to take over much of his life; by 1965 he was bankrupted by legal fees. He died penniless of a methadone overdose in August 1966. For much of this time he was gigging - catharting his stuff and downloading the contents of a teeming mind to an intrigued audience.

It's a sign of those times that throughout, he was never hostile towards his audience; there was no indulgent ironic anger or second-hand raging at authority. Quite the opposite. He spoke to them as equals, often without guile, honestly sharing his bewilderment at the madness of the situation he found himself in. While Lenny was offering insight and overview of contemporary American society, he was also conducting a self-examination. Lenny's gigs were intimate affairs, and although there were many hundreds present, they had the mood of confidentiality, as if he was thinking aloud while writing up his diary.

The 1961 recording of his non-stop three-hour gig at the Curran Theatre, San Francisco, contains sequences that surpass any in stand-up comedy. The potency of the moment and much of the content is lost on us now - the samplings, local and cultural references, the detail, even some of his opinions and slang - it's all a foreign country. But forget the material, forget the word play and the twisted cliché joke structure; listen to the technique - the orchestration of his range of attitude. Just listen to the jazz of it.

Lenny Bruce delivered his witty insights and opinion in a spectrum of personal voices all in close attendance, but none getting to solo for more than a few seconds. While it wasn't always immediately funny, it made for a decidedly vital performance. He chatted honestly and openly, confided conspiratorially, wisecracked asides, mused soulfully, shared very personal observations, pleaded world-weary bewilderment, groped earnestly to understand and laughed delightedly at his own conclusions. He also rattled off opinionated short-hand information, sampling two decades of popular culture with comments, quips, quotes, snapshot characterisations, imagined official conversations and references to the local-immediate. Any of it could escalate into flights of nonsense and surrealism or slow to thoughtful reflection. There was a continual reprising of some of these references throughout in a range of fresh contexts. Another part of the textural glue uniting his act was a generous peppering of Yiddish slang, hip slang, jazz slang, showbiz slang, concocted language and verbal sound effects. All of it a deliberate artifice to help release his stream of consciousness and its free associations. He even alludes to this fact in his act, one voice offering an ongoing explanation of his comedy technique. Listening to Lenny Bruce, you get the feeling there was nothing in his life or art that he couldn't express through stand-up comedy.

THREE

THE ROOTS OF ALTERNATIVE COMEDY

I was standing pretty close to 'down stage centre' at the birth of Alternative Comedy, struggling to get an act together. I kept a fairly consistent personal diary documenting most of my gigs, as well as getting feedback from friends, lovers and comrades. Most pertinently, I also had two audiotape buffs recording whole evenings of what I was involved in. Although it was little more than 20 years ago, I've yet to read an account that bears anything more than a passing resemblance to what I experienced. Alas, best leave Max Miller, Dan Leno, Joey Grimaldi and Robert Armin with the bones of poor Yorrick who knows what they really got up to.

My interpretation of recent history starts in London, South of the River, at the end of the 1970s.

Oval House

Monday April 2nd, 1979. 10pm. I am standing alone in the wings, just about to go on at a makeshift cabaret club, upstairs at Oval House, Kennington. There are fifty people in the audience, including a small support group and some fellow performers who are almost as anxious as I am about what I'm doing. I'm wearing my best grandpappy vest, a jumble sale evening suit held together with safety pins, and sporting a lapel full of badges. My hair is a mop of black shoulder-length ringlets tinted with burgundy henna. A black star dangles from an earring. I'm not in character - I always look like this when I'm out for the night. I'm an over-typical post-punk hippie squatter; I haven't done a serious day's work in six years and I am about to deliver my first stand-up comedy set. In my pocket is a toilet roll with the complete script written in longhand. I've been trying to learn it all day and for the previous few months; I've been assembling it for a lot longer. It's a montage of personal anecdote, opinion and witty political slogans plus a few updated old jokes. Most of it is original; I've hardly nicked a thing.

Although I'm only vaguely aware of it, there's other fringe performers out there also toying with the idea of radical stand-up comedy. I have no idea that I am 'one of a group of innovative new comedians who are about to change the face of light entertainment'. My sights are set higher - I want to be local shaman in a performance-led, grass roots, flowering tops, anarchist revolution.

Despite knowing who I am and what I want to say, I'm horribly wobbly. I feel naked, vulnerable and unprepared. Yesterday I made the mistake of trying to rehearse the whole thing from the top at Speakers' Corner.

I got ripped to shit by hecklers. I should've known better. It's a very different medium. I won't do that again.

Meanwhile, I've just learned that the pungent smell that permeates the whole Oval House building is due to a broken sewer pipe. That's why the toilets aren't working. I know this much about live performance - you have to 'address the now' - 'give voice' to what is going on in the room for the audience. So, at the last minute, I decide to think up a new opening line and comment on the drains.

And now, please welcome Tony from Rough Theatre...

When Lenny Bruce walked out on stage for his marathon 3 hour 1961 Curran Theatre gig, there was an audience of only 300 in a venue with a capacity of almost 2000. He spent the opening five minutes improvising a sustained piece of inspired nonsense about giving away free tickets to the local drunks, who then heckle him, disrupt the show, refuse to leave the theatre, participate in the concert the following night and get great reviews. In the late sixties, long after his death, I got the album out of the library archive along with the two other Lenny Bruce seminal concert recordings, 'Berkeley 62', and 'Carnegie Hall 63'. I'd always harboured a fantasy about being a comedian, but it wasn't until I heard this stuff that I knew what sort of comedian and how serious the fantasy.

So it's a rather ignominious kick-off to my career, when the best I can come up with is a straight lift from Ken Dodd:

When I arrived here tonight the Oval staff all came out and cheered me - they thought I was the man from Dynarod.

It hardly gets a laugh, and I am so busy worrying if I've actually said the line correctly, that I forget the next line and then fluff the following one. Two many agendas will scuttle your concentration. I know nothing of such subtleties, but I do know that 'the show must go on'.

I plough into the prepared silly stuff to warm them up:

I'm waiting for a 36 bus to come here tonight. I'm waiting and I'm waiting. Not a 36 in sight. So in the end I get two eighteens!

And yes, they laugh. I like the sound of it. I have a complete stand-up comedy set in my head and I'm delivering it to an audience who are going to hear me out. Apart from a ten-minute slot in an am-dram Variety show at the Hillingdon Youth Theatre in sixty something, when I'd performed a composite imperson-ation of Max Miller and Frankie Howerd (nicking their best lines), this is a first. It's not been easy, but at last, I'm doing it.

Folk Clubs

In the early seventies I'd stumbled onto various stages and slowly learned how difficult it was going to be. MC and token poet at my local folk club in Hayes, Middlesex, was the closest I came to experiencing anything like the right context - live intimate cabaret. While audiences would tolerate some of the established acts witter-ing on for a few minutes by way of introductions to their songs, they weren't about to let me do the same, particularly when all I promised was a few rhyming couplets, a joke they'd heard before and an announcement.

In November 1972 I moved into a squat in Westbourne Park and joined West London Theatre Workshop, a radical community theatre group run by Bruce Birchall. The following summer I got to play the part of Dennis the Menace in a production that toured 28 different adventure playgrounds across London - great training if you want to learn how to crowd control pre-pubescent kids. They would demolish the fourth wall on a daily basis. A year later I joined up with fellow dole-sponsored thesps, John Miles and Farrel Cleary, and we founded Rough Theatre, adding yet another experimental theatre group to the London fringe.

Fringe Theatre

The London theatrical fringe had emerged in the years that followed the abolition of theatre censorship in 1967. Beyond the pub and studio theatres, and the worthy 'Theatre in Education' stuff going on in schools, a clutch of innovative independent theatre companies emerged. Many of the actors were directly involved in the political and cultural events of the late sixties. Some of their work was inspiring - a gang of Santa Clauses giving away presents from West End shops - now that's what I call performance art. Although very little of their work reached Johnny and Jo-anne Punter, it did, however, redefine the actor's role. By the mid-seventies these groups had multiplied and there was a substantial sub-culture of left-wing and radical theatre exploring a whole variety of styles ranging from Agit prop to public spectacle. Central to the political ethos of much of this theatre was its commitment to finding a popular theatrical form to reach, and then to politicise, the prized working class audience. Their initial aim coincided with the liberal bureaucrats at the Arts Council who, under a Labour Government, had initiated a policy of directly funding projects which played to 'non-theatre-going audiences'. Some of the experiments were delightfully ludicrous. The daftest one I eventually walked out of, was by a theatre group in South London who staged a series of bingo nights which somehow managed to include Marxist economic theory.

Comrade Thesp

Among the uppity ranks of Comrade Thesp in the political theatre groups, there was always something to squabble about. So it was no surprise when less-politicised jobbing actors with talent won auditions over Trotskyist activists, whose idea of dramatic conflict was to get the audience arguing about the date of the next general strike. Theatre groups without funding formed and split up as regularly as rock bands without a record deal. But many of those committed to either art or ideology survived. Inevitably a pecking order emerged. Top of the list and brand leader was the 7 / 84 Theatre Company (7% of the population owns 84% of the wealth) which featured the work of Scottish socialist playwright, John McGrath.

Also, although they were not the favourites of the Arts Council, hard-core political outfits like CAST, Red Ladder, and Broadside managed to pull a bit of funding and fulfil (more than most) their mandate to find new audiences. They played in colleges and community centres, as well as playing a fair sprinkling of solid 'working class' gigs organised by younger elements in the trade unions and local trades councils.

Rough Theatre

Rough Theatre was committed only part-time and down the scruffy unfunded end of the yard. Our sporadic offerings lampooned Comrade Thesp, and were aimed not at the working classes, but firstly at our immediate tribe - the political activists and the lively squatting sub-culture. We were entertaining the troops and occasionally writing and performing some very good local jokes. '7% of the political theatre groups get 84% of the fringe grant' being my particular favourite.

But I rarely felt totally comfortable on stage. For the best part of six years I convinced myself I could overcome the problems of style and technique by simply writing even better material. I never came to terms with the fourth wall. I never knew when I was allowed to break ranks and come off script. Whenever any of us did successfully 'address the now', it was seen as a major triumph of taboo-breaking proportions, but a practice that carried a severe warning. We also attended political meetings and were only too aware of the shambles and uproar that could ensue once our sort of audience sensed the opportunity to argue about politics.

I probably reached a larger audience with the one-liners that I wrote on walls than I ever successfully cracked on stage. 'Squat Now While Stocks Last', graffitied across the front of a prominent boarded-up building in Westbourne Grove, had an elegance and immediacy about it that was worth hours of street theatre.

John Miles and I developed alter-ego characters and were groping towards a double act; Ormskirk Arthur and Cyril Sleazby were our pair of skip-dwelling dossers. John's repressed northern manic street preacher was straight man to my larky amoral cockney. I spent a lot of my time on stage standing at John's shoulder listening to his demented lyrical rants and mugging my confused reactions to the audience. Gradually I dared myself to add asides. But it was always theatrical. No matter where we performed and how much we deconstructed what we were doing, we always produced 'plays' and they invariably worked best in studio theatres.

The Benefit Circuit

Meanwhile, there were other elements shaping the style and content of live entertainment during the seventies. Rock Against Racism, invigorated by the punk explosion of '76, had spawned a nationwide benefit circuit of fund-raising gigs and socials for all manner of political causes. At first only po-faced comrades ventured out on stage in the change-over intervals between bands, making announcements of demos or perhaps a brief anti-fascist speech before quickly getting off. Soon these difficult performance slots were being occupied by ranting poets, agit-prop buskers and fringe performers.

Rough Theatre had sporadically been braving these sorts of audiences with the 10-minute play of the graffiti 'Squat Now While Stocks Last'. It was a scripted piece with only token acknowledgement of the audience, and despite the talents of actors like Maggie Ford and Stuart Golland, we were still struggling to find a style that successfully cracked the fourth wall.

It would be another five years before I would eventually have a 30 minute solo set of strutting combative stand-up comedy for rock events, but in 1977 I was nervously attempting to MC them and having panic attacks before, during, and after performing.

Rough Theatre Roadshow. L-R: Tom Costello, Jonathan Graham, Tony Allen.

Roadshow

In 1978 I teamed up with Jonathan Graham, a trained actor and a gent, and Rough Theatre irregular, Tom Costello, a clowning, juggling, punning, sweet jazz saxophone-playing delight of a man. Both of them had recently done a bit of knockabout commedia dell'arte', so with very little rehearsal, we started accepting gigs for the Rough Theatre Roadshow. I had come up with a structure that I believed would solve the fourth wall problem. The fifteen minute play was set in the here and now and was a brief explanation of how the three

characters - an actor down on his luck, a drunken escapologist and a would-be radical comedian, came to be in front of the audience. It involved acting, busking and stand-up, some knockabout inter-action and a three-way snatch-juggling routine. It expressed our dilemmas and our options and was also heavily influenced by a style of street clowning from Europe.

Hippie Circus

The Festival of Fools in Amsterdam seemed to operate as an ongoing street theatre festival and had its echo in several major European cities, notably Christiana - the squatted city within a city in Copenhagen, and the Tempadrome Circus settlement by the wall in West Berlin. A diverse sub-culture of experimental and knockabout theatre mixed with circus and rock music was forging a circuit and producing its headline attractions. Jango Edwards, an American based in Amsterdam, was front man and founder member of Friends Roadshow and best described as a 'rock clown'. Although he played to packed thousand-seater venues on the continent, he was unknown in Britain; he was nevertheless a strong role model for Channel-hopping street performers.

In the more restrictive climate of the UK, the West Country summer festivals of Hood, Elephant and Glastonbury offered annual venues for Festival of Fools-style acts, including home grown ensembles like Welfare State and Footsbarn.

Busking and Covent Garden

In central London the spirit of the Festival Of Fools was most evident in and around the Covent Garden Development area, where there were plenty of opportunities to squat empty derelict property for both homes and rehearsal room cum venues.

Throughout the 70s there had been several campaigns to establish and legitimise busking and street theatre in Central London. In 1978 Rough Theatre Roadshow got involved with performance art activists Demolition Decorators, plus a large ad hoc group of street entertainers, and we attempted to run an alfresco cabaret in the newly pedestrianised Leicester Square. There was a very larky and rowdy scene when the event was stopped and police rounded up the ringleaders and marched us off to Bow Street police station. The street party atmosphere continued outside for a further two hours, forcing our premature release on bail.

I made several court appearances as one of the Leicester Square 3, which played to packed houses at Bow St Magistrates Court throughout the year. The case was finally dismissed, helped by among other things, my arresting officer contradicting his own evidence - unable to remember whether I was strumming a unicycle or stunt-riding a ukulele banjo. The experience I gained from carefully heckling the procedures of British Justice whet my appetite for more solo performance, but not in the courtroom. I wasn't much taken with all the hours of waiting around in corridors.

When the squatters were finally evicted and redevelopment of Covent Garden was eventually completed, a concession of several legalised busking pitches was granted to a promotion group called Alternative Arts, run by Maggie Pinhorn. These performance pitches grew in status and were booked like cabaret slots. Nowadays they feature the top crowd-pleasers of international street entertainment.

Speakers' Corner

The only other live performance to get me arrested was at Speakers' Corner. I'd been a regular heckler there for some years. I loved the place and longed to be a speaker, but for all my public front, I could never quite

Above: *Rough Theatre Roadshow at the Factory W9, 1978. L-R: Tom Costello, Jonathan Graham, Tony Allen.*
Below: *Rough Theatre. Allen and Miles 1977*

muster the gumption and get up and do it. I regularly abused the goodwill of Barry Roberts, the Seeker, by habitually over-contributing in his meeting. As a last resort, in an effort to shut me up, he would invite me to speak. I would always decline, concealing my sheer terror with seeming nonchalance. Finally, one Sunday early in 1978, I was heckling him and accused him of not taking enough risks, of saying nothing dangerous or forbidden. When he inevitably offered me his podium - an old milk-crate, I had no way out. I knew my moment had arrived. I confidently stepped up and delivered a taboo-breaking diatribe on free speech. In less than five minutes the police had ejected me from the park for swearing (they can't do you for stupidity or arrogance). The last words of my debut speech were: 'Even this person tugging at my sleeve came out of a cunt.'

For the following 12 months I enjoyed considerable notoriety. I held lively meetings and managed to get myself thrown out a few more times, twice landing up in Marylebone Magistrates Court charged with 'Language and / or behaviour likely to occasion a breach of the peace' - a law brought in to curb the racist oratory of Oswald Mosley. I was talking about making love. Your honour!

I was found 'guilty as charged', despite the fact that the magistrate had appeared to be on my side. It was as if he wasn't allowed to go against the police and find 'not guilty' in a public order case. He made this much clear by giving me a moral victory - there was no fine to pay and no costs.

On stage at the Oval I simplify the complexity of all this to the following:

I'll tell you what happened at Speakers' Corner. I was arrested about a year ago for saying the word 'cunt' while talking about sexual intercourse. And I pleaded not guilty and the thing got adjourned. Two months later a Marylebone Beak threw it out.

Three weeks ago I got arrested under the Public Order Act again, for saying the word 'prick' while talking about masturbation. Once again I appeared the following Monday and pleaded 'not guilty' and it's been adjourned for two months. Now, if I'm found 'guilty' for saying prick and 'not guilty' for saying cunt, then I'm going to sue the magistrate under the Sex Discrimination Act.

The audience laugh, but I instinctively don't like it - I've smudged the truth of what actually happened for the sake of a fairly glib joke. I'm also having problems with the ghost of Lenny Bruce. It's not just the 'obscenity charge' subject matter. It's his voice. It's in my default mode. I've not actually said anything of his yet, but I know it's there, I can hear the albums. I can also hear the albums of three contemporary comedians...

Crutch Guitar Style

Back in the folk clubs the intros to songs became longer and more polished. A style of rambling joke-telling mixed with personal anecdote had evolved. Its leading exponents had outgrown the clubs and were playing big theatre venues. As an aspiring comedian, I found Billy Connolly, Mike Harding and Jasper Carrot very frustrating role models mainly because there was no practical way to emulate them without first doing an apprenticeship as a folk musician in the folk clubs, but also because everything about them had failed to acknowledge the punk revolution and the heightened social and political awareness that was all-pervading in the radical arts. It's only in retrospect that I can acknowledge the so-called folk comedians as being the direct forerunners of the alternative wave. But at the time they had no street-cred and were considered provincial and passé. I listened to their albums, of course, and I learned a lot, but it was hard to forgive Connolly in particular his penchant for stag night gags.

Meanwhile, the legacy of Lenny Bruce and the work of subsequent American stand-ups like Woody Allen, Robin Williams, Steve Martin and Richard Pryor all influenced and contributed to the breakthrough that I was about to become part of. But it was the sad state of traditional British stand-up and its total irrelevance to the post-sixties generation (never mind the post-punk generation) that was probably the most important element. There was an enormous vacuum and it had to be filled.

Traditional Stand-up

In the late seventies live stand-up comedy in Britain was a very seedy and deeply unfashionable business. In London it could be tracked down to a handful of weekly venues in East End pubs - two of them in the Old Kent Road. There was also a smattering of Working Men's Social Clubs in the suburbs. The Variety Club circuit had always been stronger in the North of England, but even there its fortunes were on the wane. Granada Television may have twice repeated the weekly mid-seventies show 'The Comedians', but it never made a new series. It showcased mostly Northern club comedians, like the cheeky racist Stan Boardman and the deliberately offensive Bernard Manning. They performed sanitised versions of their xenophobic, woman-hating live stage acts in front of a studio audience. Their acts looked and sounded the same. Dressed in frilly-fronted shirts and garish evening jackets, they told jokes, old jokes, often the same old jokes. They appeared to be petrified in a state of self-parody.

In 1976 I saw *Comedians*, an oddly prophetic play by the left-wing playwright Trevor Griffiths,

which attempted to deconstruct this sub-culture and its approach to comedy. Two years later, I discovered it for myself...

The only way into the world of down-market traditional showbiz was as an amateur act on what was an irregular circuit of agency showcase-cum-talent nights, held anywhere with a liquor license and a functioning stage. These gigs were advertised in the classifieds section of *The Stage* newspaper and it was generally understood by all concerned that they were rigged in favour of acts from the host agency. I spent many an evening in late '78 travelling by tube to Hainault or Ruislip to reconnoitre these events without ever daring to declare an interest. The bills were noticeably short on comedians and usually comprised a conveyor belt of solo vocalists singing familiar old standards and backed by two jobbing musicians on Casio and drums. Sometimes the only stand-up comedy all night would come from the MC. These guys were on the bottom rung and going down. They went through the motions of simulating showbiz pazazz while at the same time sending it up in such a yawn of a style that it had only a genetic memory of irony.

Apart from summer seasons at Butlins and the like, working comedians of this period played two circuits. Alongside this fading variety circuit, and slightly in the shadows, existed the stag circuit where comedians could earn regular money working with strippers and playing to men-only audiences.

Hosting an agency showcase or a pub gig one night and supporting a couple of strippers the next, they had to have two sets of material - a club act and a blue act (echoing Max Miller's white book and blue book). A struggling comedian on a club stage could always dip into his blue book and shock the audience into laughter and submission. On a stag night, playing to an all white, all male, drunken mob, they opened by scraping the bottom of the barrel. A stag set started off with racist generalisations - 'they come over here shagging our women' - with gags against stupid inept Irish, culturally hapless Asians, and lazy, horny West Indians - often performed in character and wearing a black stocking with holes for eyes and mouth. It then moved on to nagging wives and monster mothers-in-law (our women), and finished off with a barrage of hard-core rape and whore gags. Follow that - bring on the strippers.

At the Dueraggon Arms in Homerton, I sat and watched every Thursday for about six weeks before I finally walked out heckling a stocking-face, never to go back. When I heckled a racist in the Old Kent Road, I felt obliged to leave soon after for my own personal safety.

Bernard Manning and racist comedy

Sometime in the seventies, Bernard Manning was interviewed on telly by Michael Parkinson and responded to a question about racism in his act with an apparent honesty and worldliness.

> *'Michael, all joking apart, I believe that white people, black people and Chinese people should all live in peace together, and unite as one community... and beat shit out of the Pakistanis!'*

Beyond the obvious offence of this joke, there was also a subtle barb that was aimed, not at Pakistanis, but at Parkinson and the ease with which celebrity chat show guests can slip into mouthing liberal clichés. That Manning had the nous to do this intrigued me. That particular clip was repeated as an example of 'classic Manning'. Other similar Manning 'classics' occasionally turn up as quotations in *The Guardian* and the like, but they are not typical. For sure Manning knows a good subtle gag when he hears one and is probably capable of creating his own, but given the magpie nature of the sub-culture and his status within it, many of the 'best' gags will inevitably end up attributed to him.

The truth is that Manning's joke structure is rarely subtle and depends mostly on blunt unashamed bigotry, with an attitude almost wholly motivated by cynicism.

Lenny Bruce once observed that a lot of racist abuse was targeted not at racial minorities, but at the liberals who leapt to the defence of minorities. Often Manning's humour will appear to be very naughty - calling a spade a spade in defiance of the mealy-mouthed liberal establishment. But this has little to do with smashing taboos; it merely masquerades as saying the unsayable. In his own club, in front of his own audience, there are far more pressing taboos to be explored than the one of taking yourself and the world too seriously. Manning rarely took on that job, preferring to feed prejudice rather than question and confront it. Nevertheless I learned an important lesson about 'addressing the now' from the Manning / Parkinson interview and would apply it to my own comedy:

> *So the booker for Oval House rings me up and says, 'Tony Allen?' I say, 'Yes.' He says, 'Good. I'd like to book you for a gig. But before we go any further I have to ask you one or two questions. Is what you do in any way racist? Is it anti-ethnic minority group?' 'No,' I say, 'course it ain't. No worries.' '...And is it sexist? Is it anti-women?' 'Well no,' I say, 'not so it notices - I'm working on it. Yeah?' '...And is it...' And I thought, Oh for fuck's sake! 'Listen...' I said, '...what I do is broader than all that, I'm more sort of 'anti-life'!' And it all goes quiet at the other end of the phone - while he confers - and then he comes back on and he says, 'Oh that'll be alright, that's not a sensitive area.'*

This was when I heard the laughter of recognition. Three big ones in the space of a few seconds. This joke in particular really made them laugh. Interestingly, it had nothing to do with the Oval House cabaret booker, Belinda Kidd, but was, almost word for word, a conversation I'd had, punting for Rough Theatre gigs from a Student's Union Ents Sec. It was a very tasty gag. I got to state my case on racism and sexism, plus I'm mocking the new orthodoxy. More importantly, it was my truth and I had said it in my own authentic voice without Lenny Bruce or Billy Connolly hovering in attendance. I follow this with more original material - stuff

from life that I'd honed in confessional mode at Speakers' Corner. It starts with a re-jigged heckler exchange and then a blatant steal from a George Karlin album.

Masturbation? You know what they call someone who doesn't masturbate yeah? - A liar! If God didn't want us to masturbate he'd have given us shorter arms. But we believe now that we've got a more liberated attitude towards masturbation, sex generally, don't we. Remember all that heavy guilt trip stuff that was laid on us?

'You keep on doing that and you'll go blind!'

'Oh! Can't I just do it a little bit, and wear glasses?'

'Don't do it!'

'Oh go on. I'll eat a lot of carrots! Please!' But we feel that we've transcended all that! Don't we? Now when a kid says,

'So, it's alright to do it then is it?'

You'll say, 'Yeah. Er. Sure. Go on and do it, it'll relieve a lot of tension.'

'Can I do it a lot?'

'Yeah. Er yeah course you can. But not in here! Take the book and go in your own room.'

'Can I do it every day?'

'Yes yes yes!'

'Do you do it?'

'Er. Yes I do it. I mean we all do it. It's not just me.'

'Do you do it a lot?'

'Er. Yes umm!'

'Every day?'

'Look! Just go and do it. Alright?'

Maybe you can do that - be that open. But can you... never mind you. Me. Yeah? I was lying in bed the other day, making love to myself - a bit of autoerotic sexuality - and my mate walked in. Immediately, I hook the duvet up over my groin. My clothing's askew; I'm blushing, sweating a lot. He says, 'Oh, what's up with you?'

'Er. One day flu.'

'Eeurgh! What's that?'

'I sneezed?'

Now. If I'd been in bed with somebody else - making love with a lover - and he'd walked in, he'd have said,

'Oh. Sorry.' And I'd have smiled - a bit pleased with meself, 'See you later yeah?'

So just how liberated are we?

I carry on in this confidential first person vein and I'm getting big laughs, much of it coming as a release from embarrassment. There's a couple sat up the front - silent throughout - they're having none of it. Eventually

after a longish routine about censorship in the cinema, I stop, laugh to myself and say to them ironically. 'You're really enjoying this, aren't you?'

I'm improvising. I'm addressing the now. And I'm inwardly congratulating myself and I'm not paying attention. I lose my rhythm and now I'm stumbling on through a whole bunch of stuff about drugs, street crime and the police. I'm trying to reach a punchline as if that's going to be any use without a set-up. Finally I lose my way after messing up my best political insight.

> *What I want to know is: Where is the cop on the beat when it comes to arrest-ing the real criminals - the multinational corporations who move the economy of one part of the world to another part of the world and waste whole communities? Where's the cop on the beat when it comes to arresting them? 'Well I was walking in a north easterly direction in the boardroom of Amalgamated Conglomerates, when I noticed the accused and several other 'persons unknown' making a dubious decision as to the economic future of Latin America. I cautioned him, arrested him, and bunged him in the back of the transit. That's when he must've hit his head.'*
> *Doesn't happen, does it?*

But I don't say it like that. I get it all wrong. I say the punchline first and work back. It's a botch. Now the embarrassment is mine. I blank out completely. It is very lonely. But it doesn't hurt, because I've prepared something. Something very silly - very Rough Theatre. And it works.

> *Now what was I gonna say next? I didn't think I'd get this far, as it happens. No, hang on, look! They said to me, 'Just in case you get into trouble with it, go and sit down somewhere quietly and write down what comes next.'*

I produce the toilet roll. There's a laugh. I unravel yards of it, trying to find my place. When I read out, 'Masturbation, Speakers' Corner, multinational corporations,' there's a bigger laugh as they realise that I have actually bothered to write it all down on a toilet roll. There's giggling. I play with it. *'You thought all this was off the cuff didn't you?'* I'm almost back in control. To finish with, I have two lateral-thinking homilies on the subject of avoiding arrest. It should be plain sailing. 'How does all this affect us?' I read out from the roll.

> *Police numbers are 22000. Should be 28000. They're 6000 short. Plus there's also a massive turnover in the police force - they've gotta bigger turnover than the SWP - it's a thing you do when you're eighteen. The courts are chocka block. There's on average a 4 - 6 month waiting list to get on. Worse than this club.*
> *So, even if you're caught on a liberating spree in Tescos. And the tinned salmon is there. And the cop's hand is there. Always plead 'not guilty'. In court the following morning - 'Not Guilty'. Case adjourned. By the time your case comes up in 4 to 6 months, your arresting cop will have left the force - on an oilrig somewhere.*

Rattling off statistics and flaunting my familiarity with police and court procedures is clearly Lenny Bruce territory. But I'm still surprised when I hear myself confidently say:

Store detectives. Dig where they're at... they've either been chucked out of the police force or they couldn't get in in the first place.

'Dig.' Dig is Lenny Bruce argot. I rarely use the word. It certainly wasn't written on the toilet roll. I wince inwardly, and try and keep it together, only to repeat it immediately:

And dig what they do for a living. They hang around all day in supermarkets watching other people do their shopping. And listening to Tony Blackburn. They're busting innocent people just to break the monotony.

How to get out from under a store detective? The reason a store detective can bust you is 'the citizens arrest law', but they can only bust you once you have left the premises 'with the goods about your person'. If you're on your way out and you've been spotted, you can't leave. You have to hang about by the door. You know he's there. But he can't make his move. He's just standing there behind you. And you wait. You wait until the biggest, beefiest, straight- est, have-a-go type citizen comes marching along. And just when he's about to come alongside, you leap off on to the pavement in front of him, turn to the store detective, put your hand on his shoulder and say, 'This is a citizen's arrest!' Then turn to the have-a-go bloke and say, 'I've just made a citizen's arrest on him. You look after him. I'll go for a cop.' And then you split! And that's what I'm gonna do now. Thank you.

I've finished my set confidently, there's a big laugh on the final punchline and I come off stage to sustained applause after 16 minutes of having stumbled and soared, dried and sweated, plunged and finally succeeded. I'd never experienced the like - I was elated.

Post-Oval

During the mid-seventies I had co-written four comedy plays broadcast on BBC Radio 4. But Auntie had me in for a chat and said that Radio 2, not Radio 4 was the place for comedy. Radio 2 had me in for a chat and said that my plays were unsuitable for Radio 2 because they expressed an amoral attitude towards crime. I wouldn't write another radio script for ten years. Meanwhile I had co-written and devised several stage plays for various theatre groups, but only one - for a youth project at the Royal Court - had been a good experience. In the final Rough Theatre project - the Roadshow - I had found a way to deliver bits of stand-up material from the safety of an ensemble. In the six months that followed, I concentrated on assembling and writing the solo show. I believed that everything I wanted to say could now be expressed as a solo performer. It had all been leading to that gig at Oval House. That was my turning point and they'd only heard the half of it.

The day following the Oval gig, Peter the Tape was round the house and four of us sat down and listened to his recording of my first public catharsis. I had very mixed feelings - embarrassed by my occasionally plodding style but proud of the passages where I'd found some energy and made it work. Within a couple of

days most of my immediate gang had heard the tape and were giving me feedback. There was general consensus that the masturbation and censorship stuff was best and what's more, it had worked the best. I was told that if I was going to talk about drugs, then I should get my facts straight, and also that reinforcing the stereotype of the stupid police officer wasn't going to help anybody. While I agreed and spent a lot of time chatting about the content, I never quite had the language to ask the important question - Who the fuck was I on stage? There was a sort of consensus that I was not really being myself enough. Not a lot to go on.

I had a very clear idea about what I wanted to say, but I was very surprised by who ended up saying it. There was a mischievousness about my material that I was hardly expressing in my core stage persona and what concerned me most was when I wasn't on script, I was struggling to find it. There was lots of umming and aahing and I was repeating things to fill in the gaps. If anything I'm more in the style of a didactic Woody Allen although, unlike him, I am not incorporating or using any of the nervousness; I am simply being nervous. My delivery comes alive when I play the hip dissolute dude which had less to do with me, and more to do with the Lenny Bruce baggage I'd inadvertently brought on stage with me. The 'Dig' lines were said with an energy that was often lacking elsewhere. I'd never been one of those fans who learned and repeated bits off Albums. Consequently, my problem with Lenny Bruce had more to do with hero worship than actual arbitrary plagiarism. So, although I was very familiar with his and other people's material, I wasn't about to replace their lyrics with the ones I'd forgotten. No, I was more likely to sample a word or a phrase, often an expletive that summed up the attitude I was going for. It was going to take a while to unload Lenny, for no other reason than I quite liked the decadent image. At the time I found all this very hard to admit to anyone else. I expressed the problem in my diary:

> *How do I stop myself repeating something that I've heard dead Lenny casually improvise on an album, fifteen years ago, in another context and on another continent? Dig?*

And more uncomfortable still:

> *What minority personality is unconsciously getting himself arrested on charges of obscenity, just to emulate Lenny?*

I did try and keep it in check though - whenever I looked into a mirror, I had a serious word with myself. 'You are Tony Allen. You are not Lenny Bruce.'

I set about re-jigging the act in the belief that I could write my way out of any problem. The 'Racism-Sexism' routine would be my opener. The Oval opening jokes were just plain silly and were only there because I wanted to kick off with something in familiar stand-up comedy mode. It wasn't necessary. I applied the same sort of writing criteria that a playwright or a novelist would use. If it neither describes character nor moves the plot along, then it's out. Hence everything in the act had to describe me or express my point of view. Everything in the act had to be serious and funny. Well, almost everything.

Born Again Christians

On the born-again Christian platforms at Speakers' Corner there's always been a lot of guilty uptight men confessing their sins on a weekly basis. These guys look capable of murder; listening to them in passing, that's what it sounds as if they are confessing to. On closer inspection, their sins are along the lines of 'taking the

name of the lord in vain', or some other innocuous misdemeanour. This act of confession then gives them the right to condemn the sins of the rest us. Sins of the flesh are their favourites. Sex before marriage, homosexuality and masturbation being the sort of thing that will have us all burning in Hell if we don't seek forgiveness and take sweet Jesus as our own personal saviour. The logic goes - Jesus loves everybody therefore everybody must love Jesus. I advocated cutting out the middleman.

It was against this background that I started celebrating sexuality and introducing Ladbroke Grove-style sexual politics to the populace. I was also finding time to take it a bit further and hold a sort of gentle cathartic confessional of my own with a handful of listeners.

Catharsis

It never looked like becoming a mass movement to usurp Christianity (double figures would have been nice), but I did, however, manage to generate a fair bit of meaty stand-up material talking honestly to people in small groups.

I was writing my potential stage act in a first person raconteur style, which I intended to be intimate, confessional and even shamanic. I fantasised about repeating the sort of honest personal confessions that were the stuff of the consciousness-raising groups I'd been involved in. I had originally been introduced to the process in a Rough Theatre workshop several years earlier - each actor in the group was given half a day to talk about themselves and their sexuality. The rest of the group sat there making encouraging noises and improving their listening skills. I'd had an unsuccessful marriage in my early twenties and those sessions were the first time I'd had any support to honestly explore it. It was an extraordinary experience talking through my stuff. It was also a revelation hearing about other people's emotional life, relationships and family stuff. I had subsequently joined a Men Against Sexism group and delved further.

Mutually sharing embarrassment and guilt was quietly liberating. It was comforting to know that I wasn't the only one. It seemed a whole generation of men and women with hapless uptight parents had fumbled their way through adolescence and blundered in and out of relationships and failed to deal with any of it, until they'd got some distance and a few good experiences behind them.

My immediate anarcha-feminist milieu was into various strands of self-help therapy; it was an important way of bonding. We joked that the process would scare off police infiltrators. Like many of my local tribe, relationships were something of an obsession and when we weren't experimenting or changing sexual partners, we were talking about it and quietly catharting in small groups. In my diary I referred to listening to someone else's catharsis as:

Experiencing a great chunk of awkward memory dislodge itself from inside my brain and have it come splashing down into my stream of consciousness.

That's what I wanted to do on stage to an audience - reproduce that sense of disclosure, but somehow to the accompaniment of healing laughter.

My own 'first sexual experience' involved a demeaning scenario of late adolescent ineptitude - a one-night stand on holiday - in which I more or less plead with a woman to have sex with me. She eventually agrees, more out of pity than anything else.

Within the sub-culture of sexual politics, there was a strain of strident feminists that had a shorthand language for what I had described - 'the petty rape syndrome'. 'Petty' because the woman had not

refused to have sex. 'No means No' not being an issue. I wasn't a rapist and I didn't believe 'all men were rapists', but it opened the discussion and I had written it up as a confessional piece drawing the similarities with rape. I dovetailed it into a more familiar 'sex-pol in the bedroom' example of reluctant sex and then revealed the disturbing connection. It was a bit guilt-trippy for men, but I turned it round at the end with a tilt at the feminists too and the way that this line of thinking left men with nothing but their guilt. The piece came at the end of a long reflective routine about sex with quickly diminishing laugh lines...

'Oh, go on. Oh why not? You did it with him.' Finally I made it with her. She said, 'Go on then, get it over with.' My first conquest? Hmm. Hardly.

I got into a similar situation a little later. You might connect with this...

'Oh look at the time. I've missed the last tube. Can I sleep here tonight?'

'Look, I'm very tired.'

'Oh nothing like that, I'll sleep anywhere. Anywhere. You name it. In the front room, out in the hall, in the garden. Oh, you've got a double bed.'

Within five minutes the conversation is going, 'Now, are you sure you really want to?' and she's going, 'Yeah, yeah!' But what she's really saying is, 'Go on then, get it over with.'

When I made that connection, I realised why some guys are fanatically against rapists. I mean, not just against rapists. We are all, or should be, against rapists. But fanatic with it :

'If I got hold of one of those rapists! I'd rip his bollocks off! What they do to women! Kill! Kill! Kill the bastards!'

Now if you hate something that much, there's something of you in there. Because you are what you hate.

Now, I have never been there, but I know that when some psycho breaks into the Nurses Home late at night, with a stocking over his head, and rapes some poor soul at knife point, I bet I know what she thinks, or she says or mutters under her breath, just before it happens. She says, 'Go on then, get it over with.'

When I made that connection, I thought, 'Shit man, you're a rapist! No, I'm not. Surely not? Shit, I am, I'm a rapist', and I'm wracked with guilt. I'm thinking, 'This is not good. I've got to do something about this. I'm a rapist, I'm a rapist.' I go along to the local Men Against Sexism Group to tell them. They already know. They're all sitting there going, 'I'm a rapist. I'm a rapist.' The whole lot of them, all going cathartic with it.

An argument with myself about whether or not I'm a rapist is one of the few potential laugh lines in several minutes. From there I could only make it ridiculous.

I know, we'll get some whips, with bits of glass and nails in the end, right, and we'll walk down Portobello Road and we'll whip each other, and tell everybody what we've done. Get it out in the open and start afresh. That's what we'll do.

We'll go on to Portobello Green and we'll have a big medieval flagellation scene, right there. Then everybody will gather round and watch - cos it's interesting, right. And maybe some of the Ladbroke Grove feminists will be there, and we will give them the whips, and then they can whip us. Then after, maybe we'll get chatting to them about stuff and maybe go down the pub for a drink and organise some sort of consciousness-raising group, and you never know, we might even get laid.

Psychologically Stripping

I was very careful where it was placed in the act. I had rightly cut it from the Oval script which was, after all, my first gig, but it was always my intention to make it one of the central themes of what I was doing. My closest friends, especially the women, were encouraging me to perform it. They assumed, of course, that I'd be doing it in a studio theatre situation.

I, however, believed that it was possible to win over any audience. All I had to do was be honest, start off warm and friendly and then get increasingly more personal and confidential. I called it psychologically stripping. I assumed that I could just pick up from where Lenny Bruce had left off. What I failed to grasp at the time (although I knew it in theory) was that Lenny had been 'free-forming' - improvising - and with fifteen years of stagecraft behind him. Throughout his act he was acutely aware of the audience's response and was continually revising what he was saying and how he was saying it. More pertinently, his audience had come with the expressed intention of seeing him. I was no more than an 'open spot'. I had done one gig with a tightly written script that only sounded spontaneous when I read it through to myself. I was in for a big shock.

In three weeks' time I had a little run of gigs with more in the diary. I was gloriously happy and living an idyllic low-budget communal lifestyle. But that was all about to change. Some of those closest to me were planning to leave London. I wanted to stay put and be a stand-up comedian. Life was going to be very different. Within twelve months I'd be re-housed in my own flat and earning a living as a nightclub comedian in Soho.

Audience Terror

Three weeks after the Oval, I turn up at the Carlton Bridge W9 on a Sunday lunchtime for my second gig organised by some friends. I got no closer than a hundred yards from the place, when I stopped in my tracks. I imagined the stage, the mic and a full house - lots of ordinary people making their own entertainment, chatting away to each other and getting drunk. Probably the only time they get to meet. That was my excuse, anyway. I just turned on the spot, walked away and pretended it had never happened. Three weeks, months, years of preparation squandered. A complete and sudden loss of faith - an internal collapse. It had happened before in Rough Theatre but then it was to do with drying - forgetting lines, and then I'd at least managed to get myself on stage before going blank and helpless. This time it was cowardly. 'Stage fright', 'audience terror' more like. I had a serious word with myself, which amounted to a threat. 'Do that again and there's no career in comedy'. I resolved always to go on stage and work through the fear and try and come out the other side.

Here and Now

My second gig proper was an interval slot supporting Here and Now at Queen Elizabeth College, Kensington. The large subdued audience, including a lot of young hippies, were sprawled around on the floor. The band

had democratically set up in front of the stage on the same level as the punters. I strolled on confidently and did the opening ten minutes of my act and got quite a few laughs, but I walked away feeling not like I'd stripped, but like I'd exposed myself. The audience got a night of throwback prog-rock with a masturbation confessional in the interval. In retrospect it sounds as if I might have been very much on message.

Oxford Poets

There was a peculiar pressure about my third gig, at a poetry club run by anarchists in Oxford. I knew that if I couldn't win over such an obviously simpatico audience, then it was really all over. By way of a warm up, I stood by the Grand Union Canal and rehearsed it perfectly all the way through. They had been surprisingly unreceptive to the opening acts - all poets - but when I went on, I grabbed them immediately. I performed the act that I'd prepared; it included the long sexual politics routine and all the updates I'd worked on. I wasn't even paid, but on the train coming home, I felt revitalised. In two weeks' time I had two gigs, both in agency talent shows, and I was resolved to try the same set and not to bottle out. Before that, however, I had to attend a gathering of the clans in Scotland.

The Torness Occupation: 5th to 7th May 1979

I don't know what I thought I was going to get up to at the demonstration at the Torness Nuclear Power Station. I hadn't been paying attention to the detail of what my immediate anarchist comrades were doing. I knew that both our houses and several other local groups were going and that some of us knew more than others. Which is just how it should be when you trust people and you're organising a revolution.

There was a campsite on the beach near the small town of Dunbar a couple of miles from the power station. The locals had apparently welcomed us and a local anti-nuke group had been working with our national group for some time. On the second day, several thousand anarchists marched out of the campsite and up on to the A1 heading for the power station, with a convoy of traffic building up behind. I was full of myself trying to lead the chanting and generally messing about, but when I started to encourage people to take up more of the road and stop the odd car nipping along the outside, I was taken to one side and told to behave myself. When I started arguing, one of our own group came over and said, 'Tony, we're here to occupy the Torness Nuclear Power Station, not a few yards of the A1.' So I shut up and paid attention.

The route took us alongside the high wire perimeter fence of the power station and as we approached the main gate on the horizon, we could see a knot of police vehicles and a reception committee. Then a huge lorry appeared and pulled up in front of us. Scores of people ran towards it and scores more ran purposefully over to the fence. The back of the lorry opened up and big hay bales were pushed out. Within minutes a giant staircase had been built up to the top of the perimeter fence and then down the other side. The main body of the march just stood there watching and applauding. It was a very satisfying thing to be one of thousands marching into a nuclear power station under the noses of the police. Once we were up and over, some of our group then turned into purposeful comrades and we all went running up to the main gate on the inside of the fence. When we got there the police were all outside having barricaded and padlocked the gates. Our job was to make sure it stayed that way. There was monstrous size building material everywhere and it didn't take long for twenty of us to manoeuvre some of it and completely block the gates. Some deal was negotiated with two security guards sat in the gatehouse and we went off to find everybody else.

The actual power station was being built closer to the sea inside a fenced compound. A handful of workers and eight police were surrounded by thousands of demonstrators. Various efforts were made at

breaching this final line of defence - everything from prayer to industrial secateurs. A chief inspector was running up and down inside, warning people against committing criminal damage to the fence. It was one of those eight-foot high jobs, which curled back on itself and had barbed wire along the top. Some heroes were trying to climb it, so I followed their lead. I managed to somehow sit myself on the top of it, held in place by the wire. Pretty soon the Chief Inspector came along to tick me off, and I started cheeking him and entertaining the troops. To my surprise, someone below started quietly feeding me information along the lines of, 'This must be Inspector Reid of Edinburgh Leith. The Dunbar police have refused to do the duty.' It was better than any of the material I could come up with; so I started to use it and for about half an hour I sat there doing the best gig of my career so far. Inspector Reid (it probably wasn't him but the name of his superior) was duly impressed and was joined by two more cops. I had only one intention - I wanted to make them laugh. As soon as I achieved this by just chatting to them and gently taking the piss, everything else started to happen as well. A youngster up on the fence close by suddenly fell off, but clung on to the overhang and there was a ping ping ping as the fence came away from the concrete post and he drifted down to earth in slow motion bringing the fence with him.

Hundreds of people now stand on the fallen fence faced with three unarmed and disarmed police-men. More and more people are gathering behind us and we are edging forward. Someone offers a cop a ciggie. He accepts it. Someone else steps up and offers him a light. His mate accepts a piece of flapjack. The Inspector says nothing and is almost tongue in cheek about his predicament. It is a short stand-off that can only end in laughter. As we shuffle towards him, I say, 'So Inspector Neptune, your move.' As we walk in, I offer to shake his hand but he refuses me. Instead, shaking his head, he says, 'You! You! I quite liked you.'

The actual occupation and disabling of the construction equipment, the meeting up with the second front coming in by sea and from the campsite along the beach, was all a bit of an anticlimax for me. I was feeling invincible, which, when you're a stand-up comedian, is a feeling 'worth staying with' because it won't last long.

Working Class Hero?

It was at Isleworth Working Men's Club, in front of a big family crowd, that I first got angry on stage. It wasn't really the fault of the audience that they happened to share my suburban West London prole background. I dragged so much baggage on that stage with me, so much smouldering hatred, and I dumped on them bigtime. I started off alright and got a few laughs, but when they started wandering in and out getting the drinks in, and generally behaving as they always did in their own club, I started to get unsettled. When they didn't laugh at my West London wanker jokes, I turned nasty - very nasty. I apparently shouted at them accusingly in a raucous local accent:

> *Whadda you people want eh? Howabout I do a coupla of anti-Irish jokes? A coupla of anti-mother-in-law jokes, coupla choruses of my my my Delilah and off. Eh? That suit yer? They told me this was a Working Men's Club. It's more like Margaret Thatcher's living room!*

I was out of control and raving at them. Then I started mixing apologies with the abuse. The sporadic nervous giggling stopped; they didn't even talk to each other.

There was just this big silent room full of unexpressed mixed emotions - disappointment, sympathy, embarrassment, fear, edgy excitement and awkward expectation - an unearthed wave of it, experienced as a deep communal sigh.

Scary! My first attempt to go through fear and out the other side amounted to reeling off a few

bravado 'dying' jokes that I'd picked up watching trad comedians in the East End. 'Strong smell embalming fluid in here.' 'Come on folks, keep it down to a gentle riot.' I didn't get any response, so I went back to insulting them and then I walked off in a huff. I knew that I had serious stuff to sort out and it was all about my rejected roots, not about comedy. It was a wonder I hadn't been thumped. My behaviour was really appalling, really unforgivable and really exciting. Although in many ways I regretted every word of it, I couldn't deny the fact that somewhere I was also feeling as high as a kite. I may not have improvised anything funny, but for a few brief flurries there was a fluency in all that rage.

The Nose

The Brewster's Arms in W10 was actually on my patch. It had very recently had the innards ripped out and been given a cheap Flintstones style makeover. It was now a cavernous one-bar affair with rough arches, no right angles and a basic stucco plaster job throughout. At the bar I met a mate, Paul O'Donnell, who had come to see me perform. He took one long look at the place, thought about it and said, 'This is like standing around inside someone's nose.' 'Is that joke yours?' I said. 'No,' he said, 'I just thought of it. It's yours.' It was the only genuine laugh I got all night. During my set somebody went and re-told it to all the people talking at the bar. Some of them even wandered through to see if I had any more, but I hadn't. By then I was experimenting with comedy suicide. The nose joke was purely incidental.

I knew it was going to be impossible from the off, so as an act of commitment to myself, I had decided to repeat more or less the same set that I'd done in Oxford. This included a lot of very esoteric sub-cultural material plus the sex-pol routine - I actually stood there saying, 'I'm a rapist! I'm a rapist!' I knew it would be met with incomprehension or hostility in a working class pub, but I did it. In truth I was ignored by the majority of the potential audience; of the thirty or so that were listening, half were my friends, squirming with embarrassment. Only Keith Allen found it amusing. He couldn't believe I was continuing with such a lost cause. I could hear him giggling in the silences at my expectation of laughter. I'd learned the sex-pol routine like an acting part. I was leaving unnecessary pauses for the laughs and for effect. It was a painting by numbers approach to stand-up comedy and must have been hilarious for Keith or anyone else with enough self-possession not to identify with my embarrassment.

I felt small and humiliated. I went round thanking people for coming and apologising to them. After I'd had a few days of reflection, I consoled myself with the fact that I'd been brave enough to go through with it. I'd had a rehearsal in gruelling conditions and if nothing else, I'd proved that I'd learned the script thoroughly. To cap it all, Peter had taped the bloody thing and somehow missed out the nose joke.

Barrow boys on Portobello Road still (20 years later) remind me of the nose joke and occasionally shout the punchline out at me as I walk by. Then they explain the set-up to whoever's listening. They only remember that joke, nothing else, just the fact that I'm a comedian and I once played the Brewsters. That joke is part of West London oral history and it is regularly and wrongly credited to me.

The Walcot Beano Club

The Walcot area of Bath, Somerset, was Ladbroke Grove in the sticks. The Beano Club was its community venue and I'd played it several times with Rough Theatre. It was packed with 130 expectant punters and I loosened up and rose to the occasion, delivering the full (now 30 minute) set, which was growing all the time with lots of new anti-nuke lines. I really needed the warm reception; experiencing the ups and downs of stand-up comedy was like imposing arbitrary manic depression on myself. Doing a gig would dictate my mood for

the following few days and of course I would never know the outcome in advance. Although a pattern was emerging which made gigs like the Walcot Beano pivotal - if I'd failed that audience, I could never really expect other than gloom and despondency performing to any audience other than my tribe. That dynamic was to change radically and at a club in Soho of all places.

Comedy Store Audition

At the end of May 1979 I did an audition for the Comedy Store. I was immediately fascinated by the venue and by the sub-culture surrounding it. It was like nothing I'd experienced before. Whatever happened at the audition, I definitely wanted to return and see the place when it was up and running. Yes, this was the belly of the beast. I also rather liked the idea of performing in a strip club, which is how Lenny Bruce had started his career.

The audition was perfunctory - I stood on stage with an audience of two - Peter Rosenguard and Ashley Roy. After they'd laughed a few times and looked at each other approvingly, I saw no sense in continuing. 'When do I start?' I said cockily. It had taken two minutes. I was busy the following weekend so I agreed to perform, for no money, on the Saturday and Sunday of June 9 -10th. I now had four gigs on those two dates.

The Buskers' Concert

In the meantime, I MC'd the Annual Buskers' Concert, organised by Stripey Richard at Meanwhile Gardens W10. A pleasant gig, a few hundred people sat on the grass slopes of the amphitheatre, a bill of street musicians playing to an audience who wanted to listen to their songs from beginning to end, rather than catch a snippet in passing. Good concept, never an easy gig. There was always so much going on and for brief spells early on, absolutely nothing going on except in the pub over the road. A couple of years previous, after dark, Heathcote Williams started to blow fire and was joined by Mr Joe - a seventy-year-old bohemian who rode around West London on a motorbike too big for him. Joe dribbled paraffin down his protective bin-liner and briefly set himself on fire. That, plus some other antics, had put a dusk curfew on the gig, which called for a tight running order.

As usual after a slack start, it just got busier. Among all the clones there were some really good acts and fine musicians, but fitting them all in, and remaining a democrat, wasn't easy. Every year Richard, who also stage-managed, would resolve 'Never again', and I agreed, but we carried on doing it for several more years.

I got a lot of feedback after the event; friends said I was like a controlling adult and my partner Karin (always very astute) called me 'Super-parent'. It was a 'good call' and it went right to the heart of my stage persona. I was all right when I was chatting seriously to an audience of equals with a script full of clever jokes, but when I was called on to improvise and deal with people behaving badly, it wasn't long before I was poking my finger in someone's direction. Wrong! There has to be part of a comedian's persona that is more extreme or larky than the silliest person in the audience. Finger-wagging that turns into bizarre OTT finger wagging is fine, but finger-wagging on its own is not funny.

Attitude Elusive

In my sporadic attempts at MCing benefits and socials, the tapes reveal me as a boss clown with the emphasis on the boss - a rather earnest uncle with occasional witty lines. I had the same persona when delivering prepared speeches in my frequent appearances at Speakers' Corner; even the bantering with hecklers was teacherly. The only respite comes when I cede authority to someone else - the police or a respected regular

- then I become larky and playful. It's the voice of Cyril Sleazby, my Rough Theatre alter-ego character, created as a naughty foil to an authoritarian boss clown. Sleazby is the voice of my fool. At the time I failed to recognise that the witty lines in my speeches and anecdotes were being set up by my serious self (boss clown) and capped by larky self (Sleazby). I didn't see it - I thought they were just witty lines.

I should have been using any available stage time (or plinth-time) to push my own serious orator to excess and see where it went, or perhaps continually interrupt it with lateral asides. The idea of knowingly inhabiting Sleazby at Speakers' Corner or as a way of writing a future stand-up act didn't seem an option. I believed that the subject matter would be trivialised if Sleazby got near it.

Rock Against Sexism

I felt like a gigging comedian when I set out for the first of four gigs in two days, Rock Against Sexism at Caxton Hall, Archway, supporting Belt and Braces - the rock band of the theatre group. I've never liked the room - more of a gymnasium than a performance space. I started off 'and now stand-up against sexism' and that's what I gave them. It was a left-wing crowd, not a regular rock audience, but neither was it my crowd. I was bit shaky in places but my material (including the sex-pol routine) won them over in the end and I was in pretty perky shape for the next gig on my list.

Midnight at The Comedy Store

I turned up early to the Comedy Store with my partner and one of her friends. The comedy room was above the strip venue, through a topless bar and up an exotic staircase. The room was already packed with expectant punters and I hardly recognised it as the place where I'd done the audition. I liked the room immediately. It held about a hundred with the audience sat at tables, except for the thirty seats in a raised flank stage-left, which was like a little gallery. There was a bar at the back and waitresses with clothes on were serving tables. Apart from the entrance being a tad close to the stage, it was perfect.

It was also the complete antithesis of everything we stood for. To be fair, the sort of striptease that Don Ward was presenting was very tasteful; nothing like the seedy stuff I'd seen recently in the East End in my efforts to track down comedians. The Nell Gwynne was a sort of saucy gentleman's club and everyone concerned referred to the strippers as exotic dancers and, by modern standards, that's exactly what they were.

To my surprise, we were settled at our own table, drinks were paid for, and I was asked when I wanted to perform. I didn't see much of what went on before my spot because of my preparation routine. I found a fire escape route and went out on the streets of Soho for a rehearsal of the act while walking around the block turning left and left again and hopefully ending up at square one. I got quite familiar with the streets of Soho over the next few years, occasionally finding myself in some murky cul-de-sac when I got lost in my material.

I was committed to doing all the squatting and sex-pol stuff as an antidote to the surroundings and to hell with the consequences. So that's what I did, in a spirited performance that apparently cut right across what had gone before. Nobody heckled me; they got into it straightaway with the 'sexism-racism' routine. I finished off my set with the line 'I'd like to thank the Mafia-I-mean-management without whom etc. Goodnight.' I'd done twenty minutes and stormed it. Rosenguard joined our table and ordered a bottle of champagne in a bucket of ice, which I found out afterwards was not an unusual reward for anyone getting a few laughs and avoiding the gong.

St Hilda's Club

The next day, Sunday lunchtime, I did St Hilda's Club - a community venue in the East End run by some anarchist mates. I was a tad wary at first because in many ways it was like a scaled-down version of the working class family crowd I'd lost my rag with in Isleworth. I did much the same set yet again and it worked like a dream. It was good to be reminded that there actually existed a working class radical audience that shared my worldview. Chris Bott who booked me said, 'It was like listening to an ace stoned rap.' I wrote that down immediately.

Comedy Store Again

At the Comedy Store I repeat the set for the fourth time, but this time I am sailing. I'm in the zone with it, chancing untried bits of material and getting laughs with fresh improvised lines. It was up there with 'my best gigs so far' and in that venue, with that material, and to that audience, I saw one of the straight comedians who had been on earlier and had gone down well, now laughing at my stuff. It hadn't been a one-off; I'd done four of them. The secret of comedy - stage time. I was high on adrenalin. As I walked off, I stopped momentarily in front of the gong hanging at the side of the stage and sneered at it dismissively. I'd wanted to do that from the moment I saw it hanging there. For an inanimate object, that fucking gong was to have a long memory.

The Early Days of The Comedy Store

Alexei Sayle

At the Comedy Store I'd had an immediate connection with Alexei Sayle and we became, not friends or comrades, but allies. We had a lot in common. Apart from both being working class, which he thought important, both of us had been in Brechtian-style theatre groups that had satirised and questioned the left. We were also both quietly out of our depth in alien territory.

Alexei had a big mean talent bursting to get out of the straight-jacket of what was ostensibly a character comedian - a working class scouse intellectual seething with repressed anger and class hatred. His only material was a handful of short exquisitely written first person anecdotes about artistic or political arguments he'd had in unlikely settings. They invariably concluded with someone being thumped or nutted over a minor philosophical difference of opinion. He would present these set-pieces alongside his MCing, which was far less stagey and very abrasive, full of disparaging comments 'addressing the now'. He was constantly going in and out of character and in the process of merging the two into the style of an eccentric comedian, which is what he soon started doing very successfully.

I invited him to share a lunchtime gig with me the following Sunday at the Factory in North Paddington, where we'd both previously met in passing when using the rehearsal space. That gig, with Helen Glavin, a singer songwriter, and Stripey Richard performing songs and poems, was the seed shit of what would become Alternative Cabaret in the months ahead. What I didn't tell Alexei was that all my gang would be there in force, so it was a bit of shock for him when he was gently heckled for being 'sexist' while talking about his 'girl' friend. It was his first introduction to an audience who would soon be screaming for him to do 'more' on a regular basis. I meanwhile performed a relaxed intimate rap - updating my friends on what I'd been doing.

It was another major advance for me and I needed it; the other two gigs that weekend at the Comedy Store were horrendous. I may have walked into the place like the conquering hero from last week, but I left with the refrain 'gong' as a new sub-plot in the vocabulary of my dreamtime.

Both Alexei and I knew that the one thing the Store needed was a large input of radical acts. One of the contributing factors to my two gonged-off gigs, was the fact that I was sandwiched between very slick traditional club comedians or at least audience spots aspiring to be like them. We needed more allies, so I now made it my business to get as many fringe theatre actors, buskers, speakers and musos down to the Comedy Store to at least see the show, if not persuade them to get up and do something.

Old Material

Back in 1978 I had been commissioned to write a play for May Day Theatre around the subject of sexual politics. The director, Christine Eccles, had rejected the draft scripts I'd submitted, including my scenario about an impotent blue comic who lives with a frigid stripper. We had agreed that I fulfil the contract by contributing scripts to a revue style sketch show.

I enlisted the assistance of an ex-writing partner, the very witty Ken Robinson, which led to the involvement of Ken's un-reconstructed but demonically witty housemate, Roger Selves. It took them one afternoon and more red wine than I'm used to, to produce the goods.

I only mention this because soon after I started doing the Comedy Store, the May Day show folded, so I went back to the script, salvaged one of the pieces and customised it for my stand-up act. It was a parody of a television programme that I personally had never seen, but the Blue Peter orgasm routine was a winner.

The only thing I've seen recently, that told kids anything about sex, was in The Daily Mirror - The Daily Mirror yeah - the monosyllabic progressives. Anyway, they had this rush of radicalism and printed the facts of life for kids in the editorial. This is verbatim from The Daily Mirror:

'What they should know about sex! - A man and a woman, who love each other, lie down naked, and the penis of the man slides in to the vagina of the woman.' That was it. Great innit? You can imagine it the following morning, can't you? Up and down the country, thousands of kids lying down naked.

'Hasn't slid in yet then, has it?'

'No, that's probably because you don't love me.'

'Oh yeah.'

Wrong place for the information! Where it should have gone out, was on the telly. On Blue Peter. Now I don't know who does Blue Peter now, probably some gushy middle class Wally I expect.

'And this week on Blue Peter, for all those of you fed up with mountain climbing, hang-gliding and collecting milk bottle tops, we're going to show you how to have an orgasm! Now, here's Chris and Leslie... and they've got the hots for each other. In a minute, they're going to leap onto this mattress. Rip off each other's clothing. Put bits of each other inside one another. Now I know it sounds complicated, but it's things like fingers and noses and bums and genitals... Then they're going to get a lot of frantic, frenzied friction together

and then they're going to have an 'orgasm'. But all that would take far too long, so here's a couple who had an orgasm before the programme started.

I wasn't sure whether I'd ever perform the sex-pol material at the Comedy Store again, but wherever I did next give it an outing, it would always follow the biggest laugh I could give them.

Hecklers

My intention was to use the stage time at the Store to experiment with new material and try and understand what I was doing. I began to enjoy mixing it with the audience and I quickly utilised a whole range of Speakers' Corner put-downs and started building little routines around them. It got silly in the end because people would heckle me just to hear my put-downs. At last the playful Sleazby was venturing on stage. I learned a simple rule for dealing with hecklers: for the first heckle, I'd respond with a censuring look or just a raised eyebrow. If they continued, I'd repeat what they said word for word in an exaggerated parody, giving me time to choose the most appropriate put-down.

My mate, Paul Durden, arch prankster and another witty bastard, started suggesting all sorts of material for me to customise, particularly heckler stoppers.

Listen pal, this is my fantasy to be up here expressing my silly self. What's your fantasy? To sit there in the dark, on your own, shouting out 'bollocks'?

No mate, for sentences you have to get all the words in the right order. I tell you what. Do you wanna have another go at it? I can't be any fairer than that. Can I?

Inappropriate Material

Some of my new material proved of limited appeal: describing a peace camp, a squat rock party or wittering on about the mores of communal living. 'Don't talk to me about toilet seats!' gave the enemies of my life-style the fuel to criticise it. It was a dilemma, although I knew that if it couldn't stand my critique, then it wasn't worth a jot anyway. It became a calculated risk, and I reckoned that if I owned and identified with the content of the material, I was also defending it. So part of my agenda became trying to find ways of making awkward esoteric material funny, not acceptable, but funny. I was beginning to realise that this was not a writing job - it was to do with my stage persona.

Uppity Hillmans

After a few weeks, I was paid a fiver a gig to be a sort of resident comic and a stand-in MC. The Sunday show started early and could sometimes be thinly attended, but on Saturday it started at midnight and was invariably packed, often still going strong well past 3am. While the gong was actually a useful filter, given the come-all-ye booking policy, playing the Store's drunk and uppity audience was sometimes a humbling experience for me and for most of the people we invited to perform. Many of them couldn't hack being regularly booed and gonged off, simply because they weren't very good at what they were doing. They hung around though, and in turn heckled the technically accomplished mainstream comics, and Alexei dutifully gonged them off too, usually because of their awful old jokes. The Comedy Store became an ideological battleground where not only racism and sexism but any victim-based material was publicly confronted.

The Liggers

What made it such a hoot, such a hangout, such a melting pot of extremes from seedy showbiz types to political rabble rousers was the policy of giving every act a guest ticket and two free drinks vouchers. No one questioned a comic's credentials or their whereabouts and often a bill of 20 might well have half a dozen acts go AWOL. And while Johnny and Jo-Anne punter paid their four quids, members of rock bands, theatre groups and their crews slipped in gratis and formed a sizeable minority likely to favour the innovators when howling for the gong. What had originally been conceived of as hospitality for the comedian and his partner was quickly turned into the convenient loophole for a Saturday night post-gig lig.

The Management

The Nell Gwynne Strip Club was owned by one-time club comic Don Ward whose modest striptease empire was already losing out to the advent of porn video. My understanding was that there was a falling off in trade and that Don didn't have the inclination to take the live-sex-on-stage option. When he was approached by one of his customers, Peter Rosenguard, a wealthy insurance salesman who wanted to run an American-style comedy club, Don saw a way of diversifying. Rosenguard had lifted The Comedy Store name from the American club. The concept of a gong show was an American TV idea, which had also started out as a live club format. For perhaps the first few months of the Comedy Store, most of the acts came in answer to classified ads in the weekly *Stage* or the London evening papers. The audience were mostly the sort of people who look for a late night drink after seeing or even performing in a West End show, plus a mish mash of old customers, bohemian Soho types, and mates of performers. Neither Ward nor Rosenguard knew of the existence of *Time Out* or its occasional theatre reviewer, Malcolm Hay, who was to champion the Alternatives and bring in the trendier and more radical crowd.

Jim Barclay and Andy De La Tour

For all the excitement and interest around the early days of the Store, there were very few of us would-be radical entertainers turning in consistently competent performances. Myself, Jim Barclay and a bit later Andy De La Tour were getting it right about half the time, which in my case, given the nature and turn-over of my material, was no mean feat. Jim Barclay, who I've always rated as a fine actor, had a lot of problems performing tightly-scripted comic characters. He got a lot of encouragement from his occasional storming bravura performances, often against a backdrop of 'male egos at five paces' style stand-off comedy. Like all of us, the good nights kept him going, but it was always going to be difficult for a character comedian with all that authenticity going on.

Andy De La Tour fared little better. He had a chatty raconteur approach, but he too was winged by snipers when he was too tight on script. All three of us were struggling to understand what we were doing and we gave each other valuable feedback and helped nurse each other's wounds. The content of my material started off as the politics of life-style; with Jim and Andy it was topical politics from the start. We influenced each other and cross-pollinated with the best of the rest.

Wines and Spirits

What is forgotten about the Comedy Store is that there was a clutch of regular talented performers who represented various strains of British comedy styles. There were also singer songwriters and piano players. Between them, they supplied a solid part of the bill every week. Few of them fitted in neatly to what was about to become fashionable, but without them the early Comedy Store would have had very thin line-ups. Most notable were...

Andrew Bailey

There are some approaches to comedy that you have to applaud simply for their sense of adventure. Andrew Bailey was (and still is) on the lunatic fringe and got it right enough times to make him a 'must-see-don't-miss' act among the other comedians. One of his more successful daft ideas (and he kept them coming) was a piece of raw anti-ventriloquism.

Some traditional vents have mastered their technique to the point where they can bring their dummy to life and get an audience to suspend its disbelief and go with the obvious deceit. As an audience watching such an act, there's always a moment when you have to remind yourself that it's not real. Andrew turned this on its head and managed to pull off a bizarre deconstruction of the process. He fumbled around with five or six of the most rudimentary puppets - they were just bits of wood with roughly carved noses and an eye drawn in marker pen. They were all individual characters with their own names - members of a regular men's consciousness-raising group that met once a week in front of the Comedy Store audience. He'd deliberately make the lamest efforts at ventriloquism - the audience couldn't for one second accept the theatre of it. He, meanwhile, would be lost in the character interactions, giving voice to serious discussions about male-bonding and oppressive sexuality. The whole nonsense of it would suddenly kick in when one bit of wood would threaten another bit of wood, then regret it immediately, but still be seething with anger. Then Andrew, totally engrossed as a sort of group facilitator, would have to intervene encouraging the lump of wood to 'stay with that feeling, George'. It was at that moment you laughed and realised that it was Andrew that had been hooked by the deceit of it.

Bob Flag

I was also a fan of Bob Flag when he got it right. A Milliganesque one-man band, Flag was a refugee from that trad jazz-based strain of comedy music ensemble, the mainstays of which were groups like Bob Kerr's Whoopee band, that toured round the country on their own circuit and occasionally surfaced in the British pop charts with ensembles like the Temperance Seven and the more contemporary Bonzo Dog Doo Dah Band. Flag attempted to recreate this style all on his own without the full complement of support or the tools for the job. A central part of his comedy was his abject failure to pull it off as a down-at-heel solo performer. The dishevelled Flag related brief anecdotes of life on the dole in between his efforts to reproduce the Glenn Miller big band sound with just a battered cymbal, a kazoo, and his own dogged determination.

Peter Wear

Peter Wear was a character comedian, clearly a professional performer, who stood out immediately from the lightly-raced new comedians and the audience open spotters. He had affiliations with the Festival of Fools and when he wasn't gigging elsewhere, he appeared regularly at the Store with his dependable Sam Spade private detective spoof, Frank Shovel. It was an extended monologue that showcased his considerable mime skills and inventive verbal flair. Although it was a bit old hat, it was a regular audience pleaser. Wear's early role model was important - he proved it was possible to be consistently well-received. As the new flexible authentic approach became the house style, and Wear's unchanging script became familiar, he was increasingly heckled. His character facade was eventually unable to deal with the interruptions and he stopped appearing, having better things to do.

Clive Anderson

I've never been a fan of Clive Anderson, but he braved the Store audience regularly and fared better than average. He was performing the raconteur style of stand-up that I was trying to master and had been in the Oxford Revue, but he was also versed in another performance tradition - he'd trained as a barrister. He had a knowing, self-deprecating stage persona that was capable of turning sharply defensive under fire from hecklers.

Lee Cornes

After experimenting with all sorts of clowning and traditional styles, Lee eventually discovered a low status self-deprecating stage persona that would disarm the rowdiest of audiences. In later years he would go on to MC the Store. For me, his greatest achievement was in the mid-eighties when he teamed up with the Oblivion boys - Steve Frost and Mark Arden - in the wildly experimental Wow Show.

Arnold Brown

Arnold was a slow starter, relying solely on his quirky one-liners and with little effort at presentation. Sometimes the poor sod would be gonged off after a minute or two. Then, very tentatively, he improved with each outing, until one night he really got it right. He found the attitude that summed up who he was perfectly. With a combination of gentle bravado and self deprecation, he surprised everyone and performed half an hour's worth of prepared one-liners and improvised banter to a packed room. A couple of weeks later, he did it again and from then on his status at the Store grew steadily.

Waiting in the Wings - Keith Allen

Meanwhile, back in Ladbroke Grove, Keith Allen invited me to the talent contest at the Brewsters Arms. Him and his post-punk group the Atoms had all managed to separately book themselves solo spots on the bill, and they dominated the line-up. It was a wild night and the crowd at the bar came in to see what all the fuss was about. In a phrase, he brought the house down. Keith deliberately contravened the house rules by staging a strip-tease and by playing loud rock music. Apart from Kevin, Keith's brother, singing an almost hymn-like version of 'My Way' in cod Welsh, all the memorable parts of the show were dominated by Keith. As well as vocals and vigorous percussion, he pranced around like a demonic Max Wall and topped the evening with his anti-showbiz anthem, 'Max Bygraves Killed My Mother', performed with such harsh tongue-in-cheek aggression that he seemed to be threatening the audience with physical violence. I became a fan instantly.

Comedy Store Part Two - Anger Management

On Sunday 8th July 1979, Keith Allen finally performed at the Comedy Store. He had taken his time about it, brooding around on the fringes, waiting on his moment. His first performance was electrifying and had an immediate effect on everyone concerned. His subsequent performances compounded the impact and within a few short weeks, stand-up comedy at the Store became angry, urgent, and authentic - it was no longer a game we were playing (even if it was a game that Keith was playing).

Keith Allen was a delinquent iconoclast and without his inspiring risk-taking example, the whole Alternative Comedy thing may well have collapsed due to ineptitude in the first twelve months. It was not unusual for Keith to walk on stage at the end of an already long night and deliver an hour's worth of blistering and outrageous comedy to a packed out, pissed-up, crazy cross-section of an audience. Keith Allen was a consummate clown, a fool, a storyteller and that very rare phenomenon - an actor who can perform stand-up. And it was astute and disturbing stand-up; his understanding and control over his emotional range was technically awesome and it equipped him to tackle a major local taboo - the deceit at the root of performance - and make it part of his comedy.

Only a congenital trickster could have done it. He spoke directly and honestly to the audience with an alert cockiness as if he had something important to say that shouldn't be missed. At the same time, he entertained them with mischievous asides and playful business. It was an ability to both challenge and disarm simultaneously.

He'd do it brilliantly - he'd fulfil their expectations of radical on the edge comedy and there would be a glow from the audience that said, 'Yes, this is the stuff we've come to see.' And from there, only a few minutes into his set, he'd acknowledge their complacency and then mercilessly rip it all apart. He'd escalate into a whole range of extreme emotions, displaying a dark surrealism which topped anything Alexei was attempting because it was juxtaposed with naked realism. Keith was capable of tearing away all the artifice of the performance and reminding them of the fact that he was just a bloke and this was real life and we were a hundred people in a room somewhere NOW! And there were to be no more jokes. No more laughter. Only Keith's mounting anger. Then, in a moment, he'd undercut all that and become the cheeky entertainer again.

It was the thread that ran through his act - suddenly cut the entertainment and establish a seemingly authentic consensus reality and then dismiss it as a joke, while ridiculing the audience for being so gullible as to have accepted it in the first place. In simple terms, it's a variation on the clown who stops clowning to offer the handshake that turns into a thumbed nose and wiggly fingers. It had never been done before with such apparent authenticity.

Keith Allen often scared audiences before turning on the charm and making them laugh aloud in sheer relief. The precedent of demolishing all the rules and then re-establishing them was an extraordinary hook, and it totally focussed their attention. Much of what he did on stage was delightful fooling and surreal story-telling about his exhaustive efforts to find the spark of revolution in the British countryside. There weren't many memorable lines in the text; it was all in the telling. He would inhabit characters to bursting point, the grotesqueness of the caricature sometimes making them barely capable of speech or action, and just when the audience were loving every nuance, he'd snap out of it and casually berate them,

'You love all that, don't you? Me busting a gut up here entertaining you?'

The word 'entertaining' enunciated and loaded with venom. He once started a set at the Store, after a full show with many of the regular acts doing good sets, by reviewing the evening so far - mentioning performers' names and scoffing or snarling an insult. I got a despairing sigh. But the hook was always there as a sub-text. The mood could always change. We were never quite clear where he would take us next. There was a palette full of attitude informing Keith's complex stage persona and it could all get curly.

A Doctor of Philosophy once told me that I was an existential comedian. I confessed that I'd nicked the idea off Keith Allen.

Keith's flair for experimentation was stretched further when he became a minor cult, with audiences turning up at the Store at two in the morning to see only him. For a short run, he pretended to be at another venue and would set up the mic off-stage and start his act talking over the PA. Sometimes he would appear in the nude and sometimes he'd sit and play piano, eschewing comedy for longer than anyone thought reasonable. Not everything he did was successful, but it was always compulsive.

Keith's act was the closest thing I've ever seen to the shamanic quality that I strived for and would continue to strive for. At its most successful, his act was intoxicating - a calculated confrontation with the whole concept of entertainment and not something that could be commodified. It was a situationist manifesto from the barricades - actualised.

The writer, Bea Cambell, was very disturbed by one of Keith's performances and told me that she felt as if he'd psychologically kidnapped the whole audience. 'Oh, the old psycho-kidnap routine. Yeah, that's a good one'. I didn't say that. At the time I'd only just started learning from Keith's example. He influenced everyone around him. Alexei Sayle upped his game instantly and he had the stage time to develop it - deepening his rage and extending his childlike extremes. He quickly became a master of hilarious bile-spouting eloquence.

Oscar McLennon, a wiry street-wise Scot, also took his clothes off and got angry, lyrical too. He took what he'd learned and tried it every which way with many flashes of brilliance, before finding a more appreciative audience elsewhere as a performance artist.

Rik Mayall's character, Rik the poet, was based in tour de force parodies of the attempted radicalism that was going on around him, and whether or not it was a conscious lampoon, it had all the resonance of one. Rik's snotty 'angwry' poet was a delight. He couldn't get angry, only very annoyed; his revolutionary poems and tirades were the ditties of an insufferably petulant new recruit who made hollow threats he was incapable of following through. Rik Mayall rarely put a foot wrong and his act was an elegant comedic response that complemented Keith's charismatic punk. The Keith clones queuing up to do open spots invariably sounded more like Rik's poet after they'd been given a drubbing by the Comedy Store crowd. Never copy the innovator.

I personally underwent a profound change of approach - my questions about attitude and stage persona were being answered. I knew instantly that writing good material never made a good performer. I was also aware that I had to learn from the new role model and avoid imitation. It was difficult to express anger without inwardly acknowledging a debt to Keith, but anger wasn't my concern; I wanted to get my larky clown on stage. I never seriously thought I could produce Keith's level of emotional range. I was just happy having a working example of what was possible in such close proximity; it was both intimidating and exciting.

The wild energy level, the experiments and the licence to intimidate became almost a house style: tables were overturned, glasses thrown, and a lot of free booze was splashed around. Pauline Melville, who rarely played the Store, epitomised the new authenticity when one night she pulled out a six-inch blade and waved it at the very first heckler who interrupted her act.

'Be warned man! I'm two days away from my period.'

A middle-aged Canadian journalist appeared in the nude several times, stood on one leg with his portable typewriter balanced on his knee, and documented all the heckles and abuse thrown at him. Peter O'Connor, an Irish novelist and obscurist, did a running commentary while playing tape-recordings of the Yorkshire Ripper's phone messages to the police. When American lesbian comedian Kate Phelps was heckled

with, 'Show us you tits,' the heckler was both booed and cheered until a feminist actress in the audience resolved the dispute. She pushed her way through and stood directly in front of the heckler's table blocking his view, and then bra-less, she ripped open her blouse and shamed him into silence. Conversely, when Annie Smith, a stripper from the club downstairs, made one of her several appearances as a comedian, instead of displaying fashionable male anger when heckled, she resorted to the basic unreconstructed female response and used her sexuality and showed her tits without any request being made.

We encouraged several of the strippers to try comedy, but only one - Jane Janovic managed to make the change of career. She became part of a double act with chunky camp street performer, Phil Herbert, under the title 'Hubert and Hilary Haddock's Fish and Fire Fantasy', which became a popular surreal novelty act that involved throwing fresh mackerel around the auditorium. At one point after throwing her arms in the air on a 'tarrah' cue, Hilary's left breast would pop out apparently unbeknownst to her, and for the next minute or so Hubert would be stage whispering, 'Yer tit's hanging out!' until she was alerted and adjusted her dress. It made me laugh every time. Phil Herbert also had a ludicrous solo act - Randolph the Remarkable - which involved him immersing his large stomach in a bowl of luke warm water and 'achieving suction'. It wasn't so much the stunt that was funny, it was his attitude - a demeaned serious h'actor reduced to performing a tawdry street busking stunt. It was highly original, very messy and absolute nonsense.

It was never clear from one week to the next what Ward and Rosenguard thought of all this. They definitely didn't understand it. Ward in particular couldn't comprehend why Keith Allen insisted on creating and then wrecking a perfect cabaret ambience. He thought such spoiling excesses somehow dishonoured Keith's talent. No sense of history or understanding of art, some people. Neither did Ward have any sympathy for the strippers who wanted to try comedy. He may have been hauling his own ass out of striptease, but he wasn't about to allow his strippers to do the same. Strippers were perfect casting as comedians - they already had a basic grasp of performance and a wealth of unexpressed things to say, not least their opinions about sexploitation. There were at least three strippers who showed early promise in their first few appearances as open spots, but Ward put a stop to it and nipped the potential careers of several female comedians in the bud. Imagine the ramifications if he'd had the nous to encourage, instead of deter them.

As for Peter Rosenguard, I've never understood the man. He's always been a mystery to me. He's never disagreed with a word I've said. Which is a higher hit rate than I've got. I once finished a conversation with him and discovered I'd bought an insurance policy.

Like all the rest of us, Ward and Rosenguard must have been shocked by the way the audience occasionally responded. Some nights the rowdy failure of two or three would-be 'wild men of comedy' early on, would ignite a combative mood in the audience that was virtually unplayable for the rest of the night. Often a hapless comedian could be ignored, stood on stage observing a shouting match between his supporters and opponents. Once Andy De La Tour's material about Northern Ireland caused a dispute in the audience, which ended up in a fistfight and the police being called.

Meanwhile, the other undeclared war between the trad comics and the new-wave comedians was being settled in this first eighteen-month period. The axis of top-drawer originals Keith Allen and Alexei Sayle was the bedrock which dictated the agenda. The steady flow of trad club acts and visiting American carpet-baggers that the management were quietly encouraging, were mostly gob-smacked by what they witnessed, which of course added to the growing word of mouth.

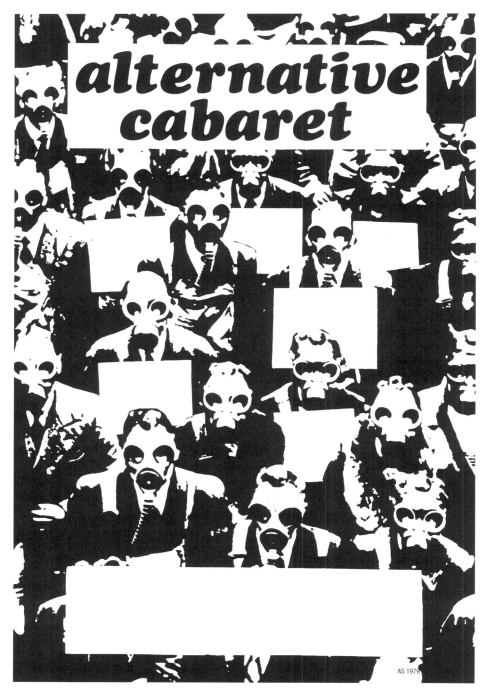

Alternative Cabaret - Original poster by Alexi Sayle 1979

Alternative Cabaret - Shouting, Swearing and Politics

'I came to Ladbroke Grove for the free love and squatting.'
Conversational and informative

*'I settled for sexual politics and a licensed derri.'**
Cheerfully resigned and vaguely exhausted

That was my opening line at the first Alternative Cabaret gig at the Elgin. It received a big laugh. A few nights later I tried it at the Comedy Store - hardly a titter. There was my dilemma and it has never quite left me - I'm at my best when I explore what I know about, and for that sort of stuff - there's only a limited audience. In the summer of 1979 I didn't need much encouraging to set up a regular local cabaret gig where I could play to a home crowd. It was a fantasy squatting the brains of a lot my friends and fellow performers.

The Elgin

Ladbroke Grove in 1979 was a run-down inner-city area. For the previous decade or more its shabby streets of four-storey Victorian terraces had suffered development blight and neglect; they were now heavily squatted and seething with community activism. The Lord Elgin, on the corner of Ladbroke Grove and Westbourne Park Road, was bigger than most local boozers and still had its original décor, grimy but intact - wooden panelling, grand ornamental wall mirrors and windows and dusty chandeliers dripping with glass. Apart from that, the place was a tip with very basic amenities. In the spacious back bar, a cheap single spotlight was angled at a small stage with an extension constructed out of beer crates. Occasionally local punk and squat-rock bands played benefits for housing campaigns; more frequent were spontaneous acoustic sessions by Irish musicians who never bothered with the stage, preferring to sit gathered round a table behind their drinks. The Elgin was the pub of preference for scruffy political extremists, bohemian arty types and those barred from everywhere else.

The Clientele

On various nights different political factions and campaign groups held their weekly meetings elsewhere, and had a drink after in the Elgin, where other wilder and less formal groups of people met, flirted, argued and socialised. On any given night in the Elgin, you could meet up with rock bands, feminist groups, plotting squatters and law centre workers.

 The bar manager, a sharp Irishman called Don, encouraged the business and discouraged only the bottom line drunks. It was open house so long as you could put up with being occasionally harassed by unofficial table poets, leftie newspaper sellers and anarcho-pampleteers.

 After a few ad-hoc meetings in June and July, various comedians and cabaret acts agreed to be in a talent pool under the label 'Alternative Cabaret'. The plot was to set up gigs in venues around London and then try and establish a few residencies. Alexei Sayle designed a poster and he and I both committed to playing a fortnightly gig at the Elgin Ladbroke Grove. I would help my mate Brian Montague and a few others to organise it.

 On August 15th Bob Flag organised the first-ever Alternative Cabaret at the Pindar of Wakefield

*Derri - derelict house

(now the Water Rats) on Kings Cross Road. Apart from the fact that I died on my arse (for reasons I never recorded), it was well-received. The following night, August 16th, our crew launched Alternative Cabaret at the Elgin, where I fared much better and the evening was a resounding success. Three weeks later Bob Flag announced that he was leaving Alternative Cabaret because, in his own words, 'I'm into shit, chaos and nonsense and you lot are into something tighter'. Much as I loved watching what he did, there was no argument.

Acts

The Alternative Cabaret pool comprised five comedians: myself, Alexei Sayle, Jim Barclay, Andy De La Tour and Pauline Melville, two folk duos - Gasmark and Hopkins (including Oscar McLennon), Chisholm and Stevens, and Combo Passé - a five piece Jazz / Salsa outfit led by Bill Davis. All of the comedians had been in Fringe theatre groups and were used to forming collectives to get gigs (and grants). What we were actually forming was an agency with its own regular showcases. We were all individual acts apart from my poetry and jazz efforts with the band; there was no attempt made at any ensemble approach. True to their word, the core members set up Alt-Cab gigs in pub venues and colleges all over London, and for the next 18 months we always had at least one a week, sometimes two or three.

From August 1979 until May 1980, every other Thursday night, the Elgin was the brand-leader Alternative Cabaret venue. The room held about a hundred and fifty and it was often packed. The deal was simple - the cabaret in the back bar was free, but we could busk it and Don would bung us £30. On a good night we'd get another £20-30 by passing the hat round. The acts were on a door-split, which meant we were starting to earn a little money. It was important to have a band or a couple of musicians on the bill, partly for the variety of it, but also because the musicians supplied the PA system. This suited me; I liked to finish off the evening with a chat in the other bar while the audience chilled to half an hour's funky jazz or high-energy diddly.

Apart from a couple of aborted attempts at a double act, Alexei and I alternated from gig to gig as MC and resident comedian. In practice, the other comedians on the firm played the gig intermittently because they didn't have the turnover of material. There were acts we co-opted when necessary - Helen Glavin, Arnold Brown, Peter Wear, and the actress Maggie Steed who had a memorable routine 'taking out her cap' (from its plastic container) and discussing sex and contraception. There was also a vague commitment from Keith Allen, who appeared once, delivering (for him) a fairly subdued performance. While Keith played the other Alt Cab venues fairly regularly, he seemed wary of the Elgin crowd; they weren't so easily hyped and they fragmented into factions like no audience I've ever experienced.

We also made up numbers by inviting improvers from the Store like Jerry Bernstein, and another quirky Jewish intellectual, Norman Bright. Ray Campbell, a gritty young Irish actor and squatting activist, put in several spirited performances, as did a fair sprinkling of other local talent - poets, singer-songwriters, buskers, and oddball-experimenters, plus the occasional comrades jumping on stage to announce meetings, actions or benefit gigs. On reflection, it could easily have been seen as my version of Bob Flag's shit, chaos and nonsense.

My Subject Matter

My intention was to take the opportunity and chat through my diary, and although this was sometimes impossible, given the cantankerous nature of the crowd, on most nights I managed it.

I would start off my set with bits of familiar material and then update the gang on my court appearances or other gigs I'd done and spin-off on relevant issues. Most of these sets were taped by Radio Pete from the West London Media Workshop, and the few that remain offer an intriguing insight into the intimacy of some of those nights. Sometimes people shouted, 'How's your mother?' because I'd described having an argument with her at the previous gig. I would oblige and update them, but I generally kept my immediate

personal relationships out of the act. My material was never overtly about topical politics. In those days and with that crowd, if there was any interest in Margaret Thatcher, it was because she was a woman. Beyond that, she was just the Prime Minister, much the same as the last one. Thatcher never became important until the Falklands war in 1982. My comedy was motivated by my life experiences and the politics of the campaigns I was involved in; it was always a first person thing. My experience had to be at the centre. I worked up material that explored my dilemmas around various social issues and I usually had a little snipe at the party lines being demanded by the straight left groups. Which, of course, was generally the audience's angle as well.

Friends, lovers, comrades, fellow creatures - greetings. Yeah, hello. It's gonna be a bit of a laid back set tonight... I'm on drugs. No. Valium. No, I woke up the other day all sort of tense, nervous and hyper. I was in a heavily 'yang' space. And I thought, You can't be like this - you'll be like everybody else. Mellow out, Tone, mellow out.

So I went along to my alternative paranormal anti-establishment acupuncturist osteopath homeopath herbalist natural healing practitioner... to get a pill. Or a meditative massage or a Tarot reading. So I went along yeah, and he wasn't there...he'd gone - gone off to India. And he hadn't left word how long he'd be gone for. Because he lives in the 'now'. I tried living in the now once myself. Gave it a two-week trial period, but it didn't work out.

Mate of mine went to India to find himself yeah? Lost himself completely - came back dressed in orange with a different name. What is it he's calling himself now? Yeah that's it - Dumb Cluck.

So anyway I had to go see the straight quack. Now I am a bit wary of the straight quack, cos the last time I was there, she gave me a thorough examination and then she said, 'I am sorry I can't find anything wrong with you. I can only put it down to too many drugs.' So I said, 'Fair enough, I'll come back when you're not so stoned.' So anyway I'm back there, and I wait in the waiting room for about three hours with thirty ill people and I finally get in to see her and I say:

'So Doc, I'm in a heavily yang space yeah? Lay some downers on me.'

'I beg your pardon.'

'Oh shit, sorry, yeah. Valium. Give me some Valium. Er please.'

'I'm sorry but I can't go dishing out drugs to the likes of you. I've got a professional code of ethics to adhere to.'

'Now I know different, see. Cos I've been in there when it's got a bit hectic, right, and she's moved her desk out of the surgery and into the waiting room. She's got her Mimms catalogue there, prescription pad and pen there, a long queue of punters and it's a bit like this...

'OK, which way do you wanna go, up or down?'

'Up, Doc. Up.'

'Scribble scribble - Benzedrine. Next!'

'OK, which way do you wanna go, up or down?'

'Down, Doc. Down.'

'Scribble scribble - Valium. Next!'

'OK, which way do you wanna go, up or down?'

'Oh er, up and down, Doc.'

'Hmm. Scribble scribble - Here's a letter for the psychiatrist. Next!'

So I told her, 'Listen,' I said, 'If I was some housewife off the housing estate, too hyper to get the hoovering together, you'd lay a load of Largactyl on me before I could say Glaxo Laboratories.'

Yes! That put the dialectical Doc Martin in. Didn't it, eh?

Whatever position I took on an issue, there was always an individual or group voicing a more extreme opinion - it was a given. Not everyone listened to the whole show; some women would only listen to the female acts. As a joke some men would only listen to the male acts. The antennae were out for the complexities of sexism and racism, but there was a strong situationist inclination that was far hotter on the cult of celebrity - some comrades were just as happy (or unhappy) sitting at the back discussing whether entertainment was necessary in the first place. I defended my position by saying that I was trying to learn how to tell the truth in public. Which was the truth and I said it in public. Or rather screamed it at them by way of self-justification:

Stand-up comedy can be more than just the scented aerosol in the shit-house of existence! I don't want my soul so bruised and scarred that I can no longer bare it in public! Sometimes up here, I feel like an avant-garde Butlins Redcoat.

And in more reflective mode, the following exploded moment:

I was walking up Portobello Road to the health food shop the other afternoon to get some yoghurt for me breakfast. And I've just got to that graffiti that says, 'Use your birth certificate as a credit card'. I'd just got there, and there's this voice behind me saying:

'Tony Allen. You bastard, you've sold out.' Not that. I don't want that at this time o' day. I'm not alert. Anything but that. All of a sudden there's this matrix of images. A litany of all my contradictions. Who could it be? I know. I know who it is. It's a militant vegetarian seen me coming out of the butchers. Oh yeah, they're getting very active. They are. Check Dewhurst's window - they've sprayed: 'Do not feed the animals. They are all dead.'

I used to be a vegetarian, me. I did and then I went into the health shop one afternoon and I said, 'Half a pound of Cheddar,' and she said,

'The rennet free or the usual?'

'Rennet? Rennet? What's rennet?'

'Oh, it's a stabilising agent. They put it in the cheese.'

'Oh yeah, and what exactly is it then?'

'I'm not sure, but they get it off a cow's stomach lining.'

'I see, and the cow would presumably be dead - course it would, yes. Tell

me, just how long you had the rennet-free in here?'

'Oh, it's the first time.'

Three years of going round as a vegetarian. 'Oh yeah. I'm much less aggressive now. Much more passive now, me, since I no longer have the karma of dead animals on my conscience. I'm in a very Yin space. Really, I am.' And then I find out about this - rennet. She said, 'What you going to have then?' I said, 'I'll have a pound of mince and a sirloin steak.'

'Tony Allen, you bastard, you've sold out.'

Or, it could be one of the London Squatters Union who's found out that I'm paying rent. I am, I am! But seriously, I admit to it. No see, there was fifty of us squatting activists, and what we did was, we got together in a housing co-operative and we confronted the authorities. We said, 'OK you! Listen up right! Every one of our members wants their own place, own front door, living room, bathroom, kitchen, all mod cons, the lot.' Do you know what they did? This is how they solve the housing problem, right. They gave us everything we asked for. Still two million homeless like, but they've bought off the militants. Who'd credit it?

I did a squatting benefit recently, a squat warming party it was. A bit down market, you know, the electricity was coming in from the squat over the road; there's a cable across the street, cars are going over it, it's crackling in the rain Zizzit Zizzit, corrugated iron curtains. The basement was so damp, if you run up the stairs too fast you got the bends. Boom boom!

'Tony Allen, you bastard, you've sold out.'

Erm? I know; it's a sexual politics fanatic - Stalinist tendency, found out I've been having a monogamous heterosexual relationship for the last eight months. I know that's another big one. I know what you're saying. 'It's bourgeois, it's nuclear family, couply-couply.' I know, I know. I did it. I admit it. It was love.' Yeah, that always quietens them, Tone, when you say that. It does. 'What's he saying? He's gonna start talking about love? Come on, let's go. We can get a carry-out, go home and watch telly.'

Love, yeah. I'll tell you - I do Speakers' Corner, yeah. I've got the 'full frontal anarchy platform: No government, No Property, No Law, and know yourself. Eat the rich, smash the state and love each other.' The weird reactions I get, when I talk about love.

'He's talking about love and he's not a Christian. This I've gotta see.' Or it's almost like, 'Tony, you can say fuck and cunt as much as you want, but if you use that L-word in front of my kids....', could happen.

'Tony Allen, you bastard, you've sold out.'

I don't know who it is. I turn round and there's this guy going, 'You, you bastard! You've sold out - you're part of the problem - part of the commodity / spectacle scenario. Your picture's in Time Out!

Which would lead into the stories about being arrested for saying cunt and prick at Speakers' Corner.

Sexist Shit

Some nights when I stood in front of the Elgin crowd, I looked out on a sea of faces that I recognised. I was all too aware of the state of heightened awareness, if not tension, around language. Women heckling macho rock bands with, 'Sexist shit!' was commonplace, almost a sport. It was often shouted at me, although mostly as a joke. So I played around with it from my perspective of a re-constructed male on the road to post-guilt liberation. This involved a lot of swearing and a lot of jokes about sex and language and resulted in some wacky exchanges.

> *'Heterosexist shit! You can't say that!'*
> *'But I've just said it! Where does that leave us?'*
> *'No dialogue with men!'*
> *'What's this then?'*
> *'No dialogue with men!'*
> *'Well that certainly sorted out the persons from the persons. Didn't it?'*

I didn't always win these encounters, but I was allowed to bounce back. As a local anarcha-feminist squatter, I was playing to my tribe. The audience was generally supportive. Often they would urge me on to take more risks, as a ruse to wind up another section of the crowd. They were never wholly judgmental; someone would always defend an underdog, especially if there was an argument begging. Ideological bickering could erupt from a heckle or from a heckle put-down. Mostly, protagonists were told to 'fuck off into the front bar'.

Swearing

There was a lot of low flying dodgy logic around swearing and use of language in the early days of Alternative Cabaret. My immediate tribe, particularly the women, were enthusiastically reclaiming the word 'cunt' and seizing every opportunity to use it. I was used to hearing the word across communal dinner tables in front of the children.

Arguing in court for my right at Speakers' Corner to use the word 'cunt' in its appropriate sexual context was clear, even if it was parlance only in a relatively small sub-culture of radical feminists and their male fellow travellers. Censuring its use as a heavy duty expletive was, in retrospect, both priggish and ludicrous, especially with the use of the word 'fuck' still being debated among the comrades. I was happily promoting the position that you didn't fuck someone, you fucked with them. While I could argue coherently that the reason that 'fuck' was an expletive was indicative of society's problems with sexuality, my own vocabulary was (and remains) peppered with fucks. It's a slovenly passé fashion in permanent retro that invokes pseudo masculinity, working class bravado and adolescent rebellion, and every generation re-enforces it and there's fuck all we can do about it. In a phrase, 'the fucking fucker's fucking fucked!' There, that's the answer; exhaust the cunt.

But those who heard every heckle of 'sexist shit' as the establishment of a rigid new orthodoxy, were missing the point. It was only the first knockings of a new orthodoxy - the arguing was part of it. To stand up in front of people as a comedian is to be privileged. It also opens a debate about everything said. Every audience contribution can be scrutinised and turned into comedy. A good comedian can get laughter from their own opinions, from begging to differ or from admitting they are wrong.

My selective swearing on stage at the Elgin was a political position within the new orthodoxy. At the Comedy Store there were no such subtleties and I veered from seeming a puritan on some nights, to a sufferer of Tourette's syndrome on others. When I swore at a showcase, I was called blue. I wasn't blue. I was

neither blue nor mainstream. What I was doing was an alternative to that.

Pauline Melville

Pauline Melville (who would later become a successful writer) had first performed her stand-up character, Edie, when she was part of the music / cabaret group Sadista Sisters a year or two earlier. By the time she appeared at the Elgin, she was exploring performing as herself. She also had a highly satirical impersonation of the Queen, 'Hello Objects…' that she'd update and present occasionally. But it was Edie that resonated - a busybody working-class housewife who had adopted a veneer of left-wing ideals. It was a pertinent image to place before political activists. She took one look at the place and the crowd and said:

> There's nothing bourgeois here, is there? Well, I wouldn't be here if there was.
> It's so radical here, I could faint…
> …My husband, Derek, wants us to have an open marriage. I wouldn't mind
> really, I just don't want him finding out. He said, 'Edie, monogamy is finished.'
> I said, 'Yes Derek.' He said, 'Monogamy is the reproductive core of Capitalism.'
> I said, 'Yes Derek.' He said, 'We have to smash the family!' I said, 'Smash your
> family - yes. Smash my family. No.'

Edie, clutching her big handbag, dressed in an overcoat and lumpy hat, cut a gloriously incongruous figure on stage, gossiping to the audience:

> We've got Marxists moved in next door to us. No, you see, there you go -
> making judgements before you know - they're very nice people. I went round
> to borrow a cup of sugar and they were having a house meeting. They were
> very pleasant about it. They put me fifth on the agenda.

Pauline's material worked best with a radical crowd where the irony was appreciated as a healthy critique and wasn't feeding prejudice against the left.

Alexei Sayle

Nearly all the comedians who played the Elgin indulged in sending up the left - it was so easy with a broad-church anarcho / squatter crowd. The hard left comrades in the audience either heckled as they walked out, or kept shtum, especially during Alexei Sayle's set. Alexei's surreal domestic vignettes of childhood in a family made dysfunctional by his parents both belonging to bitterly opposed ultra-leftist Maoist groups, was perfect material.

> 'Lex, ask that running dog lackey of imperialism - your mother - to pass the Ketchup.'

His constant arbitrary references to Eastern Block esoterica had immediate impact with an audience au fait with far left groups, all of which echoed the factions involved in the Russian Revolution. Alexei quickly became the main attraction and some of his performances were uproarious.

Watching Alexei at the Elgin and then at the Store, I was very aware how the same material was

interpreted in a completely different way by a different audience. At the Elgin, obscure references to Albanian tractor factories were greeted with the laughter of recognition at the audience's own political nerdiness. At the Store these same lines became funny foreigner gags made acceptable by the broad anti-Communist sentiment.

Whereas Alexei was to finally accept and embrace much of this, I began to take on more and more sub-cultural gigs which, although they kept me alert, would eventually anchor me to the cultural fringes that I'd always called home.

The Last Night
22nd May 1980, I MC'd the final night which featured Arnold Brown, Gasmask and Hopkins, and Andy De La Tour. It was memorable for Heathcote Williams reciting a piece of vitriolic satire stood beside a screen projection of Fluck and Law's latest latex Spitting Image of Home Secretary Willie Whitelaw. Ian Hinchliffe, wearing purple lipstick and dressed in post-punk decadence style, closed the night with a Grand Guignol parody of a rock group. For his last offering, he ate a glass but mistakenly selected the wrong sort (some glasses break into harmless chunks and some into vicious shards), and he started bleeding from the mouth. In his pique he threw the glass at the nearest chandelier and sent it crashing all over the audience with surprisingly little damage. The last night went wonky, but nothing could tarnish what had preceded it. Most of the time I loved playing the Elgin: it was a hoot. I performed and improvised material there that I couldn't ever contemplate performing at the Comedy Store. Twenty extraordinary gigs to an extraordinary audience.

Wrongly Attributed
I was once stopped by a regular Elgin punter in Portobello Road who said, 'I'll never forget your line the other night: 'The two biggest lies in this world are 'Your giro's in the post' and 'I promise not to come in your mouth' - brilliant.' It may have been funny, but it wasn't mine; it was Maggie Steed's. It wouldn't be the last time I'd hear material quoted and wrongly attributed to someone else on a bill. I quietly committed myself to the long-term goal of performing only with cabaret and music acts and to gradually extricate myself from the homogenous all-comedian line-ups.

Beyond the Rule of Three
Part of my process of coming to terms with Lenny Bruce's presence in everything I was doing, was to have a gentle pop at him - a public show of irreverence.

> *'Lenny Bruce finished his career, out of his head on drugs, hassled by the police and dying in a toilet... that's how I'm starting off.'*

When I came up with that little gem, I thought I must be a comic genius and that I'd be writing loads of similar stuff for the rest of my career. In truth, I've never bettered it.

For many years it never had a permanent place in the act. I kept it in reserve, using it in an emergency - whenever I was losing it on stage I'd muster up a bit of cockiness, give it authenticity and lay it on them. If I'd not used it by the end of my set, then I'd finish on it, as the capper for a short routine about a previous gig from hell at the Comedy Store.

Clearly the joke was more potent when I first wrote and performed it at the Store in seedy Soho. I referred in the act to having been arrested a few times for minor public order offences; also it was known that the police had been called to the club to stop a fight in the audience and were sniffing around for drugs on

other occasions. Although Lenny Bruce had been dead 13 years, the last time London had witnessed the sort of comedy some of us were attempting was when Lenny had played the Establishment Club in the early sixties only a few blocks away, and had subsequently been barred from the country to pre-empt any repeat of his US drugs and obscenity trials.

But apart from all this contextual stuff, the structure of the joke is pure elegance and contains a quantum packet of a punchline lighting the fuse on at least three laughs. Consequently the audience respond in waves of delayed laughter.

The structure starts off like a classic rule of three - establish, reinforce, surprise. But there's no spin on the third. The actual punchline - *that's how I'm starting off* - puts the spin on each of the three in retrospect. *Dying in a toilet* is an exact play on words; there's no approximation. *Dying in a toilet* is exactly how Lenny's life ended - sprawled on his bathroom floor, the result of a methadone overdose. *Dying* is comedian's slang for going down really badly and *toilet* is comedian's slang for a horrible little venue. The audience laugh and even while they're laughing, they run their minds back up the 3 and get a bonus 2 and 1 realising the comedian is *out of his head on drugs*, he's celebrating being *hassled by the police* and to top it all, with the arrogance of the upstart, he's intimating that he's already more decadent and dangerous than the God Lenny and, if you care to follow the perverse logic, a superior comedian.

What is actually being said is pure bravado: This is a shit venue, I'm on drugs, I'm in trouble with the law and as for Lenny Bruce - you ain't seen nothing yet.

I still use the joke to this day, but now I say *'...that's how I started off'*. Clearly it was more potent in its original context and in the days when I didn't have to explain who Lenny Bruce was.

Origins of Alternative?

When the Comedy Store book was published in 2001, the word 'Alternative' was used in a way that I'd previously accepted - like it had been there from the beginning. Apparently, top dodgy geezer Malcolm Hardee and myself are both said to be claiming the coinage. Just for the record, and so that nobody has to ask me again, I can't ever remember coining the phrase 'Alternative Comedian' or 'Alternative Comedy'. My understanding of it goes like this:

In the early summer of 1979, a bunch of my mates were editing the info-directory *Alternative London*, so that name was in my head when I booked our cabaret package to a promoter who'd rung up to book me solo. When he asked me for a name, I just plucked 'Alternative Cabaret' out of the air as a meantime ting. In the following weeks no one came up with anything better, more gigs started coming in, and the name stuck. 'Alternative Cabaret' soon becomes 'Alternative Comedy' when referring to a show that features a bunch of comedians. Yadder yadder yadder. But it takes a long time for such a cumbersome phrase to become parlance. It was probably either journalists or imitators who first used it.

In the autumn of 1980 the phrase 'Alternative Comedy' seems to have been used in the media as the generic term for a new approach to stand-up comedy. It caused more or less every comedian in the constituency to deny being an 'Alternative'. Alexei Sayle, who by then had left Alternative Cabaret, had a gag he spat out, 'I'm an Alternative Comedian - I'm not funny!'

I defiantly embraced the term around this time and there is a brief mention in my diary on 27th Nov 1980. But previous to that, I'd always thought of myself as a radical stand-up comedian with Alternative Cabaret, although I was occasionally toying with Cathartic Comedian. By 1985 I was calling myself a Post-Alternative Comedian.

Other Venues

There were two venues putting on full-scale new-wave professional cabaret shows in the summer of 1979; most notably the Albany Empire, Deptford. They booked Alternative Cabaret artistes separately on a regular basis. Right from the off, it became one of the top gigs to play. Keith Allen and Alexei Sayle played a string of extraordinary shows with the local Albany team directed by Jenny Harris, and with John Turner's resident band. There was also a similarly run show at the Half Moon Theatre in the East End with another resident team of actor-performers and musicians.

The Alt / Cab gigs that we set up around London were many and varied, including noisy college bars and inappropriate pub function rooms. The Green Man on the Euston Road was one of my favourites. Combo Passé had set it up so whenever I played the gig, I got to do at least one rant and jazz piece with the band. The jazz crowd liked my Elgin-style updating my diary approach and I developed several long reflective routines there which would prove to be wrong for other venues like the Comedy Store. I was gradually generating extremely diverse sets of material and it was only by trial and error that I painfully discovered their constituency.

Telly

In April 1980 I was approached by Paul Jackson from BBC telly who offered me a spot on a pilot he was trying to launch. Over the following months he approached a dozen other Comedy Store and Alternative Cabaret acts, plus some of the actors from the Half Moon. The result was two shows - Boom Boom! Out Go the Lights. I did both of them. 'Boom Boom! Out Go the Lights' was the signature tune sung by The Paul Jones Blues Band. It was an old blues song about a bloke beating up on his woman. A mate gave me the line 'What is this - Open Door for wife beaters?' *Open Door* being an access show of the time. Jackson, the producer, left the line in, but he cut out some of my best material, including a post-coital conversation:

> *'How was it for you?'*
> *'It was all right.'*
> *'Oh. Only all right?'*
> *'It was nice.'*
> *'Ah, you didn't, you didn't finish, did you?'*
> *'Doesn't matter.'*
> *'It matters to me.'*
> *'Listen, I said it doesn't matter.'*
> *'It matters to me. When I sleep with a woma...'*
> *'Listen, will you get your ego out of my cunt!'*

Interestingly, he even turned the sound down on the last line so that the studio audience wouldn't hear it. It was recorded in May and went out on the 14th October 1980. I didn't like seeing myself on telly. I did the follow-up show a few months later. I liked that even less. At the time I swaggered and said I wasn't doing any more telly because they censored my material, but the truth was that I knew I wasn't ready for such exposure. My performance was nervous and edgy, and behind my arrogant front I was out of my depth. I hadn't found a consistent performance style, I was still experimenting - at every other gig I was learning something fundamental. Television could wait until I trusted myself to relax in front of the cameras.

Sharon Landau

In June 1980 I took a two-month-break in West Berlin where I met chanteuse Sharon Landau who was based in Amsterdam and playing a festival at the Tempadrome Circus by the Wall. There were a hundred plus packed in the Kleine Tent cabaret venue. Sharon performed half-sat at a piano, fronting an acoustic band; her musicians knew her well, they had to - she was a volatile performer. In mid-song she'd turn thoughtful, jump up and come downstage to explain a lyric, indulge, get annoyed with herself, corpse with a twinkle in her eye, apologise, laugh, return to the piano, compose herself and start playing something different without further interruption for two or three numbers. Her songs were gritty, lyrical and interestingly awkward. It was an erratic and dimensional performance and I liked it a lot. I did two ten minute interval spots for her on the following nights, the second being intermittently drowned out by the massive reception being heaped on the rabble-rousing comic Jango Edwards in the Main arena. I hadn't performed for a month and wasn't on form but Sharon had seen enough. It was the beginning of a long professional relationship which, in later years, when she went solo and moved to London, would have us touring round Britain with occasional excursions to Europe.

Edinburgh Festival

Soon after I returned from Germany, Alexei and I split the bill for an Edinburgh Fringe Festival show - Late Night Alternative, produced by the Bristol Express. We were the only stand-up comedians on the 1980 Fringe. Ten nights at the Heriot Watt Theatre plus half a dozen more promo gigs at the Fringe Club and at Café Graffiti in Stockbridge, a counter culture venue that was right up my alley. I even had a spout at the local Speakers' Corner on the Mound in Prince's Street.

Provocateur and Raconteur

It was a good experience performing 25-30 mins every night - it was the first time I'd had such a focussed wodge of valuable stage time. I rang the changes and gave much of my oeuvre an outing, threading fresh and existing bits of material into routines, making them dense with laugh lines. Alexei, meanwhile, was also using the opportunity to experiment with his 'mod' character. It didn't appeal to everyone. To the casual punter, it must have seemed as if he was just gratuitously haranguing and swearing at the audience. I could see that he was really getting on a roll and forcing open some space to improvise - some of his barrages of aggression curled into brief hilarious bouts of childishness and surrealism - he was finding something really important. He was also getting regular walk-outs who never hung around to see me. So halfway through the duration, we agreed to stop alternating the running order and I would go on first every night. The gist of our reviews said we were very London-based; Alexei was 'ebullient' where I was 'reflective'. In the years that followed, the Edinburgh Fringe quickly became a sort of Stand-up Comedy trade fair. I continued to perform there regularly, treating it as an annual holiday and a great opportunity to work up the act. In the early nineties, the Edinburgh Fringe was saturated with highly promoted stand-up, the rents had soared on performance spaces and my usual low-key operation meant that I lost money. I've never been in a hurry to do it again.

Brown Rice and Bright Lights

Back in London, new clubs with distinctive characters opened in the autumn of 1980. There were several leftist enterprises that were easy to rabble-rouse but that I found difficult. I was booed off at one of them led by the heckle, 'Call yourself alternative?' Leftists generally don't like anti-work material and I had lots of it. I preferred the hippie gigs, particularly the Earth Exchange, a veggie café on Archway Road run by Kim Wells.

Here I was on the same bill as a Sanyassin comedian, a stand-up psychotherapist and a (Bob) Dylanesque poet.

At the other end of the market, in October 1980, Pete Richardson (one half of The Outer Limits with Nigel Planer) launched the Comic Strip round the corner from the Comedy Store at another strip venue - Raymond's Revue Bar. Rik Mayall and Ade Edmondson, Dawn French and Jennifer Saunders were the other two double acts that formed the show, with Alexei as compère. There was room for guests and I played the Comic Strip regularly, but I never liked the theatre setting, which suited the revue-sketch style of those who had set it up.

With Alexei's absence, I also started compèring the Store fairly regularly, especially when it went five nights a week for a spell. I'd never been a consistent performer, but eventually I became quite accomplished at spending three or more hours a night fucking about and arguing. I was also on £25-30 a stint.

Hindsight

In retrospect, the 1979 wave of performers can be seen as a belated grittier London response to what was already going on around the country and beyond. Dave Allen, who developed rapidly in the mid-seventies, had taken his lead from twenty years of American raconteur role models.

Two influential American performers who became giants of seventies stand-up comedy, Robin Williams and Richard Pryor, had both picked up on the legacy of Lenny Bruce's exploration of attitude and technique; they extended the form to embrace a range of physical business. Williams had heart and charisma plus the ability to play spontaneously with whatever was available. He could sample a vast range of characters from popular culture and cross-cut them with his own personal voices, flipping between them at will - a masterclass of contemporary high energy clowning. I was in Berlin and missed his first gig at the Store in the summer of 1980

Pryor had a harder edge. He too had an incredible gift for snapshot characterisation and inhabiting character, and could change the pace from outrageous flights of rapid street-talk to measured reflection and pointed statement. My recurring image of Pryor's filmed stage act, is of him in anthropomorphic mode, when with pure delicacy of physical expression, he inhabits a gazelle (or somesuch) at a watering hole, suddenly alerted to danger - it's one of those fleeting moments that elevates stand-up performance.

The raucous raconteur Billy Conolly was also well-established by the late seventies. He displayed a range of personal attitude and observational flair that was new to British comedy. To a lesser extent, so did his contemporary folkies, Mike Harding and Jasper Carrot. They were followed a little later by Victoria Wood and the spiky self-critic, John Dowie.

Alternative Ethos

William Cook, the *Guardian* comedy reviewer, has several times stated that Alternative Comedy's main contribution was its promotion of personal authorship, rather than its championing of anti-racist and anti-sexist material. We did both, of course, but I disagree that either was the main contribution. The two things were inter-connected; the first was already happening and the second was inevitable. Raconteur comedians (with personal material) were clearly in the ascendant well before 1979. It's more difficult to hide behind 'It's only a joke', when you are owning your material and when there's the relative freedom to talk about almost anything. Meanwhile, racism and sexism were being confronted throughout the arts. The trad comic's ethos of all sharing the same archive of offensive victim-based jokes was therefore in the process of being usurped anyway.

Provocative Comedy

There was one specific advance made in the comedy of 1979 that distinguished it from what had gone before. The range of a performer's available attitude was extended - it became possible to not only express an emotion like anger, but also to sustain it and make it part of the core stage persona. When this happens, the raconteur comedian has become the provocateur comedian. The audience are no longer engaged or charmed; they are challenged and confronted and if it works, they are hooked. Keith Allen pushed back the boundary; Alexei Sayle was almost there and followed, but few have even ventured onto the turf since.

My contribution, according to my friends, who kept feeding me material, was that I kept unloading fresh subject matter into the arena: sexndrugsnrocknroll, relationships, benefit gigs, work ethic, communal living, squatting, community policing, alternative medicine, summer festivals, life on the dole, vegetarianism, sexual politics, back-street psychotherapy, wacky religions, anti-nukes, stop the city, how to enjoy political demos, selling your soul to Mammon - all the stuff 'me and mine' were obsessed with.

The Texas Outlaw comedians, Sam Kinnison and Bill Hicks, had a raw version evolving in the States at the same time - their precedent was in rock music. It took five years for Jerry Sadowitz to emerge and a few more before Ian Cognito would get into his stride. There are few other notable examples of provocation in stand-up comedy apart from the appearance of a generic brash laddishness of style in the late eighties, its slick cynicism echoing the manner of Manning.

In the first eighteen months of being a comedian, I learned a lot from making mistakes in front of an audience. I'd go on learning and making a lot more mistakes. I tend to be opinionated, erratic and intellectually reckless; it makes me a very slow learner. It would be another eight years before I found the range and mix of attitude in performance that allowed me to produce the sort of work that I would be proud of and with the level of consistency that wasn't dispiriting.

Anarcho-Punk

In early 1981 I was purposefully taken to see Poison Girls, a mixed-gender anarcho-punk revivalist band. The lead singer, Vi Subversa, was a minor cult - a feisty, powerful middle-aged woman. Some of her songs were like raw Music Hall anthems with highly charged political lyrics and she growled them out to barmy armies of gobbing kids, twenty-five years her junior.

> *I'm not your fucking mother*
> *I'm not your fucking whore*
> *I'm not your little sister*
> *Or the girl next door*

Poisons had just broken their long association supporting punk extremists Crass, were about to headline a nationwide anti-nukes tour, and were looking for an innovative support act - a difficult job in difficult circumstances - but also, as it turned out, in excellent company. But that's another story.

Bill Hicks

Bill Hicks was an exact contemporary of Alternative Comedy. In 1979 he was a precocious teenager playing his first paid gigs as a solo stand-up at the Comedy Annexe in Houston, Texas. When he was 21, he is said to have got wildly drunk for the first time in his life and then staggered on stage to perform. Two hours later he was still there, lying on the floor hugging the mic and shouting the refrain, 'You fucking people…. You're the problem with this country.' It was a mantra that would inform much of his comedy for the next ten years. He continued the ranting and the drinking and started experimenting with a range of drugs - tobacco was the one that finally did for him. By Feb 1994 he was dead from pancreatic cancer aged 32.

Hicks was Lenny Bruce on rock music. Where Lenny was trying to blow like Miles Davis or Charlie Parker, Hicks was going more for the style of Jimi Hendrix playing the star spangled banner at Woodstock. Like Lenny Bruce, Hicks was not anti-American; he just wanted America to live up to its promise. He was the bright suburban kid who sees the lie. In Bill's version of the American dream, there's love, creativity, endless magic mushrooms and information beamed down from UFOs, but first everyone and he means EVERYONE has to take responsibility and be vigilant lest the corporate cocksuckers of the government, the media reptiles, and the Christian bigots turn the people into morons.

Where Lenny engaged and intrigued his audience, then disturbed their complacency by sharing his lateral insights, Bill got his crowd on the back foot from the moment he walked on stage. He insulted them, confronted them with his emphatically held opinions and blamed them for having none of their own.

What made Bill Hicks such a compelling performer was this ability to get the audience bristling, to deliberately unsettle them, and from there proceed to make them laugh. The particular nature of that tension and the quality of the focus that it creates, is unique to live stand-up comedy and Bill, like Keith Allen a few years before him, explored it thoroughly.

Confrontational and Challenging
With his audience already on the defensive, Bill Hicks's all-important curl of comic attitude exists in the intensification of the 'fiery rant' mode and in the relentless sequence and unashamed deepening of the passion.

I want my children to listen to musicians who fucking rocked.
Uncompromising, passionate and opinionated

I don't care if they died in puddles of their own vomit.
Dismissive, undeterred and sneering

I want someone who plays from his fucking heart.
Demanding righteous and emphatic

'Mommy, mommy, the man that Bill told me to listen to has a blood bubble on his nose!'
Almost affectionate caricature of childhood innocence observing harsh reality

'Shut up and listen to him play!'
Blunt threatening and authoritarian.

Maybe he was extending material worked-up at the previous gig, or perhaps we're hearing a repeat of last night's session of screaming at MTV in the hotel bedroom. But it sounds spontaneous and Bill is always in control of his excesses and aware that the performance still needs to be textural. His flair for pulling it round after a wild tangent was part of his style - quipping asides about his own motives, 'I haven't got laid for three months'. Or interrupting himself, often with the voice of the most fragile or embarrassed audience member, 'Bill's really mad at us now', he added ironic light relief to his angry ranting.

Bill Hicks was at his best in this mode, particularly when pushing a provocative, even dubious or impractical idea to its limits and upping the ante with each push. Then trying it from a completely fresh angle; maybe characterising the opposition and giving them a voice for a few first person shots, just to see if they can find a punchline to the routine. Sometimes he accepts he's wrong and considers the bigger truth of it. His defence of his right to smoke anywhere he pleased led him to imagine himself dead. In a similar routine he is wheezing and pathetic and cornered by psychotic anti-smokers (over half the audience) who kick the shit out of him and kill him. It's the closest he ever got to self-deprecation.

Bill Hicks was a professional stand-up before he was an adult. So perhaps it should be no surprise that there was very little personal reflection in his work. He expressed passion and humour through his opinions and kept a part of himself to himself.

Sometimes his choice of subject matter didn't warrant the passion. No matter how funny the embellishments or accomplished the technique, moaning about problems with hotel staff is just another way of saying, 'You can't get good servants these days.' But his lapses were far outweighed by his successful experiments, some of which took diversions that must have surprised even Bill when they first came pouring out.

In one opening routine he commences by completely eschewing comedy and opting to go straight into a lyrical riff about starting a new religion. After the first few nervous murmurs in the audience, he suddenly checks himself:

> *There will be dick jokes coming along very soon folks. I know I was starting to lose you there - Just digging a hole right here. Where did Bill go? He dug himself through the planet. I was through to China there for a minute.*
> From then on he's being heckled by a Chinese voice advising him to:

> *Do more dick jokes. You're losing them. They don't want to hear your political philosophy.*

Having got enough laughs to remind them he's capable of comedy, he gets straight back on the religious tack again.

Bill Hicks may have gone to China, or hell and back to state his case, but if the truth and the comedy demanded a different outcome, then he accepted it. His legendary routine that starts off,

> *'If anyone here is in advertising or marketing... kill yourself!'*

is a relentless pursuing of an idea where the voice of his adversary almost brings him to tears. It ends up with Bill conceding:

> *God, I'm just caught in a fucking web. How do you people live like that? And I bet you sleep like fucking babies at night, don't you? You do, don't ya? This is your world isn't it?'*

There's no punchline and Bill's on the losing side of the argument, but it's a brilliantly successful piece of comedy and a monument to his style.

Listening to his albums now, there is a marked difference when he eases up on the confrontational and challenging approach and lets the audience off the hook for a spell. While his performance is understandably less dimensional and less interesting, it also feels oddly old-fashioned. Bill the innovator was merely slipping back into the contemporary generic style of his day - and of the present day - contained, trivialising and media-obsessed - a comedy that wants comfortable boundaries and is increasingly ritualising the interaction with the audience and erecting its own convenient imaginary fourth wall.

Final Show

Bill Hicks walked on stage for the last time with an opening routine that had served him well. With very little irony, he got the hook into the crowd and let his attitude curl around the following:

> *How you folks doin'?...Y'all good?...You gotta bear with me...I'm very tired...ah...tired of travelling...ah...tired of doin' comedy...Ah...tired of staring out at your vacant faces looking back at me, waiting for me to fill your empty lives with humour you couldn't possibly think of yourself...Good evening... Been a while since I been here man, great to be back here wherever here is. I always love coming here...So bear with me as I plaster on a fake smile and plough through this shit one last time.*

'Comedians' by Trevor Griffiths

Trevor Griffiths' 1975 play *Comedians* is a confusing and complicated piece of work. Its failure to understand the subtleties of its subject matter and the flair with which it appears to offer solutions to the questions it poses, is typical of much of the woolly thinking leftist theatre of the seventies. Strangely *Comedians* continues to be revived, and its status as a challenging piece of theatre continues to grow. It is particularly popular with actors because it gives them the opportunity to perform an ersatz stand-up comedy routine from behind the safety of the fourth wall.

Act one opens with the final session of a stand-up comedy workshop in a 1970s Manchester Night School. Six wannabe club comedians prepare for a showcase-performance later that evening during an interval in the bingo at a local Working Men's Club. Their coach, retired headline variety comic Eddie Waters,

reminds them of what he's taught them.

The character of Eddie Waters is the first thing that's wrong with *Comedians*. Put simply, he knows very little about performing stand-up comedy. He is solely a mouthpiece for Griffiths' didactic arguments about the content of jokes. Rather than prepare his class and warm them up for the gig, the plot demands that Eddie give them something awkward to think about. He takes them through a workshop exercise where they have to ponder an uncomfortable part of their life, then talk about it and make it funny. It's an excellent exercise for an earlier session, but not one he should be introducing at this juncture in a workshop. It could well throw up a lot of heavy stuff, and of course it does. When one of his students does manage to squeeze some laughter from his pain, Eddie offers little in the way of encouragement or simple deconstruction that would be useful just before a gig. Instead, he makes the following ponderous and unhelpful statement:

> *It's not the jokes...it's what lies behind them. A joke that feeds on ignorance starves its audience. We have the choice. We can say something or we can say nothing. Not everything true is funny, and not everything funny is true.*
>
> *Most comics feed prejudice and fear, and blinkered vision, but the best ones illuminate them, make them clearer to see, easier to deal with.*

Discuss! Only if you are a drama student or a comedy nerd, but not if you're about to do a five minute agency audition in seventies Salford. There's more - Eddie follows this by giving his class something very real to worry about - the agent coming to check them out and possibly offer them work, is an old enemy and disapproves of Eddie and probably everything Eddie's been teaching them.

Having turned the final session into a tension-filled downer, Eddie makes no effort to sort it out. Griffiths has him go wandering off with a minor character in an unnecessary sub-plot.

Act two - show time. The comics respond to their dilemma in different ways: two of them change their acts to please the agency man. One remains true to Eddie. The double act split down the middle - best moment in the play and a brilliant idea. And Eddie's favourite student Gethin, a tearaway with talent (who has secretly decided to discard what he's worked out with Eddie), commences to express his class hatred with a vicious and ultimately clumsy piece of performance art.

In act three Gethin and Eddie meet back at the Night School. Gethin asks his mentor what he thought of his act. After a pause, Eddie begrudges, 'Brilliant!' 'But did you like it?' Gethin pushes. 'No, It was full of hate,' says Eddie. Although better advice would have been, 'Listen, if you want to do that sort of stuff, go down to London and join some poncey fringe theatre group. What we're doing here is stand-up comedy!' But he doesn't say that. He goes into a very gloomy monologue about being a soldier in Berlin at the end of World War Two and witnessing the concentration camps. But he doesn't make it funny. Instead, he confesses to getting an erection at the sight of all that human misery. 'Some part of me liked it,' he confesses. And that's why the man doesn't laugh anymore. Well, no wonder he's such a crap stand-up comedy tutor.

The problem of how to discuss political ideas in popular forms of entertainment had been obsessing his contemporaries in fringe theatre for several years. Griffiths places the discussion in the most pertinent, if unlikely of settings. In the character of Gethin, he creates a believable zeitgeist angry young man - talented, intelligent, sullen, mischievous and aggressive. Just the sort of volatile individual that would be fronting rock bands for the next five years. Griffiths clearly had his finger on the pulse - there were urban riots followed by punk rock less than a year later in 1976.

The director of the current (Nov 2001) revival, Dominic Dromgall, has suggested in *The Sunday Times* that '*Comedians* may well have been the inspiration for the outbreak of Alternative comedy four years later.' I can understand why he would say that - Gethin is not a million miles away from the real life comic iconoclast Keith Allen. By its very existence *Comedians* must have contributed something to events, but prophetic or not, it is hardly a masterpiece concerning stand-up comedy. When I first saw the play in 1976, I welcomed its right-on discussion about the content of contemporary stand-up. My initial reaction to Gethin's performance was similar to Eddie Waters - 'brilliant'- and I liked it too. I wasn't worried about the class hatred, but I was very disappointed that neither Griffiths nor his characters had got any further than the rest of us clueless radical thesps in finding a popular form to express it. The problem with Gethin's act is not that it has too much hate, but that the hate is not integrated and expressed as stand-up comedy. Much of it is performed behind a fourth wall. Gethin would have literally lost the plot if he'd been confronted by hecklers.

There are further flaws in *Comedians* that reveal Griffiths' lack of real insight into the nuts and bolts of his subject matter. His understanding of stand-up comedy is only in terms of its style and content, as a sort of sub-genre of acting limited to joke-telling techniques. He is only vaguely aware of its dynamics with the audience - apart from some ludicrous business with taped coughing - Eddie's workshop hardly acknowledges 'Addressing the Now', the agenda that defines stand-up comedy as opposed to 'acting'.

He is equally unclear about the importance of attitude, which is why (again, like the rest of us) he couldn't comprehend Gethin expressing that much focussed anger as a stand-up comedian. The motivation for Gethin to drop his original stand-up act, which promises to be a gritty example of his own passion plus Eddie's teaching, is a dramatic contrivance to hide the fact that Griffiths is out of his depth.

Theatrical Solution

This is then compounded by the confusing error of Gethin's choice of cabaret styles. Ironically the exotic theatrical solution Griffiths supplies can't even be contained within the theatrical style of the play. Up until the moment when Gethin decides to mutilate a couple of life-size dummies dressed as toffs in his stage act, *Comedians* has been a piece of social realism. Suddenly there's unacknowledged theatrical license being taken and the conventions of the first 90 minutes of the play are broken and extended to embrace something that is supposed to be happening around a small cabaret stage. This poses some niggly questions. Who was Gethin's stage manager? Just who humped the two life-size Aunt Sallies on stage, quietly and on cue? Who was on lights for those close-ups with the follow spot? Who cued in the taped violin? And where did the second violin come from? Gethin's act would have been impossible to stage in the context of that Working Men's Club, and it will always be the most complex part of staging a production of *Comedians*.

Three years later Keith Allen wouldn't require elaborate props to be wheeled on from the wings; he'd be displaying the sort of anger that disturbed his audience's complacency simply by tightening his facial muscles and spitting out the name of a hated politician or celebrity. Allen's cheeky trickster persona had a deeply rooted dark side anchored in references to being humiliated as a child by his father. He created awkward if hilarious comedy with these brief pathetic vignettes of childhood; his attitude embraced hatred and tenderness and it allowed him to vent his spleen and spit bile at anything and everything, often guilt-tripping and intimidating his audience. But unlike Gethin or anyone else, come to that, he had the comic genius and devilment to say, 'Only joking,' before repeating the cycle of intimidation and let-off over and over again. In late 1979 most of Keith Allen's experiments with anger and stand-up comedy were an awe-inspiring revelation and Griffiths can be forgiven for not having the foresight to suggest them in 1975. But he clearly knew

that the theatrical complexity of what he did offer was inappropriate and wouldn't work either on a club stage or in the social realist drama that he had written.

December 2001

Mr Social Control - September 1999

I've never been one for highbrow poetry. I still find T S Eliot's *The Waste Land* impenetrable - a string of very difficult crossword clues. Okay, there's passages of Wilfred Owen or W H Auden that appeal to me, but it wasn't until the late sixties when I read the Mersey Sound anthology of Patten, Henri and McGough, that I read anything that lingered in my untutored consciousness. Up until then I'd have settled for a good Dylan lyric any day. Heathcote Williams finally turned me round with his epic extravaganzas - *Sacred Elephant*, then later *Autogeddon* and *Whale Nation*, which were so faithfully reproduced by Roy Hutchins under the direction of John Dowie. While I loved them, they were long and best appreciated, as they were presented, in a studio theatre setting.

On the live benefit stage alongside bands, I toured with Mark Miwirdz (later comedian Mark Hurst), Seething Wells (later rock journo Steven Wells), Benjamin Zephaniah, and occasionally Attila the Stockbroker. They all had their moments but it wasn't until the mid-nineties that I encountered again the sort of Heathcote Williams style of lyrically organised pertinent information that had originally turned me on.

Mr Social Control, on form, channelling his arrogance, relishing his diction and rising to the occasion, is as good as it gets. I like my poets dedicated. I want them taking on the big stuff. I want them witty and weighty; I want clarity, elegance and demystification. I don't give a toss whether it rhymes or not, just so long as I can understand what they are on about and learn more from each listening. I want my poetry resonant. I prefer 'Soc' to any contemporary comedian. He is bursting with choice information - a performance poet on a serious political mission.

'Soc', pronounced 'Soash', was probably one of those really awkward kids at school, the sort of kid that teachers fear most - the oppositional swot. A too clever by half, lippy anarchist. He must have gone through hell.

He comes on stage as if he's about to blow the whistle on the whole of Western civilisation and he embarks on his thesis with the sort of relish you'd expect from a government official turned feral a month before the revolution. To my mind, the best Mr Social Control poem to date is his masterpiece 'Debt'. It is a history of money and explains, among other things, all that difficult stuff about exchange rates and the futures markets at the end of the news. It is a political revelation.

I once asked him if it was printed anywhere and he sent me a copy - it was totally different from the one I'd heard him perform, although still an excellent little document, but very different. When I went to see him next, he again performed 'Debt' and it was updated and different again. He improvises and improves the thing each time he performs it, incorporating the latest financial crash or war zone or his research of the most recent surrealism that we are asked to accept as the norm. See him and request it. Don't let him leave until he has performed it. He is decoding the zeitgeist.

Bespoken Word at The Manor, April 2002

I'm sitting in a smart comfortable downstairs lounge bar of a trendy restaurant; most of the fifty people in the packed audience couldn't afford to eat here. I don't even consider buying a drink - I'm sharing a secreted half-bottle of brandy and I'm here to observe. It's a little experimental Spoken Word club, less than a hundred yards from where I live. The core performers keep cropping up in different venues around the area. There's at least three weekly venues within walking distance. Bespoken Word has recently been bursting at the seams. What a crowd - half of them are familiar faces - black, white, young and old - a cross-section of local characters - fringe musicians, grizzled looking poets and spurious maverick artists. At least three of them could be played by Dennis Hopper. There is no stage, no lights and no mic, only ambience and expectation.

Dr Stewart, tall, slim and elegant, strolls purposefully into the central aisle between the tables; he has the studied grace of a denizen of the catwalk. He could be a male model or a late night dude television presenter. He addresses the room and immediately focuses attention. The clown behind the cool is quickly revealed as he introduces the evening with a self-deprecating innocent playfulness that disarms even the meanest punter. Dr Stewart's spontaneous rap is a constant medley of voices orchestrated into a fluent whole - he could fulfil with ease that old cliché about getting laughs from reading a random page of the telephone directory. Within a ten minute opening spiel he expresses delight, regret, curiosity, knowing, and overwhelming largesse and he has sampled West Indian street talk, Nigerian barrister, West London barrow boy, showbiz polari and the local post-mod penchant for emphasising quirky and archaic argot. He qualifies, apologises, underlines, laughs and prattles away on tangents before interrupting himself, mindful of his function as the MC.

After performing an animated set piece spoken word fragment to 'warm us up' (as if we needed it), he introduces the first guest. We welcome John, who sits on a barstool and reads a cracking little piece of self-observational prose that is greeted with nods, smiles and the laughter of recognition. After ten or more minutes, he leaves us wanting more. Then Simon, dressed in a kitsch woolly jumper with a CCCP motif across the chest, reads a long snarling and entertaining obituary for the Queen Mother who was buried earlier in the day. It's well received; it won't be the night's only expression of class hatred. As he closes the first half, Doc Stew is obliged to redress the balance and briefly juggles with the themes of life, death, royalty and celebrity, then opts to repeat a conversation with his wife as they watched the funeral earlier on telly. He sees the privilege and the wealth but then with empathy he acknowledges the obvious: 'Hey, what's happening people, somebody's mum's died. Innit - Hah!'

Doc Stew starts the second half by pulling off a complicated example of one of my stand-up comedy workshop exercises. 'Tell the story of a joke being told, describe the original circumstances, remember to tell the complete joke and to include the reactions of the original audience.' Everyone has been there and the most popular scenarios are the innocent kid blurting out an adult gag at a family gathering, or the faux pas of a prospective long-term partner, told at the first meeting with the 'in-laws'. The device encourages a comedic range of voices and it demands to be carefully structured. Doc Stew is unaware he's doing it; it's all spontaneous to him and he takes it a step further. He tells the story of a post-gig conversation in the bar at the Hackney Empire, about the audience reaction to a joke he had just told on stage. The black audience had surprised both of them by its over-the-top response to his portrayal of an African TV Weather forecaster. I am watching a performer discussing his process. He repeats the gist of the bar chat while all the time setting up the original joke. He considers what I perceive as the latent racism of the crowd and questions

THURS 16th SEPT 8.30PM Late bar

20th Anniversary
Alternative Cabaret

ELGIN FROG & FIRKIN Ladbroke Grove W11

Legendary fool

JONATHAN KAY

performance poet and demagogue

MR SOCIAL CONTROL

IAN COGNITO

The bad boy of Brit com

RORY MOTION

Renaissance man from Huddersfield

LUCY "piano" WILSON

stylish new singing star

DEN

MC: mixed-ability shaman

TONY ALLEN

NONIKA

stand up beyond the pale

Plus GUESTS

Adm **£6**

Advance tickets **£5** from the venue; also
Portobello Music All Saints rd & Alchemy 361 Portobello Rd

THURS
17th
AUG
Adm £6

21st Anniversary
Alternative
Cabaret

ELGIN
FROG &
FIRKIN
Ladbroke
Grove W11

DOORS: 8.30 SHOW: 9PM LATE BAR

MATT
"Mr sensitive"
HARVEY
the bard of Totnes

Ian Marchant &
Chas Ambler are
YOUR
DAD

RONNIE
RIGSBY
MC from Hell

DR STEWART
star of stage, screen & street

mixed-ability shaman
TONY ALLEN

still at large
SIR GIDEON
VEIN
(deceased)

LUCY
"piano"
WILSON

WACKY
AGGIE ELSDON
a laugh, a song, a demonic possession

THE GREATER LONDON
CEILIDH BAND
post-diddley cross-over

Plus: PRO-CELEBRITY, HARA
KIRI, KAMIKAZE, KARAOKE
ALSO LOSER-FRIENDLY FUN-STYLE RAFFLE

stylish new
singing star
DEN
REVVIT

GERVAIS
"BANJO BOY"
CURRIE

ADVANCE TICKETS £5 FROM VENUE

New Agenda promotes innovative performance with workshops, showcases and fund raising events

his own part in it. Then ties up all the threads and concludes with '... and the sun is over here and the rain is over here. So if you don't wanna get wet, get over here'. Stew believes it to be an innocent joke with an African accent just as cartoonised as any other accent he samples. Nevertheless, he has noted a criticism and now told the joke as a quotation with a question mark after it. He's achieved all this with far fewer words than I've used to explain it. Like much of his 'in-between-stuff', it was almost throwaway. A transcript would be indecipherable; a video would barely be a record and miss out mood and nuance. It was complex attitude and technique condensed for live intimate performance - you had to be there.

After an accapella gangster rapper with dextrous diction, and a bi-lingual Norwegian poet translating from a hand-held text message auto cue, Stew encourages us all to take risks by participating in his latest set piece called, 'Taking Risks'. He fiddles with his hi-tech pocket drum and bass kit, the backing music starts and we follow his lead by repeating words with added emphasis and providing a chorus of sound effects. It's an unsentimental Lord Buckley-style homily on living life to the full and he means every word of it. The applause at the end comes even heartier from those of us who heard him read a back-of-an-envelope version the previous week.

A friend has marked my card about the next act and I'm full of expectation when Stew coaxes Victoria into the performance space. She's young and petite and has an elfin quality about her; she stands and cautiously eyes up the room before strumming tentatively at a low-slung guitar. It's not exactly musical, but she smirks at our concern for such trifles. Her initial deference is now quickly discarded and replaced by an underlining coquettish confidence. She momentarily assumes a professional air and begins to sing her song about 'Lies'. There is a devilment about her and her words. 'Screw your expectations', she seems be saying as her attitude varies and intensifies - one moment light and delicate, the next bold and caustic. One song plus a fragment of another as an encore and she is gone, leaving the room entranced. Follow that? Yes, Stew has more guests for us - please welcome Yap.

Spoken Word has no obligation to follow stand-up comedy's dogma of generating continual amusement. As a new performance discipline, it must engage its audience. Beyond that, it is still marking out its territory. Yap is solid, Irish, and intense. He delivers his carefully chosen words knowing them to be loaded and ripe for interpretation - familiar news headlines and clichés of the globalised economy. He repeats them, tilting at their meaning, letting them hang in the air begging our scrutiny. His repetition escalates into brief streams of pertinent commentary performed with anger and raw intensity that rivets the attention and demands to be heard. He bellows in bewilderment, pleads for assistance with the massive tasks ahead and asks unanswerable lofty questions of the low ceiling. The performance is suddenly too big for the room and he falls to his knees containing his passion and internalising it. He thumps the floor with his fist and offers modest asides of explanation and we laugh. He shrieks and rolls into a foetal position, stands, quips, quotes, rages some more and then thanks us for listening and returns to his seat. Oh yes and thank you too. I'll be back. This little club gets better every time I come.

What Comes Next?

The Entertainer and the Artist

The entertainer gives the audience what it wants. The artist gives the audience what it didn't know it wanted.

Live Stand-up Comedy is about to go through one of its cyclical upheavals. The Ents to Arts ratio is off the dial. There is a growing audience for live intimate performance with serious content and no onus on making the audience laugh every few seconds. Spoken Word exponents and Performance Poets are learning the rudiments of stand-up comedy. They are already capable of wholly engaging their audience and many can banter and spin an anecdote to get a few laughs before they present their often weighty subject matter. Soon they will be bidding for stand-up comedy's audience.

Stand-up is seemingly in much better shape than it was at the end of the fifties when telly and rock and roll usurped Variety and it was abandoned and forced to re-invent itself in the Northern clubs. It is almost robust compared with the early 1980s when the Alternative wave replaced the club comics.

There is, however, an over-familiarity with the stand-up form - TV presenters, DJs and celebrity politicians all sound a lot like generic stand-up comedians. In live performance, few stand-ups offer much more than their media imitators. The relationship with the audience and the all-important business of 'addressing the now' has become ritualised; the real world outside of the comedy club has been reduced to another soap opera to be understood only in terms of tabloid headlines. I heard of no stand-up comedian with a considered response to Sept 11th. The big issues of the day - The Middle East, Genetic Engineering and the living hell that American globalisation inflicts on much of the planet's population are almost taboo subjects for most stand-up comedy. This is not a censorship problem but has more to do with a gradual narrowing of agendas. Stand-up comedy has become a form of escapism - comfortable and insulated.

Rob Newman and Mark Thomas, the only two British comedians to tackle heavy-duty political subject matter, perform sporadically and rarely in comedy clubs. It is pertinent that both of them performed under the Spoken Word banner in their 2001 live solo shows. A new performer wanting to follow their example and work up similar material would be much better placed in a Spoken Word or Performance Poetry context than in the McComics service industry environment of the London comedy clubs.

In the early days of what became Alternative Comedy, a small circuit of clubs opened, dedicated to serving the talent of the emerging new wave. The 1979 London Comedy Store, despite its tough audience and alien surroundings, was also a melting pot of ideas and approaches; anyone with something new to offer was always welcomed, at least by the inmates. More importantly they were encouraged to keep coming back - twice a week. Nowadays the mainstream clubs that were once hotbeds of an entertainment revolution, offer little or no encouragement to the urgent innovator.

Just me then

Whatever they call themselves, my guess is that the next new wave of potent performers will look and sound a lot like innovative stand-up comedians; they will be big on content and they will ooze Attitude.

Altercation

Artiste: Good evening. Welcome to 'Words Are Us'. As usual we've got a full-on bill for you tonight. With a truly amazing mix of styles - performance poetry, spoken word, improvised story telling, real time communication, and some other interesting stuff that literally defies classification. Hey! Anything goes. I'd like to start off with a little spoken word piece called...

Heckler: Get off! You're full of shit!

Artiste: Er... spoken word piece called...

Heckler: Oi! I said, 'You're full of shit!'

Artiste: Oh dear...

Heckler: 'Oh dear?' What sort of shit response is that?

Artiste: Look, there are some people who have come here to listen to the show. Not listen to you.

Heckler: But I'm part of the live inter-action. See the irony in it, for fuck's sake!

Artiste: What is your problem?

Heckler: I ain't got a problem. I just don't get out much.

Punter: Would you just shut up!

Heckler: No! What happens now? Does it all turn nasty?

Punter: I've not come here to listen to this sort of mindless banter.

Heckler: Oh no? What sort of mindless banter have you come here to listen to? Boom Boom!

Artiste: Oh dear...

Heckler: 'Oh dear?' We're back there again are we?

Artiste: Listen, this is not a comedy club!

Punter: Hear hear!

Heckler: Ah! Now they tell me. You'd 'ave saved a lot of trouble if you'd have admitted that in the first place?

Sorry, take it away maestro.

Artiste: Thank you. A little spoken word impro piece called, 'Let's eat the audience'.

Heckler: You really are full of shit! Aren't you? I was only joking at first.

THE EDGE OF STAND-UP COMEDY

Discovering my Clown - Tofu the Zany

Some of my most liberating moments in performance have not occurred on the cabaret stage as a comedian, but on the streets as a walkabout clown. Whether or not the incidental audience saw them as moments of high art, I have no way of knowing. All I know is that they hit the spot for me and left me with an understanding of the index of possibilities that is always close at hand - simply there to be experienced. My own personal cipher is a mute innocent post-punk august, called Tofu the Zany. He was ten years in the mocking.

Rough Edges

In the early seventies, when I had pretensions in the giddy world of anarchist street theatre, one of my favourite gigs was entertaining the troops on political demonstrations. Sometimes we'd get to perform one of our spoof agit-prop skits, but that done, we'd get down to the serious business of kick-starting the spontaneous larking around. I've had many a knees-up in the middle of Piccadilly or singsong in the offices of Kensington and Chelsea Town Hall. I actually got quite good at being noisy and adventurous, and I excelled at climbing on public monuments, being cheeky to the police and taking the piss out of the socialist left.

I didn't know it then, but I was assembling the sort of skills base that could get me into trouble. And just possibly get me out of it.

I'd always looked down on traditional clowning as a nostalgic parody of a dead form, a generic suit donned by failed actors to earn a meagre living doing kids entertainment. But I got put right on that.

Daniel Rovai

In February 1976 I got involved in a lively little campaign that built up around the case of Daniel Rovai, a French clown busted for busking on Portobello Road. Rovai was the genuine article - a red-nosed august with faultless mime technique, magic skills and a mischievous disarming persona. I learned a lot from Daniel just by hanging around with him and watching the economy of his responses to situations. It was all in his eyes - big, dark and round. He could puncture pomposity with a raised eyebrow and a sidelong glance. In his court appearances, the packed public gallery was more often being entertained by what he didn't do: minimal knowing looks and a studied no-comment composure was mugging technique at its most subtle and gently subversive. I would no longer dismiss clowns on first sight. Now I took notice.

The Rovai campaign introduced me to a sub-culture of Channel-hopping clowns and street performers who identified with the Amsterdam-based Festival of Fools which was starting to influence the London fringe theatre scene. 'Have you found your clown?' became a question that I was a long time in answering. I even started watching the bad actors in the Joey suits, hoping to pick up anything that might give me a lead.

Stripey Richard

About this time I became close friends and housemates with Stripey Richard, a colourful busker on the same mission. He looked like a barker for Barnum and Baily's Circus; six foot three plus platform heels, giant top hat, pink hair, garish three piece suits made out of striped curtain material, badges, rosettes, ornamental patches, and a been-around Spanish guitar where sat Monday, a facsimile doll of his clown. In our squat, it was Richard who was first out of bed of a morning. He had to earn his living - didn't believe in social security, never paid tax, no National Insurance number, never filled in a form; in fact, one of London's most obvious residents didn't exist on paper. I was intrigued by the stories he told and the world he inhabited - a sub-culture of drop-outs and street people scratching all manner of livings in and around Oxford Street and the West End.

Three mornings a week Richard helped self-organise busking pitch rotas at Marble Arch and Edgware Road subways, where he played his first session to the office workers. If he had a good day, he could be home when we were still sat finishing breakfast at mid-day. Richard always had a good day when he worked with a bottler. A bottler wasn't just someone standing around holding out the hat; a good bottler could treble a busker's takings for a half-share. Obviously a good and trustworthy bottler was hard to find. The word 'bottler' apparently comes from a time when they would imprison a fly in a bottle with their thumb, in one hand, and hold a tin mug for the takings in the other. A missing fly meant the bottler had been dipping in the takings. With that sort of relationship, I would imagine there must have been constant eyeballing going on as well.

Richard's sometime bottler was a young woman, a playful mute whiteface, called Jimini Moonlight, who was developing her own athletic roller skating skills. Jimi would shamelessly chase after wealthy-looking passers-by proffering the cap and harassing them with an ironic waif-like sentimentality. When Jimi wasn't around, I asked Richard to try me out in the job, and eventually he took me on.

I wasn't very good at asking people for money. At the time, I put it down to some unworked-out puritanical glitch that went with my anarchist politics, but the truth was that I didn't really have any idea of who

I was supposed to be. Every which way I played, it seemed brash, borrowed and awkward, informed no doubt by my most consistent street persona - co-ordinator of misbehaviour and rowdy chants at demos. I wasn't too happy about the constant rejection either; I tend to take that sort of thing very personally.

Roadshow

It wasn't until 1981, after I'd been doing stand-up for a couple years, and understood the value of self-deprecation, and learned how to do humility, that I tried bottling again. Stripey Richard updated me on some of the anti-busking propaganda that had been appearing in the media and how lots of people, particularly women, had spoken out in favour of buskers, saying that, in a tube station or an urban underpass, their friendly presence and live music represented safety. This was clearly no place for loud, threatening behaviour, which suited me perfectly - I wanted to try and do it mute and develop my clown, Tofu the Zany. By then I'd visited Berlin and Amsterdam and had watched a few whiteface street mimes and been deeply impressed by their lightness of touch and effortless assured presence; I was intrigued by this quality - it felt timeless

For the following few months, I experimented with make-up, and playfully strolled, strutted and strumpetted up and down the underpasses of Marble Arch, mimicking one passer-by for the entertainment of the next one, and exploring new ways to proffer my cap or introduce them to Richard's open guitar case. Passing trade is the perfect situation to work up bits of business - in less than a minute I would run the gamut from larky destitution to suppressed anticipation and then, depending on whether they gave money or not, respond with crumpled dejection or OTT gratitude by blowing them kisses. The more successful a routine or song, the more we would repeat it. There was one song in Richard's repertoire, 'Cry Me A River', where I just stood beside him motionless with a big glum tearful face. Sometimes people would actually stop and take in the tableau. Then, on the line 'and now you say you're sorry', I would break my long silence and reply in a plaintive falsetto, 'I'm sorry!' It never failed. A nice moment and a nice little earner. Soon I was gigging more than Richard and bottling for other buskers, but life on the streets is not easy and some of the unavoidable company makes it literally dangerous. Tofu, however, emerged unscathed from the experience - a delicate flower up for a laugh and without a trace of malice in his character.

Offal and Tofu

In the early eighties I teamed up with Danny Hignet (Jimi's younger brother) and formed a clown duo, Offal and Tofu. Ostensibly we were trying to earn some extra cash busking, while learning the rudiments of a circus skills double act that we might take round the summer festivals. Danny was an accomplished acrobat, juggler and unicyclist, short, strong and extremely agile. His clown, Offal, was full of devilment with a knowing smirk. I was his long-suffering side-kick: bottler, barker, support, catcher and lookout. If I couldn't tempt or inveigle a punter from the crowd to lie spread-eagled on the floor while Danny hopped over them on one wheel or skidded to a halt within an inch of their groin, then it was me that had to do it. The clown relationship that emerged echoed the reality of our respective talents, and although he was little more than twenty and I was nearly forty, Offal was boss-clown and Tofu held his coat. Offal did the dangerous (seemingly out of control) stunts and Tofu apologised for the excesses to the audience. I could still be naughty and anarchic, but it's difficult to top someone who can mount a horizontal unicycle in a split second or back-somersault from a standing position. Danny wore a very baggy light grey suit, whiteface, purple lips and black mascara - a Buster Keaton Pierrot. I wore black tights, penguin tailcoat with sergeant's stripes, kazoo pendant, whiteface with Grimaldi cheek triangles and a phallicky latex nose. We both wore boxing boots - best for climbing on each other's heads.

Portobello Precinct

One sunny spring day we had decided to make a second attempt at busking on Portobello Precinct. We'd been moved on earlier in the day, gone out up West, and were now back on home turf in the late afternoon. There was a small crowd watching us when the bureaucrat from the market trader's office, really annoyed that we'd turned up again, started shouting at us to move on. He had a phone in his hand and was threatening to call the police. We ignored him, partly because we were exploring being completely mute and didn't know how to respond apart from looking at each other and shrugging our shoulders with incomprehension. We were stripped for action and in the middle of an acrobalance shape when the two police officers arrived on foot.

I was underneath in support, so it was Danny's first move. When finally I stood up, Danny was dressed, had gathered our stuff together and was pirouetting around on his unicycle getting a few laughs. While I put on my jacket, the hapless cops made a few lame attempts to catch him, but he was pretending to be out of control and figure eighting around them earning little cheers from the crowd. One cop stood in front of me and started talking very seriously, but I didn't listen, I just cringed and pulled faces like some kid getting a ticking off from the headmaster. More laughs. They must have thought Danny was foreign because they addressed him through me (or maybe it was the authority of my sergeant's stripes). 'Tell him he's in trouble if he doesn't stop it now!' or words to that effect. I didn't tell Danny anything. I just copied what they were doing - only more so - wagging my finger at him, chasing him unsuccessfully, and blowing my kazoo and honking my horn. Now, not only does the crowd laugh, so does one of the cops. It's not easy for the police in a situation like this: first of all there's loads of witnesses, including kids, all enjoying themselves, and then there's the small matter of an out of control unicyclist who so far (without your intervention) has managed not to injure anyone. We milked it as much as we could and then the grimmer of the two cops spied my unicycle leaning against a wall. Before he could get to it, Danny was there and had rescued it, bringing it round to me with a flourish. I made a neat mount and we left, riding off unscathed and delighted with ourselves.

Police and Thieves

We rode away up Tavistock Road and turned right into All Saints Road, at that time a notorious drug-dealing street with regular busts. That's exactly what is ahead of us at the junction of Lancaster Road and All Saints. A Panda car is forming a road block, and cordons of police are containing buoyant crowds of people on three corners, all watching as police search three black youths assuming the position against the boarded-up Apollo Pub on the fourth corner. There is a hubbub of heckling and antagonism which dies to a silence when Danny and I cycle into the crossroads singing and kazooing the middle eight of 'Somewhere over the rainbow' as simulated police sirens: 'Some day-I'll wish-up on-a star-and wake-up where-the clouds-are, far-be, hind-me, nah-nah, nah-nah, nah-nah, nah-nah'. We jump off the bikes and brazenly join in the line-up, taking it in turns to assume the position and frisk each other with appropriate sound effects. Then, with our pockets hanging out, we mount the bikes and ride the 20 yards over to my flat. There is dumbfounded silence and then applause followed by general laughter from the crowd. And from the police there was a sense of disbelief that it was happening, could happen, and indeed, had ever happened.

Although we didn't set out to achieve it, many of my neighbours later thanked me, apparently for making a statement on behalf of the local community against the drug dealers and the police snatch squads. There was something else that went on that day for me. I felt connected to the ancient art of foolery, the very nuts and bolts of which was intuitive, concerned only with understanding how and when to take risks in public. This was 'licence'. Not one I could obtain at the post office, but licence universally recognised and there for the taking.

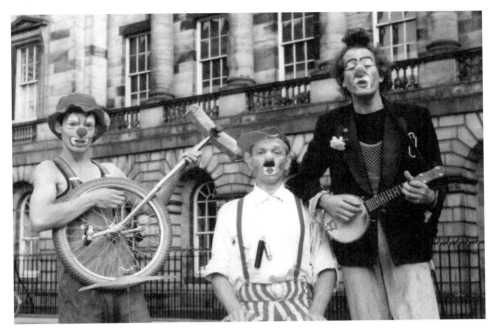

Danny Hignet, Gary Robbins, Tony Allen

Offal and Tofu eventually enlisted the aid of a percussionist, Moussaka (Gary Robbins, the drummer from Poison Girls), and later that year they larked around enjoying themselves at the Edinburgh Festival.

Ever since his discovery, Tofu has had an inclination (and then yearning) to wonder off on walkabout alone. While it's possible to share some extraordinary moments on the streets in sympatico company, the creative potential as a solo walkabout is simply 'other'. My first outings, sans sidekick, were at summer festivals as an eccentric litter picker, which I discovered provided a fine focus for meditation. There's also the likelihood of sporadic payment in the form of tobacco, dope, small change and other surprises. Plus the public service of finding people's valuables.

While buskers have to busk for no money until someone pays them, walkabouts have to walk about until someone gives them an attendance contract to appear at an open air event. That's what happened to me anyway. From the mid-eighties onwards, I started taking occasional anonymous walkabout gigs at civic centenaries and town fetes. For two years running, Tofu the Zany was resident clown in Rose Street during the Edinburgh Festival and Tony Allen did stand-up in cabaret venues in the evenings.

Costume and make-up

The costume gradually evolved into black tights and a raggedy long-sleeved black T shirt, black fingerless gloves, pink string vest and odd socks in lime green and pink, a black and white baseball cap worn reversed and a big pair of black and white tyre-soled boots with pink laces. The flesh-coloured elastic on the latex nose snapped with age, so I just tied it on with an obvious black ribbon. The face design simply entrenched itself - the older you get, the clearer the contours become that identify your clown face; I still don't like wearing

make-up - it always irritates my skin. It takes me twenty minutes of slap and pencil work and gives me chapped lips for the following day, but it's a small price to pay to amplify every facial nuance and perhaps gain admission to a parallel universe. There is a rule about make-up - once it's on, you're on. Which is fair enough really. I find it almost obscene to watch off-duty clowns chatting, smoking and having a beer in public. When I see it, I feel an overwhelming urge to report them, not to an obscure panel of Equity or the Arts Council, but to some mystical underworld order where they'd be totally intimidated and have to explain themselves and have their identity confiscated for an aeon. Whenever Tofu takes a break, I always go to a pub away from kids and even then I remove my nose, reverse my cap and hide under the peak, keeping myself to myself.

Walkabout clown has never been something that I've done for a living; I've always done it for the nourishment of my soul. But I had only ever done it in a situation where it was more or less expected - as part of an event or festival where the parameters were clear. Tofu knew no boundaries and consequently started straying from the carnival and the parade; he'd find the park gate with slack security and slip out unnoticed into the wider world where his closest relations were seemingly chained to busking pitches. Tofu wasn't interested in being paid; he had no such ulterior motive. Tofu just wanted to play.

Tofu the Zany's personality had developed considerably on solo outings. He'd become even more sensitive, alert, vulnerable, easily led, easily alarmed, naughty, curious and totally feckless. Tofu was (and still is) an aimless soul with about as much sense of direction as an empty beer can rolling around the top deck of a night bus. Tofu's short term memory is a matter of seconds, his attention can be snagged on all manner of diversions - sudden sound, bright colours, bursts of energy and absolutely anything at all that's out of the ordinary. Tofu once wandered alone up a back alley in Leeds City centre and spent God knows how long watching transfixed as a sweet wrapper and leaves danced, trapped in little twisters of wind.

There is an exquisite trick I love to play when approaching a kid being half dragged along, holding mum's hand and in turn dragging a coat or doll or something. I mirror them, apparently being dragged along myself, and dragging my unicycle behind me. Sometimes they look at me and immediately burst into tears and grab hold of mum's leg, but sometimes they make permanent eye contact which is only broken when we've crossed paths and have both fallen over; although they have a safety net and end up dangling from their mum's hand. There is a variation (my favourite) where they don't quite register me and only look round long after I've passed by. Sometimes, and it's a winner, I turn round at exactly the same time as they do, and then we both fall over.

Most people, faced with a scruffy mute clown in a city street, who is clearly not part of a municipal event, or an advertising campaign, or in any way soliciting for money, but is just somehow 'being there' motiveless, are likely to assume some form of wild eccentricity or madness.

There was a period in the late eighties, whenever I went on tour doing stand-up, I would also pack my unicycle and clown gear and then I'd go walkabout on my days off. In the Autumn of 1988 or 89, I was hitching South from a short run of stand-up gigs in the North East and I fetched up in Sheffield on a cancelled Friday. I found an empty city pub with a friendly landlord who, when he found out what I was up to, demanded that I put my make-up on, sat at the bar. We chatted throughout, but once my nose was on, I was on. I inhabited Tofu and didn't utter another word and went out to play.

After a fairly lazy hour of amusing myself and others in the town centre, I found myself standing opposite a busker mimicking his hunched banjo-playing style by strumming my unicycle (an old stand-by) and echoing the last two notes of each line on the kazoo. I was aware of laughter and noticed I had drawn a small crowd. I stopped playing and lowered my unicycle, stretched out of the hunch and extended my neck meer-cat-style, and stared back at the crowd and then mimicked them when they cracked-up giggling. Then, when a woman in high heels walked past with a dog on a lead, my wheel followed her and I tottered along behind on tiptoes - almost a copy.

Two of the crowd - a couple of young teenage girls, certainly no more than thirteen, but trying to look older, pursued me. After a few minutes, it was clear that they wanted to talk to me, which of course made me skittish and volatile. But after a bit, I let them corner me, albeit in a public place. One of them was very bossy. 'Hold your hand out.' I held my hand out tensely and screwed up my eyes as if I was about to be caned. 'He's going to buy it,' she said to the other girl. Then they both put some silver on my hand and proceeded to walk me down the street. But all the money fell off my open palm. I wasn't sure what they had in mind, so I thought I'd better introduce some Tofu logic to warn them that it might be a bit difficult. Eventually I was frog-marched to a nearby shopping precinct opposite the entrance of a large, busy newsagents. The money replaced on my palm, I was told to go in and buy a copy of *Playgirl*. I did a double-take and looked shocked, then grinned my agreement.

I was deeply touched by what was going on. These two very young women wanted to see a photograph of a male penis. It was so important to them that they'd got the money, dressed themselves up in their best clothes, and either got to the newsagent and couldn't muster the gumption to go through with it, or else they'd gone through with it and had been refused. Whatever! Their desperation is such that they've approached me. A complete stranger, a middle-aged man in clown make-up wearing garish oddments and leaning on a unicycle he can't ride properly. The job was now in the hands of an all-knowing innocent. This would be interesting - Tofu didn't do sex, but he knew what was supposed to be sexy; he had his own very clear ideas about beauty - he kept catching glimpses of it everywhere, and ugly was confined to negative feelings and intentions. Ugly was a vibe ting.

I gave the girls my unicycle, indicating that they must guard it with their lives, braced myself, took a deep breath, and purposefully marched the few yards to the shop entrance where I suddenly stopped and feigned an internal collapse, buckled at the knees, turning to face them with a look of sheer panic on my face. They in turn looked totally dismayed. I then smiled and pointed at them as if to say, 'Got you going there - only joking', and continued on my way.

When I marched into the big crowded shop, arm outstretched balancing a little pile of coins on my palm, I had no plan of action. No safety net. I was the tarot card fool stepping off the cliff into the abyss. I was unclear what I was doing, but as soon as I started doing it, I knew it was one of those things that I'd always wanted to do.

I step to the front of the queue at the cash register and present the money to the woman cashier.

There's a local hush. I describe a naked body with my hands, purse my lips and honk my horn twice. There's laughter. I follow her eye line to the other side of the shop to the proverbial top shelf. I beam my thanks, prance across and reach up, selecting *Playgirl*, *Playboy* , and several others. Soon I have them spread out on a broad, gently sloping table where people are browsing. With half the customers in the shop now watching me, I open one after another to view the contents, occasionally honking approval, while mugging shock and prurient interest. Eventually I open the *Playgirl* centrefold and hold it up high, honking to attract the attention of the two girls at the doorway. They cower in embarrassment, but hardly anyone sees them. *Playgirl* under my arm, I stroll out nonchalantly, leaving half a dozen centrefolds open on the table.

I met up with the girls out in the street; they were quite shocked. They snatched the magazine, returned my unicycle and ran away. A few minutes later, they waved from a distance and both shouted 'thank you'.

Jerry Sadowitz

Jerry Sadowitz (it's all in the name) was the first comedian since Keith Allen that actually thrilled me with his comedy. Sadowitz was appearing live very recently and can never be written off as a spent force even if the TV series was a mistake. His early stuff in the mid-eighties was full of glorious self-loathing, drawing a picture of an odd-looking Jewish kid growing up in Glasgow who escaped his persecuting peers by spending a lot of time in his bedroom teaching himself card tricks. His bilious delivery of old jokes, new jokes, bad jokes and some highly original material, was all underlined with a cartoon of compounded rage and his own ludicrous image of adulthood. I just loved every word that he uttered, or rather, spat. It felt akin to poetry. To diss yourself first and then diss a world of stereotypes, has never been a tenable position and it wasn't what Jerry Sadowitz did. Although his Ethiopian jokes and Asian shopkeeper jokes were harsh, they were deliberately so because they had to offend. Most of the time the target of his aggression was neither the racial minority nor the audience; it was pitched at the audience's expectation. It was that subtlety, and his failure sometimes to pull it off, that made the concept so dangerous and seem at times so dubious. You can never blame an offended audience for being unsophisticated, especially if you ask them to laugh not at the offence but at the delinquency behind the effort.

Sometimes this was achieved with clarity. The accuracy of intention is clear with his legendary line, 'Nelson Mandela. What a cunt!' Only the naughtiest kid in the world shouts that out. Especially in the mid-eighties with most comedians avoiding a discussion of sexist / racist language and when Mandela was still in prison and half the Student Union bars in the country bore his name. 'I dunno, you lend some people a fiver and you never see them again.' I watched him a lot and when he said the first line, although enough people always laughed as a spontaneous response to a taboo so accurately targeted, it was when they looked round at their mate's response that they laughed again, and at the point of the gag. It seemed as if it was deliberately aimed at people looking at their mates for a second opinion.

I became quite familiar with his work in the early nineties - and what made me laugh more or less continually was watching his frustration when the audience refused to be appalled by his stunts and his naked honesty. It wasn't the blow-up dolls, the nude books and his flaccid dick, or the mounting images of misery and sexual rejection, or even the hilarious nihilistic tirades against anything that anyone might hold dear. No. What

did it for me was his anger, outrage, and flashes of despondency at the fact that the bastards were still laughing.

At times Jerry could turn it all off and be quietly reflective, almost pathetic. He's been known to finish an encore in the most humble and authentic of voices:

> *'Yeah, just like to say thanks - it means a lot to me this - because I haven't got many friends. Thanks.'*

Glastonbury Notes 1998 - Ian Cognito

The Glastonbury crowd in the Main Cabaret tent looked on with a mixture of gob-smacked awe and genuine amusement as minor cult hero Ian Cognito stood before them, on the edge of the stage, chin out, cocky, and oozing belligerence. Dressed in khaki shirt and shorts, walking boots and desert cap, he looked like a yobbo scout master from a neighbouring campsite come to complain about the noise. He was inviting heckles, but no one dared.

It's a sad state of affairs, but at thirty-nine, Ian Cognito is still the current bad boy of British stand-up comedy. There's no big queue waiting to take over his job. In fact he's managed to go AWOL for over a year, return and re-launch himself and there've been no takers for the post in the interim.

Like Jerry Sadowitz before him, Cognito is loud, outrageous, full of bile and ever ready to smash taboos if only he could find any. What he does best, and what makes him worth watching at every opportunity, is that he takes risks. You're never quite sure when he'll spontaneously let go and give vent to a stream of abuse about anything that might piss him off. Greedy showbiz personalities appearing in telly adverts are his fave target but it's his honest rants against himself and the state of his life, which are most potent. I only wish he would fuck about a bit more and extend that twinkle in his eye and let us all in on the joke and for a little longer. Unlike Sadowitz, he's yet to discover his fool and consequently even his self-deprecation is laced with threatening leers and arrogance. He doesn't look like changing his style very much and I know from personal experience that he's virtually immune to constructive criticism.

One new innovation in the Cognito experience is the inclusion of an accompanist for a couple of musical numbers, but instead of getting comedic mileage out of the silent Andy on Keyboards, like Frankie Howerd did with his old lady at the piano - 'No, don't mock. Poor soul. Don't mock the afflicted. It could be your own'. Cognito introduces him as a mate and defends him as such without any hint of a double act. The musical interludes are strange fare altogether. Ye olde Elizabethan folk song about how Jeffrey Archer is corrupt, and a conspiracy ditty about Camilla Parker Bowles being responsible for the Diana crash, are both very odd and thankfully will soon be out of date and out of the act. Cognito's singing voice is the sort of 'fine tenor' that would have impressed my Dad, but I just find it old fashioned and quaint. There are those who find his whole act a bit early eighties and while I can see what they mean, I'll go on defending raw passion until it comes back into fashion.

Tony Green as Sir Gideon Vein

The Performance Club, King's Cross, 1998

At least one in five of Tony Green's gigs are disturbingly memorable. In the past 18 months, I've seen him at his best several times so I must have sat through a lot of interesting, and not so interesting experiments. What Green does on both a good and a bad night is to take risks. The most intriguing risks are with identity. Risks plural - one on top of another. He is ostensibly a character comedian - Sir Gideon Vein, an arrogant Victorian narcissist of indeterminate sexuality and artistic endeavour. But before the audience are wholly familiar with this level of the performance, another level is evident: Sir Gideon develops contemporary insights, on a whim he needs to prove he is capable of dealing with hecklers, even if none are present. He might heckle himself; he might start heckling the audience. The affected high-camp accent slips, revealing the frustrated performer beneath - Tony Green - a contemporary cockney, friendly and engaging, but no sooner has the audience begun to trust him, than the accent has thickened and a new eccentricity begun. He rages with bouts of bile and bitterness aimed at the entertainment biz and the acting profession. This ranting is eventually interrupted by a voice of reason - totally believable and level-headed. The authenticity doesn't last, a motif develops of over the top behaviour involving rampant swearing, sexual ambiguity and threatened gross-outs, followed by sincere apologies from a seemingly sane persona aware of, and above, the games being played.

But each new level of real communication, once established, can then seamlessly degenerate into demented rage or foppish affectation. The performer interrupts his creations, characters interrupt the performer, and the voice of a yobbo intermittently shouts, 'An-ar-chy!' Facades are dropped and redefined, levels of performance are dispensed with, everything is declared a joke only to be indulged in once again without warning; honest communication is betrayed, expectations confounded, and while the layers of deceit in the performance are clearly being examined, it is never that clear just who is in charge of the investigation. There's no playing safe. Once this act is up and running, it can go anywhere and it's usually off the rails. Often fascinating, always dangerous, and rarely boring.

Nowadays, in his current purple patch, there is no longer an issue about whether Green is capable of producing the goods - he clearly is, and can, and will. No, the only concern now is how long can he sustain it, and if he does manage to sustain it large and get on a roll, will he ever get off?

Glastonbury Notes 1998 - Rory Motion

Apart from performing during the main firework display, there's no good or bad time to play the Main Cabaret stage at Glastonbury. It all depends on who you're following and preceding, and how you mesh with their audiences; but a good agent can always sort out these logistics. This year there's an additional spanner in the works - the World Cup. Rory Motion is scheduled for 7.45 on Saturday evening, 15 minutes before the England v Columbia kick-off. Rory, of course, hasn't got an agent.

There's a rough and ready rock cabaret band on before him - they probably haven't got an agent

either (but for different reasons). The house lights are on and there's plenty of movement in the half-capacity audience - still over a thousand. A group of punters in front of me get up and leave when they discover that the World Cup Café is only a ten minute muddy trek away. The compère's a rabble-rouser, but to no effect.

Rory Motion is a Glastonbury regular, an antidote to the generic lad stand-up comics and one of my personal favourites. He's gentle, charming, intelligent and genuinely witty. His act is full of surprises - little gems like his Stanley Holloway parody - Albert and the Rave; a rock country version of Jerusalem, re-instating Bill Blake's original address to the children of the New Age, and numerous anecdotes which launch him into lyrical flights of language that have no equal on the Comedy circuit. At his best, he's a pure delight. At last year's Anarchist Bookfair Cabaret, he played to a packed Conway Hall with the audience laughing at every nuance.

Tonight, on a stage where he's previously triumphed, he struggles to get a response. If I wanted to be nerdy and pedantic, and I do, I'd say it was a big mistake to do an early joke which made him appear innocent of drug culture and then follow it with a string of sophisticated drug references. The audience were confused, bless 'em, and it took half the act to get them back. Not his best night, and probably his worst Glastonbury. Rory performs more often in the North of England, but sporadically turns up on bills in the South at folk festies, arts centres, poetry clubs and occasionally the London Comedy circuit. Don't miss him.

Golden Rules of Stand-up Comedy
Never do a gig on CS Gas 1998

The Green Futures field at the Glastonbury Festival is where the various eco-warrior groups and their supporters have their summer holiday. Many of them run stalls, cafés and bars; others are holding their annual general meetings. I tend to hang out in the Squall tent which is a shade decadent for Green Futures, but suits me - they serve straight tea with cow's milk and have a range of spirits. After a tea, flapjack and brandy for breakfast, I leave Squall and walk across the wet mud (the odd harsh shower has stopped it getting sticky) to Ecotrip.

The Reclaim the Streets debate and slide show is heaving. I've had a word with the organiser the previous day and scheduled myself in to have a rant immediately after. I plan to give my Millennium Bug - End is Nigh - diatribe an airing. I spend some time standing at the back by the entrance sussing out who the audience are as they come in. 'What is it man?' 'Reclaim the streets.' 'What's that?' Despite their appearance, a lot of these people are tourists. I decide to have a look at the crowd and the room from the vantage point of sitting pedaling on the bikes. I always like to make my contribution to these Heath Robinson energy-powering contraptions. In previous years as MC in the Green Dragon Tent, it's been part of my job to encourage people to take a turn at pedaling and encourage the rest of the punters to offer the pedalers whatever goodies are going round. When the festie is over and the power is cut, the self-sufficient Green Fields carry on for a day or two longer until the water gets turned off.

An hour in and the RTS slide show is over and we've started discussing globalisation, when someone runs in and shouts that the police are arresting people for spliff outside. The speaker on mic explains his understanding of what's going on and half the audience stands up and rushes out. I dismount the bike and follow them. Outside, police are getting out of a white Land Rover alongside some other police attempting to

arrest someone. It's already reached the pushing and shoving stage and there's 20 odd people in a knot arguing with the law. I assume everyone will either join the throng behind the vehicle, delaying the arrest and stopping the doors being opened, or stand in front of the vehicle, so it can't go anywhere. This doesn't happen - the activist / tourist ratio becomes more apparent and for many of the crowd this is yet more entertainment. These police aren't the Natural Theatre PC and WPC who can be glimpsed around site holding hands and occasionally snogging; these are all blokes and they're proving it. Night-sticks are being produced and someone is down in the mud. A fearless hero reaches in an open window of the jeep and pulls out a police helmet and flings it high into the air. Time almost stands still. Slowly and symbolically the helmet spins. A cheer goes up. Decisions are made. The helmet lands in the mud. Some of the audience turn into performers and suddenly there're lots of people running round looking for something naughty and imaginative to do. I kick some mud up on to the windscreen and the example is quickly followed. The mud starts flying, first caked on the windscreen and then everywhere else. I go round to the back of the vehicle just as a muddy punk is having his legs clubbed while being bundled into the back. I step forward and offer him my hand, hoping to pull him free. Police hands reach for me, and the muddy punk slips from their grasp. The last thing I see is a jet of fine white spray coming from the sleeve of a blue uniform. I'm hit. My eyes sting. My mind races - 'Outta here!' Ten seconds later and having operated on pure adrenalin, I've run 20 yards and back into the Ecotrip tent screaming my needs. Now blind and breathless, I'm collapsed in a chair and remain so for ten minutes.

Eventually, two of the Squall posse come and find me and take me back to familiar territory, sit me outside facing the wind. My face stings and feels like a giant festering herpes. The Exodus crew are giving advice and making me snot and spit out all the... What is it? Tastes like concentrated swimming pool and smells like Domestos.

Twenty minutes later, I've fully recovered and remembered I was supposed to be doing a gig. I return to the Ecotrip tent to check things out. What I thought would be a hubbub of excitement, post-riot discussion and possibly a hero's welcome, is nothing of the sort. The crowd has halved. People are queuing for food and hanging out. Pedalers are on the bikes. There's sounds. It's a cool scene. It's as if nothing has happened. I go over to the techie on the desk. 'Oh hello! Are you going to do something? I've just been CS gassed.' 'Oh, bummer!' says a young crustie. 'What happened?' I'm full of energy and bewilderment and swimming pool concentrate. 'Give me the microphone and I'll tell you.'

What followed can only be described as surreal. I calmly and very briefly describe what happened half an hour ago, and then, for effect, I put down the microphone and project my voice to fill the tent. I'm suddenly very angry and hear myself shouting. 'When the police are arresting someone in a no-go area, you have two options: you stand in front of their vehicle or behind it - so it ain't going anywhere. What did you lot do?' They are all listening. I am speaking to jaw-dropped silence. 'You lot stood around spectating like a load of fanny!' Why did I say that? I never use that phrase. 'A load of fanny.' It hangs in the air. 'Fanny? What's wrong with Fanny?' Suddenly I'm on the losing end of an argument about sexist language with two or three women in the audience. I can't believe it's happening. Meanwhile, others take the opportunity to find out what's been going on and start talking among themselves. Clearly many of them know nothing about the incident with the law. At some point I must have taken out my handkerchief to blow my nose. My wet CS gas hanky. I decide to move on to my main topic - the Millennium Bug. I even get a big laugh but I can't remember the line. My head is spinning. I ask for 'Any questions?' I get an intelligent one that I've got a brilliant and funny answer to, involving describing the butterfly effect: 'the flap of a butterfly's wing can create the vital eddy in the turbulent birth of a hurricane', but I don't say that. I mix it up and almost fall over. I realise I'm stinging

and breathless again and have given myself another shot of CS by mistake. I soldier on until I realise I'm rambling and talking nonsense. I make an excuse and rush to the exit and fresh air.

Within ten minutes I have touched both moments of performance brilliance and pure embarrassment, and now I'm back-seated outside the Squall tent semi-invalid again. Someone gives me a cup of tea and asks me if I'm feeling any better. I tell them that I've just done a gig, but they don't believe me and laugh. 'You're getting better then'. Meanwhile café society has pieced together the earlier events. Apparently it all started in the Drugs testing unit - the tent next door to Ecotrip - where there is a free service to check the quality of Ecstasy pills. One of the workers recognised two plain-clothes cops loitering around and confronted them. Very quickly the cops are surrounded and they panic and call for back-up. The white back-up jeep arrives from nowhere and the uniforms attempt to extricate the plain clothes and threaten to arrest anyone who stops them for drugs offences. To any newcomers it all looks very much like a drugs bust. By then, of course, several people were very confused. That's when I got involved.

The Summer of '93 - Benefit for Hackney Homeless
Molly Malone's, Stoke Newington, April 1993

It's one of those small one-bar, unashamedly down-market rock pubs. It's dark, scuzzy and smells of yesterday's debauch, a bit like many of its clientele. Tonight is a special; the local squatters are putting on a benefit to raise money for the Hackney Homeless Festival in Clissold Park. Last year's (the first) was a thundering success - a gathering of the tribes attended by 15,000 squatters, travellers and fellow travellers. This year's HHF is expected to be bigger and better, but may well be the last due to the government's Criminal Trespass Bill which promises to decimate the infrastructure that these sub cultures have flourished in. Held on the 8th of May, this year the event has taken on the role of the first of the summer festivals and, for many, will be the kicking off point, marking the exodus from London on the road to a long hot summer of free festivals, illegal rave parties, and anti-motorway dig-ins.

Anti-Bill leaflets and copies of *Squall* - the excellent squatters information-zine, clutter the table by the entrance where a couple of staunch female activists collect two pounds a piece off the stream of scruffy punters arriving surprisingly early. After initial 'is it going to happen' nerves, the place is filling up and buzzing with expectation, much of which is inspired by the spectacle of a slack rope hung 6ft high from a pillar to an anchored trestle on the other side of the room.

Meanwhile, in an upstairs room, MC for the evening, Stompy (formerly Bastard) the clown, is knocking back the free booze, and a few motley performers are picking at a range of salads and veggie fare made earlier in the day. This will be the only payment they'll receive for tonight's performance. In reply to a worry about the nature of the audience, Stompy bravely declares, 'I'm just going out there and enjoy meself.' Polly of the acrobalance team, Lee and Polly, has forgotten their backing tape and is humming the jazz tune to the Irish publican who just might have something similar in his collection. Ball, ex-drama student, just returned from India and one half of one-off comedy duo, Bat and Ball, is getting nowhere inquiring about professional details like the running order and microphone stands. Paka, the slack rope clown, is slapping on

make-up and musing on the safety of his rope - he originally wanted to tie it to his van parked outside. Downstairs the crowd continues to swell; at the door there are disputes about allowing admission to dogs, and then to certain notorious individuals. Eventually none are excluded, possibly to the detriment of the show. From Stompy's first opening address it is clear that many of the audience feel obliged to participate vigorously, while another section are oblivious to the proceedings. As the room becomes rowdier, it also becomes more supportive and friendlier to the acts, who go through their party pieces spiritedly on an ever-decreasing performing space. Stompy stops the show with his call and answer announcements. 'I don't do speed.' Omnes: 'Boos! Cheers! So What?' 'I don't do acid.' Omnes: 'Boos! Cheers!' 'I don't do smack.' Omnes: 'Boos! Cheers!' 'I get it all in the E.' Howls of recognition, laughs and more cheers.

Paka has his moments too: 'Fire! The pagan element,' he warns, with mock demonics, as he swings his burning clubs in the darkness. Hardened campaigner that he is, he sensibly cuts short his slack rope striptease when he starts acquiring drunken apprentices. Bristol-based busking band, The Beetroots, finish off the party singing celtic-marriachi-ompah crossover, dressed in funny wigs and Easter bonnets laden with plastic fruit and flowers, and encore with a wild version of 'Ghost Riders in the Sky'. So begins the summer of '93.

The Ultimate Knob Joke at Forest Fayre

The Great Geek and Stompy 1993

Sex is an eternal taboo, always good for a cheap laugh, but rarely the subject of a profound zinger. Contemporary British comedians are, for the most part, a bunch of verbal flashers not really daring to delve into the collective fear.

Amidst the tabloid telecentricity of the London Comedy circuit, knob jokes are rife and the recession of the imagination shows no sign of green shoots. Out on the artistic margins, however, the summer festival season is in full bloom. No slick cynicism or whimsical tosh here.

In the bottom-field tent shows, the boundaries of New Cabaret merge with Crusty Circus and Pagan Fire Ritual. At the May Forest Fayre, in the early hours, we are stoned and drunk and still up for it. We've tribal danced to the Tofu Love Frogs, catharted our personal demons while the Wicker Man burned, and been rabble roused by a stand-up Druid orator in the fire maze. Clothes flecked with torch wax and smelling of wood smoke, we join several hundred revellers packed into the wind / bicycle-powered Kiss Kitsch Cabaret tent. The entertainment ranges from the raw and gregarious to the bizarre and confrontational, performed from inside a huge gaping mouth on stage.

Above derisory heckles and hoots of approval, one of the Dongas tribe from Twyford Down recites her epic poem, updating news of battles against the motorway developers; a Digger bureaucrat barks the crowd and has a whip-round to buy land for a permanent festival site, 'So we can do this all the time'.

With the Health and Safety bod long since slumped in a heap with a mug of mushroom tea, Stompy (formally Bastard the Clown), does his Full Lotus Leap from the stage atop of 4 beer crates into a small upturned cardboard box in the audience. He then embarks on various loosely rehearsed stunts involving a

burning unicycle, a fire hoop, and a reluctant mongrel.

The giant mouth closes for a brief interval and we buy cheap hash cakes from an artful dodger lookalike. Lights dim. Music: Kurt Weill House! Expectation rises as the mouth yawns open to reveal a white-suited, shaven-headed weirdo dancing languidly in the spotlight with a mock-glam assistant (venue organiser Slater) in attendance, with a tray of odd paraphernalia. In his own time, he lights the spliff he's been wearing as an earring and proceeds to strip, places his jacket on a hanger and hooks it like a bone through the nose; from his nipples he suspends weights - they swing with the rhythm stretching into existence flat, taut-skinned breasts. There are screams, laughs of disbelief, howls of agony by proxy. This is an act by a devotee of De Sade who owes as much to Masoch. He disengages the weights. Dressed only in slacks, he moves to undo his flies. We know what must be coming next although few want to believe it will happen. He pauses, looks at us wordless, defiant, as if to say, 'Knob jokes? I'll give you knob jokes!'

Twenty seconds later we are witnessing the ultimate knob joke, surpassing even Chris Lynam's inspired 'roman candle up the bum to the tune of No Business Like Show Business'. With a bungie strap hooked through the head of his punctured penis (a full Prince Albert), he swings a four pound steam iron, lit by sparklers, over the heads of ringsiders in the audience and pirouettes gracefully like one half of an ice-skating duo. There is uproar, a cacophony of spontaneous mixed reviews. Standard audience responses no longer apply; we are in uncharted territory. Many (me included) are dumbfounded by a logjam of unexpressed reactions. Some are hallooing with mindless euphoria, impervious to the danger of being bludgeoned by a heavy low-flying domestic utensil. Others sit horrified - only too aware. There are those nursing their own personal pain and a few celebrating a memorable artistic breakthrough. In truth, we will all remember it and we all know how it was done. But none of us will be repeating the performance down the pub tomorrow night.

Not just another knob joke. This was entertainment with resonance - you really did have to be there.

Tony Allen and Sam Beale, June 1993

Glastonbury Notes - June 1993

The Contemporary Fool

It's warm. It's early evening. It's been a hot day at Glastonbury Festival. I am with two young women cheerfully crammed into a toilet cubicle with a steaming untended half-full pan. We've only just met, but we're giggling to each other like naughty children. The situation is ridiculous. Outside there is a row of about two dozen cubicles similarly occupied and a crowd of several hundred are waiting. A mood of mischief and expectation reigns. They are being joined by hundreds more - curious passers-by, who are being gently rabble-roused by the charismatic Fool, Jonathan Kay. Eventually we hear the crowd outside shout, 'Three... two... one... Go!' and we charge out of the cubicle starting stalls like racehorses. There are loud cheers as sixty of us gallop across the meadow ahead. That was what we had agreed to do, when asked a few minutes earlier. No one tells us to stop. After about a hundred yards, those ahead of me are looking round wondering what happens next. I stop and realise that the race game is now over. There's no finishing line, no winners or losers, only participants. We laugh with each other and stroll back to the crowd who are already gathering and doubtless

doing something else daft or lateral. It's difficult to see all of a Fool show if you are also going to participate.

I arrive to find the mass of people now silent and attentive. The Fool knows how to give light and shade to his performance. He gave us inter-active ensemble spectacle and now he is giving us minutiae intimate theatre. Dressed in a blue and patched motley outfit with a matching cap with bobbles, he is sat at the centre of the large but focussed crowd with a mother and child. It appears that the kid has been crying and the Fool is leading the healing process. A game of pass the sticky bogey is in progress between the Fool and the kid who is gloriously unaware of the audience. The original bogey is long gone and the Fool is now offering to replace an imaginary bogey back in the kid's nose. The kid refuses and the rejected fool idly plays with the bogey, rolling it around in his fingers. The bogey gradually increases in size. The kid is mesmerised, as are most of the large crowd. All of us are sat there in the middle of a festival, quite happy to be watching a Fool pretending to play with a bogey. When it becomes the size of an apple, he sniffs it, likes the look of it, opens his mouth to eat and looks at the kid. Remembering his manners, he offers it to the kid first. The kid is expressionless. The Fool takes a bite, enjoys it and offers it to the ringsiders. The kid is not eating an imaginary bogey, but he's happy watching the immediate audience pass it round and try out their own mime skills.

On the move again, the Fool points at a young blokish bloke passing by, turns to the crowd and asks out of the blue, 'Is this Him?' 'Yes!' comes the reply. With little else said, the passer-by is designated 'instant guru' status. Everyone gathers round him, those up the front are quickly organised to sit down, people further back drop to one knee; within seconds it becomes a scene from the Bible. 'What message have you for us?' asks the Fool, as if in the presence of a master. Bloke, bless him, rises to the occasion, corpses, thinks and then points in the air at a bird. 'Look at the bird in the sky...' he says theatrically, '...it doesn't have to go to work.' Perfect. Everybody cheers. Bloke laughs and carries on his way.

At one point in the proceedings, a large breakaway group of a hundred or more of us, some singing and dancing in the style of Russian Cossack dancers, go off on our own and into the Acoustic Music tent. Our energy is infectious and reflected by the band on stage who believe they have created the new mood. They up their game and start kicking it back out to the crowd. We, however, are singing a different tune and it becomes disruptive - left to our own devices and without the Fool to guide us, we have quickly become out of control. Meanwhile, the sight of a mass of people all purposefully going into the Acoustic tent has led to the creation of a Glastonbury flash myth among those casually hanging around outside. Suddenly, the already-full thousand-capacity tent is heaving with Van Morrison fans believing the Man is about to make a surprise appearance. So many people believe this and block the exits, that we are trapped by the continual influx and can't get out until some of the side awnings are taken down to release us.

We catch up with the crowd following the Fool. He is watching an old transit van trundle across the uneven field close by; it comes to a halt and the engine stalls. It is packed with kids, adults and luggage. Has it just arrived or is it just leaving? The driver, a bearded young crustie with spikey hair, gets out and opens the bonnet. We follow the Fool over to the van. His opening exchange causes local laughter and the crowd gathering round to hear, gradually swells to several hundred. The occupants of the transit can't get out. Questions are being asked and suggestions being made from the crowd. 'What is he?' asks the Fool. 'A hedgehog.' 'What am I?' 'Daddy hedgehog.' 'Where is the best place for hedgehogs?' 'On top of the van, so we can all see.' As the fool and the surprisingly compliant crustie climb on top of the transit, those inside are wondering what is going on; some of the kids are leaning out from the windows trying to see. The adults inside are shaking their heads and I notice that the woman in the passenger seat is resigned to the stoppage and is

skinning up. 'Now what should we do?' asks the Fool. 'Make love?' 'You want us humping like hedgehogs?' 'Yes!' comes the unanimous cry. After a scene of debauched simulated hedgehog humping with the van rocking and the enormous crowd laughing uproariously, we are on the move again. Glastonbury Festival - fun for all the family.

Throughout, there are periods when Jonathan Kay's fool does the minimum required to keep it all together. He is simply the instigator, who we find ourselves gathered around again once an idea has run its course. At one point he asks us questions and we refuse the democracy of it. 'You choose,' someone shouts out. 'Have you no mind of your own?' he asks the slacker. 'No!' we shout as one. 'Ah, so you have no minds of your own?' he asks innocently. 'No!' 'You want to be led?' 'Yes!' 'You are sheep?' 'Yes!' 'Baah!' Yes, we want him to think for us. Yes, we just want to be sheep, yes, we enjoy being sheep. It's as if he has tricked us into accepting a false irony. We've been tricked and we are laughing. And yes, we want him to trick us again.

He led us, a core group of 200 people around that part of the festival for several hours. Asking us for our ideas and helping us act them out. Any suggestion that seemed to have a consensus, we acted on. It was a uniquely liberating time in which we played endlessly, sang, danced and performed for each other, and also entertained the hundreds of incidental spectators who stopped to watch and who were then urged to join in. Many did. We tried to avoid, but occasionally gently disrupted, other performances and generally behaved like a bunch of very creative children. All the time I kept asking myself, 'Why am I doing all these bizarre things? Because a Fool told me to?' Everyone who joined our tribe of fools had a very particular and lasting feeling of community. In the days that followed, I kept meeting fellow fools and we had an immediate open connection.

Lots of the same people went back to the theatre marquee the following day to go out on another chaotic walkabout with the Fool. I encouraged some friends to come and see the show, but he'd tricked us and apparently started early with another bunch of innocents he'd picked up around the festival. We couldn't find him and amused ourselves elsewhere, occasionally checking in at the marquee. Hours later he finally returned with hundreds of new converts. We arrived just as he was organising community singing and we joined in immediately. After a few daft musical games, he got all the women and girls to get on the stage and sit down. He coaxed all the men and boys to stand close up in front of the stage and then, assuming our heterosexuality, he got us boys to sing a love song to the girls and vice versa and so on. After about 30 minutes of looking at and serenading 200 members of the opposite sex, we, all of us, realised he'd slipped out and left us to it.

Afterwards, people began to exchange stories, comparing today's show with yesterday's. Earlier today he'd had an enormous crowd of them surround a police vehicle and refuse to let it move until the officers stood on the bonnet and sang, 'We all live in a yellow submarine'. As more crowds gathered, the police had no alternative but to comply.

For Jonathan Kay, these were just run-of-the-mill Glastonbury sessions, but for many of those first time fools, it was a liberating experience. I've seen the man perform many times and it's usually an exhilarating timeless show. His fool attitude is gentle, modest, endlessly playful and seemingly boundary-less. He is a cipher and expresses bigger and more complex emotions only when sampling caricatures or imitating others. Kay's quietly charismatic performance persona, mime skills and interactive game-playing is less suited to a rigid cabaret club setting, where the world beyond the auditorium is difficult to interact with. This doesn't deter him. In most of his London shows I've seen, his audience have agreed a plot and gone out into the public arenas of the bar and the street where spontaneous risk-taking acquires the element of immediate danger.

Each time the participating audience had to deal with the non-participating incidental audience. The success of the exercise was no longer in the hands of the fool; he'd released them back into the wilds of real life, armed only with the urge to play.

The Cutting Edge at the Comedy Store - November '97

'The Cutting Edge provides the most up-to-date humour in the country, every Tuesday its team presents topical wit and acerbic comment on what's happening in the world.'

Comedy Store website

'The innovative weekly show where a group of talented comics brings you a mix of stand up, competitions, topical material, and short sets as they explore different ways for stand-ups to interact on the same stage.'

Time Out

I'm a news junkie; I'm declaring an interest. I like my comedy relevant. To review the Cutting Edge, 'a serious night out', at London's Comedy Store, I was ethically committed to experiencing the show from beginning to end without heckling. I had no great expectations of what I was about to put myself through; I'd been before and I'd walked out. In the early days I had been disappointed by the lost opportunity, and repeated visits since had just made me angry and my stays even shorter.

The Cutting Edge on a Tuesday was the last of the six regular Comedy Store nights to achieve full houses following the recently screened telly spin-offs. 400 punters, presumably hungry for satire, had filled the purpose-built venue, and were chatting, drinking expensive beer and generally ignoring Channel 4 News washing over them from a big screen at the back of the stage. This was a new feature and a nice touch. I was beginning to soften.

The week prior to Tuesday, 11th November had been a big news week: Saddam Hussein was pushing Bill Clinton to the brink. Neither was going to lose face; it was either war or climb down and fudge.

The Louise Woodward verdict had been reduced to manslaughter the previous day and now the quirky trial judge had sentenced her to time served - making her technically free. Tabloid defensive jingoism was turning into mindless triumphalism.

Another judicial surprise outcome concerned £25 million a year Formula One Racing champ Michael Schumacher, who had walked away from a disciplinary tribunal with a token community service stint, teaching road safety, after blatantly ramming Jaques Villeneuf during a major race earlier in the year. Schumacher had eluded even a short term ban, and now, along with Drop kick Cantona and Ear biter Tyson, had joined that select band of big box office sports celebs who are not only above the rules of their own sport, but also above the law of the land.

The other hot plot that had been thickening for days was not unrelated and involved Labour sleaze. Formula One Motor Racing's exemption from the Labour government's ban on sports sponsorship by tobacco companies had thrown up all sorts of goodies: not only had Formula One's chief exec Bernie Eccleston donated a million pounds to Labour party funds, his legal advisor David Mills, an ex-director of Formula One,

was married to Tessa Jowell, the Health minister responsible for overseeing the Tobacco ban through parliament. Funding of political parties was a big issue and Government ministers were on the back foot looking very shifty, very Michael Howard. The Labour Government's honeymoon period was history.

Not that this had anything remotely to do with the content of the Cutting Edge show that Tuesday. The team (from a pool of dozens): Lee Hurst, Phil Davey, Andrew Pipe, Steve Gribbin, John Molony and Martin Coyote presented a slick, safe, and unmemorable rag-bag of knob jokes and old routines: William Hague's bald, Margaret Becket's ugly, Bill Clinton's got a bent dick, my football team's better than yours, the Spice Girls have got tits and Louise Woodward, it seemed, was serving 15 years for murder. That none of the Cutting Edge team bothered to question this gross oversight from Steve Gribbin was astonishing, that they then went on to repeat it later while doing their baby-shaking jokes, was the stuff of a parallel universe. The audience too inexplicably colluded, laughing and applauding dutifully throughout. Had Phil Davey's opening set of gently baiting the ringsiders intimidated all 400 of them into a state of mindless acceptance?

Now I don't actually believe that the Cutting Edge team was uninformed. I'm sure they all did their homework and, newswise, were probably better informed than the average member of the audience. But when a topical reference is only an adjunct to the joke, and the joke is honed in repetition, and the laugh assured, information is the first thing to suffer when slack sets in.

John Molony even failed to deal with the hot sports story, a subject from the audience: 'The Schumacher affair'. 'Schumacher? He's German, isn't he?' The section of the audience who laugh at everything, laughed and a little too loud. Molony smirked a quick double-take as he caught the whiff of latent xenophobia. They laughed again. For a brief moment he dared himself to launch into an anti-German routine we would all regret. He thankfully thought better of it and, having nothing to say on the original subject, professionally segued into something irrelevant, passed the metaphorical baton and got off stage. None of the team ventured forth to pick it up, not even for a passing road rage gag.

Point of information: 12 years ago when Molony was fresh, raw and political, he would have done what any self-respecting comedian of the era would have done on hearing a hint of racism in the crowd. He would have drawn attention to it and identified it and run the risk of polarising the audience. In the early days, the phenomenon was referred to as, 'off to Nuremberg', after an Alexei Sayle line. The original Comedy Store, whose audiences and performers were always drawn from a broader constituency than the more radical 'alternative' clubs, was often the scene of arguments between audience and performer, audience and audience, but most pertinently, between performer and performer. This made comedy at the Store dangerous and by default gave the Store its 'alternative' reputation. But I digress. Back to Tuesday Nov 11th 97...

Even when the Cutting Edge team were vaguely on-message, it was slack - Lee Hurst trotted out his 'Naughty Saddam periodically turning up at the Kuwaiti border to wind up the Americans' bit, which has been in his stage act for years, but nevertheless would serve as a perfect opener for some Cutting Edge comment on the top news item of the day. But neither he, nor anyone else bothered to run with it; the subject had now been dealt with, and about as accurately as yer average 1991 scud missile. Apart from the football results, it appeared that none of these satirists had actually encountered a news bulletin for some time.

Dismal as all this most certainly is, it's top political comedy in the context of much of the current London Comedy Circuit, where the crass observation that Robin Cook resembles a garden gnome, qualifies as a topical joke about UK foreign policy.

Just what were the expectations of the original Cutting Edge team in 1990 when the Comedy Store

gave them a weekly platform to experiment with form and content?

Could they have conceived of it seven years down the line: a slick Off-West End show simulating topicality and begging the obvious question from anyone capable of joined up thinking - cutting edge of what? One thing is for sure. Presented in the regular format of four or five solo stand-ups and an MC, they would have produced no less a topical show. And if that's the case, what has the Cutting Edge achieved in its seven years of innovation and exploring different ways for comedians to interact on the same stage?

The show comprises six stand-up comedians stepping forward from the on-stage ensemble and playing various performance games, either solo or as double acts and threesomes etc. In theory this creates an environment that encourages '...acerbic comment on what's happening in the world'. In practice, this rarely happens and, when it does, it is never sustained. In recent years the well-oiled formats can accommodate any jobbing comedian regurgitating selected chunks from his current tight 20. The Cutting Edge consequently has its best nights when its most regular and most topical comedians are in the line-up. At worst, it's like witnessing an extended version of the dreaded joke competition but without any input from the loonies.

But the problem clearly goes beyond the commitment and quality of the performers, particularly when it's remembered that many of them are capable of improvising far beyond the Cutting Edge's meagre requirements. Similarly the fault doesn't lie with the games. All games have rules, and breaking rules is always going to be more entertaining than obeying them. Games, competitions, charades, theatre sports, poetry slams, all night ferret weaving! It doesn't really matter what's 'supposed' to be happening, so long as it serves as an excuse for being there - for standing in front of an audience with very little to do but to fuck about creatively with yer mates. Games are only a problem when they are taken too seriously. The construct is not at fault. The fault lies in how the construct is inhabited.

Eric Morecambe once said (rather sweepingly) of the current crop of then eighties comedians that 'there were no more funny men, only funny lines'. When Lee Hurst and Martin Coyote did the so-called double act spot, they in fact played gag tag - two concurrent solo spots, utilising selected material from their respective stage acts and picking up cues from each other's punch lines. The stunt had more in common with juggling than exploring double-act inter-action. The fact that it was adequately rehearsed and smoothly executed meant that neither of them dropped a club. More importantly, it cramped both their styles, so neither could do anything other than remember their cue lines. As for getting into stuff like exploring the shifting attitudes of low status / high status, who was Eric and who was Ernie? Forget it. They were both Ernie. Early Ernie circa 1960. Eric Morecambe would have seen no funny man, only funny lines. And no relationship.

Similarly, the bus stop game was an ensemble example of the same problem, but because it was unrehearsed, it didn't suffer from quite the same straight-jacketing: one comedian faces the audience, the rest in a queue behind, MC at the side confirming the fresh tag, tell your gag and go to the back, three crap gags and you're out. Here was a game ripe for subversion. But no-one projected their nervousness, cheated and pushed someone else forward. On the contrary. Andrew Pipe, a newcomer to the team, bless him, was genuinely doing an audition and apart from once when Steve Gribbin got miffed with an audience decision, no-one was up for a lark - they played it like good sportsmen giving of their best, trying to win and accepting the result with dignity. If that's all there was to it, then top straight man / gagman Bob Monkhouse is God. He simply knows more good gags.

Is there a Brechtian director in the house? Can somebody please tell them: the important agenda is not about winning or losing. It's about revealing the sub-text of how the game is being played.

A good telly example is *Have I Got News For You*, which has its most successful moments when it

exploits the chemistry that exists between the three protagonists. Their on-screen / on stage personas have evolved to deal with anything the other two might throw at them. Paul Merton, a yobbish suburbanite with oddball opinions, can shrug off any intellectual beating by belligerently changing the subject or lolling into apathy; Ian Hislop, a bumptious ex-public school know-all, is prone to tantrums when proved wrong or when his soap-boxing analysis is rejected, but can usually be coaxed out of a sulk if he's mimicked and made to laugh; and Angus Deayton, an Oxbridge stereotype front-man: ambitious, abrasive, cynical, devious, defensive, and who's probably been comfortably employed by the BBC since he left college 20 years ago, can, for all that, be persuasively endearing when he's wounded. The whole quiz show format, including the clever answers to the questions, and the competitive frisson around the scores, is merely the scaffolding for building the relationships and discovering attitude. Once this is achieved, all sorts of risks can be taken - Hislop, for instance, can launch into one of his political muckraking rants without having to give too much consideration to a punchline. He knows that if he doesn't get a result, then they'll cover for him. If it falls flat, Deayton will break the silence and sneer, 'whatever happened to light entertainment', and even if it works, Merton will begrudge, 'clever twat' as soon as the applause has subsided.

In the same period that HIGNFY have developed their craft, the Cutting Edge has done little more than find a lame excuse to be on the stage. Apart from the gentle banter mildly embarrassing Lee Hurst about being famous, and the soft-option Aussie bashing that briefly victimised Phil Davey, there was little development of relationships that would lead to the dramatic conflict integral to successfully sharing a stage. Where Merton and Hislop thrive on a clash of personalities, each giving it plenty of competitive welly, whether they are playing a game or not, TCE team suffers from minimising their differences and ignoring dramatic 'offers'. Consequently, they come across like a bunch of generics playing their wretched games as if they were all on the same side.

That said, what was stopping them from fulfilling their brief and doing a short but thorough retrospective of the week's main news stories back-dropped by a chaotic chorus of pertinent heckles, wacky barracking, and opinionated noises-off. If they weren't going to be eccentric individuals, couldn't they be at least a naughty chorus?

This underlying egalitarian group attitude not only stifles opportunities for improvisation, it epitomises the post-ironic new lad luvviedom: supportive without being intimate, joshing rather than confrontational, an all mates together, stick to the script, team effort. Meanwhile there's a job to be done, what was your name again? OK, have a good one - Channel 5's in, let's get this scaffolding up, show these punters a bit of technique, nothing too adventurous, give 'em plenty of laughs, fair play to 'em, give 'em their money's worth, etc etc. It's the house style of the charity fun run. Whether it is intentional or has simply evolved, is not the concern of this review - that's the stuff of internal enquiries. But it is clearly inauthentic and wholly inappropriate and what it does say speaks volumes for the motivation of the work force. It's just a job.

The entertainer gives the audience what it wants; the artist gives the audience what it didn't know it wanted. What are these blokes like when they don't have a job of work ahead of them, when they're letting go, trying it on, making mistakes, defending themselves, pushing it too far, ripping the shit out of each other, apologising, arguing the toss and taking the piss? Basically, what are they like when they behave like heightened versions of us?

There have been brief moments in history when the comedian has seized with impish delight the licence to smash taboos, tell the truth, name names and decode the zeitgeist. I had no expectation of seeing licensed iconoclasts bare their souls on stage in front of a live audience in the cultural capital of the planet,

savouring a potent moment as Western civilisation struggled to get one last toke out of the fag end of the second millennium. But neither did I reckon on such endemic cynicism, laziness and ignorance of the possibilities.

One of the regular shows would have done no better or worse in the same slot. Somewhere along the line an opportunity to experiment on the back of the Store's success has been fecklessly squandered. Artistically it's been downhill all the way to here. Totally sold out and with a full house.

The Open Heart Cabaret - February 1985

It seems yonks back, late 1979 to be precise, when the new wave comedy phenomenon came belching, ranting, and politicising its way out of the London pub scene. Nowadays its leading lights, one-time purveyors of dangerous entertainment, can be seen regularly on the box parading their wares, castrated by self-censorship and short-term ambition. Many even peddle their images to the advertising companies, their souls too scarred ever to bare them again in public: any old icon any old icon any any any old icon. Their lesser contemporaries can be heard nightly, prattling out instantly forgettable sub-Monty Pythonesque scripts for Radio 4.

Meanwhile, the live cabaret circuit reflects this mood as it spreads (thinly) into Art Centres and back rooms of suburban pubs, indistinguishable from the mellow bohemian ambience of the folk and poetry clubs it once usurped. Another generation is emerging, but it's too soon for a revolution. They model themselves on the diluted versions of the originals and slant their material at the Channel 4 Light Ents execs possibly sat in the audience. Jeremy Hardy, Jenny Lecoat and Simon Fanshawe owe more to Jasper Carrot than vintage Keith Allen or Alexei Sayle.

I had few expectations then when I visited the Open Heart Cabaret, tucked away in the function room of the George V, Chiswick High Road, one bleak Sunday in February. The evening included several trad' alternative-style acts, such as Bernard Padden and a sidekick, experimenting with the seed-shit of a good marketable comedy double act, Cecilia Scanlon with some tasty one-liners she'll have to drop if she ever wants to interest Auntie, and someone aptly named Johnny Immaterial who'll doubtless make it big.

Things started to get interesting with the introduction of Barry Roberts, who served a mega-long apprenticeship at Speakers' Corner, Hyde Park, and who is now one of the main attractions at that wild freebie venue. The range of comedic devices he explores standing on a milk crate, entertaining and occasionally informing large rabbley crowds, puts most professional cabaret acts to shame. The quiet little gathering at Chiswick 'did' for him, however, and he crumbled - the cosmic joker strikes again.

The ensuing void was quickly filled by wayward comic talent, Tony Green, who leapt to his feet and catharted a ten minute unprompted stream of consciousness, raging against anything and everything, while still managing to be disturbingly relevant. The audience was focussed and laughing too - this is the stuff, eh? The Channel 4 exec probably agreed, but wouldn't be making any offers. Green ceased as abruptly as he'd begun and Immaterial the MC caught the mood and announced the break by breaking a glass on the wall - existential puns! What next? Ian Hinchliffe. Oh No! Oh Yes.

Hinchliffe comes from the 'Let's piss all over the audience' school of performance art, and his job apparently is to wander round the cultural landscape shifting the metaphorical marker buoys and erasing all the white lines, in fact, rearranging the boundaries of art. Well, someone's got to do it. In the past he's

attempted to redefine where street theatre ends and road accidents begin; he's got a pretty bizarre line in interior decoration and on many occasions he's extended the concept of audience participation to include incitement to murder (although they'd probably get off with manslaughter).

Tonight, however, it was comedy night. He stood before us simply wheezing and golumping like a deranged dosser, before articulating a surreal litany of personal facts and anecdotal fragments. The 'humour' soon gave way to provocation: he farted and burped at will, exposed himself, kicked over drinks, re-arranged furniture, evacuated a particularly resilient front row by point-blank projectile vomiting, and scuttled a further two rows by shaking a large open-topped bottle of HP sauce. As we left, a half-cooked chick pea daal rained down on those remaining masos and art lovers. No offers from the telly, but the social sec from an art college is very interested; someone else is hoping to get their cleaning bill paid and the barman from the pub wants the room cleared. Hinchliffe has extended drinking-up time by 25 minutes. Pity he kicked over our beer.

Tony Allen *The New Instant* 1985

Poetry reading

Castlegate House Gallery, Cockermouth, Cumbria. 5th December 1997

Castlegate House Gallery, Cockermouth, Cumbria, is part of the genteel stratum of the live arts circuit. Unashamedly middle class, middle aged and middle of the road, it's a far cry from the inner-city basement clubs where I usually get my shot of performance poetry. We're not quite in the real world here; this is Wordsworth theme park territory, the world of the Georgian drawing room, string quartets, flower arranging and tasteful exhibitions of neatly framed artwork. Nevertheless, there's always the possibility that things might get real and that's what excites me about live intimate performance. I relish the frisson of a discovered taboo. I'm in awe of the shamanic moment. And I'm a sucker for free wine in the interval.

Tonight's event, a poetry reading and book signing by two women poets, Sophie Hanna and Dorothy Nimmo, and hosted by Michael Barron (a perfectly cast, garrulous, tweedy gent): it is going awfully well. Seated either side of an autumnal twig arrangement, first Hanna and then Nimmo have each stood and delivered twenty minutes worth of their poetry. Already Nimmo's smouldering attitude has unsettled Barron and he has announced that Hanna will be headlining, or at least closing the show.

'I don't perform. I just read my poetry.' Sophie Hanna had told me during the interval, when I introduced myself and referred to her 'performance'. She does perform, of course, and performs with some aplomb; that's what we'd just been watching - half her time on stage involves chatty and engaging introductions to her poems, some of it is the prepared spontaneity of a stand-up comedian - well-honed and well delivered. In fact, we learn far more about Sophie Hanna from her performance than we do from her poetry. Her attitude, which has presumably evolved unacknowledged, is of a confident young swot. At 26 she's published several slim volumes (signed copies on sale at the end of the evening), is writer in residence at a Cambridge college, has been mentioned by somebody important on the telly, and gigs round the arts centre circuit doing readings and workshops. She entertains the audience, many of whom are twice her age, in the style of an older niece showing off at a family reunion. Her poetry is clever rather than insightful, strong on

technique - a sort of elevated doggerel, but lacking in memorable content. Not so her colleague for the night, Dorothy Nimmo, who has had the foresight to go out and have a life before going public as a poet.

Nimmo is a far more substantial writer, an artist rather than an entertainer, and her performance, like her poetry, is studied, thoughtful and austere. A measured catharsis from a woman who has made courageous life decisions and now, in retrospect, is discovering a resonant language to express the feelings. Her second set is deliciously uncompromising. 'I only ever wrote hate poems until the birth of my grandchildren', was the almost snarled intro to a piece dedicated to her grandson in which she offered herself as his ally if he would dare to be different and follow his own life path. The honesty and quiet gritty passion that informed her work made her compulsive company, and occasionally transcended the setting to evoke the low status, wise crone sharing her insights with a discreet gathering. Particularly revealing were the fragments she read from her verse biog of 17th century Quaker martyr, James Naylor, which allowed her to explore the pain and isolation of the spiritual warrior. This was the stuff of the late night summer festival campfire; this was pertinent and unexpected; this is what I paid my four quid admission for and never thought I'd experience in such antiseptic surroundings. Signed copies of Nimmo's *Naylor* were not available - it was out of print. Of course it was. Long live the oral tradition.

Ken Dodd Died. Did he? No Doddy

I've been a Ken Dodd fan for thirty-five years; I was in my late-teens when I first encountered his Sunday afternoon BBC radio show. I loved its celebration of silliness with its compounded puns and concocted language and the cast of Diddymen with quirky squeaky voices who worked in a chip butty mine. Doddy's worldview was so much simpler than mine and I loved the way I was carried off on a tide of surreal images and unlikely catchphrases. 'Where's me shirt!' Even though I knew where mine was, I always used to shout out the line in the morning before putting it on. His mixture of bizarre imagery, ratta-tat-tat delivery and immaculate timing was unique. On the telly too I always remember him as full of energy and with fresh, weird ideas to match his wacky costumes, buck teeth and sticky out hair.

I've seen Dodd's live show three times, the first was at The Embassy Rooms, Skegness, in the late eighties, to a predominantly working class holiday crowd. He lifted the roof off with his comedy - a masterclass of stand-up surrealism. There was a mock sense of occasion - an infectious party atmosphere generated by his unabashed daftness and the assumed familiarity with everyone in the room. The only respite came when he lulled them into sentimental stupor with his treacly balladeering or led the Diddymen - a chorus line of children dressed as dwarves - in a few novelty song and dance numbers.

Doddy with the Diddys was always a family show. Even when the kids left the stage, Dodd's solo spots sustained the innocence and his humour had some useful parameters imposed on it. The inspired flights of nonsense with the tickling stick were only phallic if you had time to stop and analyse, which you didn't because there was a manic torrent of gobbledegook that had its own integrity.

Dodd's influence has been apparent in the work of much darker comedians - the initial sensible voice picking up an idea and turning wacky and fast-forwarding it into bizarre imagery, is evident in another scouser - Alexei Sayle, and there are echoes of Dodd in contemporary Harry Hill; even in Jerry Sadowitz.

In the early nineties, at the Hackney Empire, I saw him play to an inner city London audience that

numbered as many gay couples, squatters and black youth as it did pensioners and families. Here I got my first glimpse of the new re-invented Dodd. After the second interval, he came out yet again, and anticipating the audience, opened with the line, 'Oh yes. You don't get away with it that easy! It's in the contract. I get three goes at you.' There was a fair smattering of topical and East London gags too and references to his problems with the tax inspector, but it was starting to pall towards the end.

I got to meet him after the show, but unlike me, who wants to know, 'Who was I, up there?' or 'How did it feel down here?' Doddy was more obsessed with how long he'd done. It was probably over three and half hours minus forty minutes for support acts. 'Easy Ken, it's stand-up comedy, not a Duke of Edinburgh award for endurance.' I wish I'd said it.

The third, and I'm sure it will be the last time I'll see him, was in 1999 at the Fairfield Hall, Croydon, to an adult crowd seemingly dominated by suburban couples having a night out away from the kids and telly.

Fully re-invented, Dodd's new trademark was the marathon session - with shows running upwards of four and sometimes five hours. Watching him at Croydon, it appeared that he may be incapable of delivering a tight 60. He may have changed, but just what he'd changed into was unclear; he came on looking like he sounds when singing 'Love is like a Violin' - telly chat show guest - smart slacks, sports jacket and collar and tie - very straight. There was less mugging with the celebrated buckteeth and the hair was only wild in the one section in costume.

After a very long opening set, he gave himself (and us) a break. It's difficult to sustain 'manic torrent mode' at any age and Doddy is in his seventies. He seemed to be working a little too hard and trying everything in his vast repertoire to set-up an expectation of a long wild night ahead. At one point he went up to a hen party in the front row and said to them, 'By the time you get out here, Peter Mandelson will have paid off his mortgage'. It wasn't sharp enough and didn't seem that funny. I told Ian Cognito the gag, and he said, 'The man needs different material, I'd have said: 'By the time you leave here ladies, your periods will have synchronised!' Now that is the sort of material Ken Dodd needs to be doing. That would be re-inventing himself.

After three and half-hours (including two twenty-minute support acts - both women virtuoso musical acts off the ocean liner circuit), he was just getting warmed-up, or so he reckoned. I wasn't. I was cooling rapidly, tired of listening to acres of similarly structured pun jokes rubbing shoulders with the remnants of tickling stick routines delivered with occasionally patchy timing.

It was almost midnight and he was still churning it out, when I noted that he'd clocked up four hours but hadn't moved it on; it was the same old tosh. None of the themes were developing. I asked my mate, 'Where is this going?' 'Nowhere,' he shrugged. We knew how the jokes worked and we could see how the bigger joke was panning out. Sometime in the early hours of tomorrow morning we would be on our feet and giving the man a standing ovation while he dared us to shout for an encore.

Maybe we would have stayed if it had turned flaky and looked like being an interesting disaster, but it just sagged with familiarity. As we joined a slow trickle heading for the exit, Doddy was still bright and frothy and trying to pump some ersatz life into his vast archive of ancient saucy jokes - seaside postcard stuff. It was a bit like watching someone going for the Guinness Book of Records - longest stand-up comedy extended set.

I recently received my Ken Dodd gig list bumph from Knotty Ash (an actual place on the fringes of Liverpool where he must have an office). I looked at the punishing schedule he has set himself and winced. With a twinge of regret, I shook my head and bunged it in the re-cyc - the bumph Mrs, not my head.

Do I really want to be there when, like Tommy Cooper before him, he finally does literally die on stage? That's what he seems intent on doing, the dear old fool, because that's where he spends most of his waking life, and where he seems most at home. Oh dear Mrs.

Obituary - David Sutch: 1941 - 1999

Official Monster Raving Loony Party candidate

Sutch - the Performance

I don't usually vote but, given the choice, I've always voted Monster Raving Loony.

It was neither the message nor the man, but the audacity of the performance that got my vote. David 'Screaming Lord' Sutch's contribution to British comedy was to re-discover the top job in fooldom - the role of court jester, albeit on the wages of a village idiot. What had started off as a cheap publicity stunt by a novelty rock vocalist, turned into a unique national institution upstaging everyone from Harold Wilson to Margaret Thatcher. Dressed in a crumpled leopard-skin drape jacket and battered top hat, Sutch raised Hello Mum to an artform, and although he was penniless in his later years, he died more famous and certainly more of a national icon than most of his fellow contemporary politicians, comedians, or pop musicians.

Town Halls on election night up and down the country, he played them all. There were few participants who were more familiar with the etiquette and business of performing live on stage at the climax of the British democratic process. Sutch had been there many times before - it's what he did. He would suss the camera angle from the balcony and invariably position himself perfectly for the televised close-ups - mugging away over the Returning Officer's shoulder as he droned out the results. He would then be first on-hand to congratulate the winner and stand by their side to encourage them through their acceptance speech with a measured stream of ironic supportive heckling. 'You tell 'em son', 'Nah, fair play to you', 'Oi! Don't get carried away'.

There were good gigs and bad gigs. But Sutch on a roll was sublime. It takes a brilliant improvising comedian to enlist a bunch of po-faced politicians awaiting public humiliation and about to lose both deposits and egos, then manipulate them into giggling spot-on-cue as the telly cameras start to roll.

Most of Sutch's spontaneous patter act was lost to the viewing public. You had to be there and, if possible, up on the stage. Occasionally an enterprising TV crew would eavesdrop on the preliminaries and capture some of his act as he impishly held court at the photo call or helped usher people on stage for the result. There must be acres of footage in the archives. Caught Jesting? BBC Videos? £13.99?

Sutch's performance attitude mellowed as he started to understand the role he'd got himself into - there was less of the rabble rousing yobbo with the schoolboy humour and much more of the loveable larky Delboy guile - a sort of gentler, perkier Dennis Skinner without the snarl. He would feign intimidation and low status in the presence of the great and good, smirk and raise an eyebrow when a speaker fluffed a line, look round for a second opinion on a controversial statement. But he was at his best offering commiserations and mock sympathy to the inevitable losers. It may have been old material, but the timing of some of his asides was elegant. Who will be there now to console incumbent MPs at the very moment their careers crash, with a reassuring,

> *'Ah! ...Never mind. ...You'll get another job.'*

David 'Screaming Lord' Sutch: Died 17th June 1999.
There will be no by-election.

June 1999

Lenny Bruce live at Basin Street West -

Video Sleeve notes

The last recorded performance by US stand-up comedian and satirist Lenny Bruce 1925-1966.

The last recorded performance in August 1965 by US stand-up comedian and satirist Lenny Bruce at Basin Street West in San Francisco - at the time one of the only clubs which dared to book him. He died of a drug overdose a year later.

This is a tape for the connoisseur. For most of the 65 minute set, Lenny re-lives his experiences in the law courts defending his live stage act against charges of obscenity, the stuff that dominated the fag end of his life and career. He ridicules his arresting officers, reading verbatim extracts from the court transcripts and juxtaposing their evidence with renditions of the offending routines. He spins off on tangents, looking for new angles and freely sampling relevant and not so relevant fragments from his vast oeuvre. But, for the most part, the familiar comic 'bits' are delivered not as comedy material but as evidence; the joke now lies elsewhere in the hypocrisy of society and its creaking legal system. He's angry, obsessive, reflective, sometimes pedantic and occasionally distracted; there are the familiar Lenny Bruce shafts of insight and moments of devilment, but there is an underlying mood of resignation and few big laughs. As a consequence, the audience appears intrigued, rather than entertained. They are clearly witnessing a unique performer - a risk-taker breaking new ground. For many - the sensation seekers - it's not quite what they had been expecting. They are in on a moment, but they are unaware of its potency. Towards the end of the show, almost as a sop, he rattles off some old material for them, but he lacks conviction and throws much of it away. Then he wanders off stage to the street door, opens it and attempts to improvise, sparking off passers-by. Finally, that expectation splashes into his stream of consciousness and he gives voice to it - 'Dirty Lenny! Come and see Dirty Lenny!'

POST-ALTERNATIVE COMEDY

My Attitude

It took me ten years to discover and understand my own attitude. Up until then my core stage persona was still in 'raconteur' mode. I still believed that I had to be fairly composed if I was to discuss my version of anarchist ideas and expect them to be taken seriously. I had occasional flurries of flamboyance and aggression but I kept it in check and expressed myself in a relatively sane voice. It was learning about the madness of the money markets that finally caused me to make the necessary quantum leap.

In 1987 Max Handley and I were writing a comic strip with cartoonist Pete Rigg, for Robert Maxwell. Maxwell, a Labour supporter, launched the *London Daily News* a few months before the General Election. It amounted to a side-bet on the outcome. If Labour had won, Maxwell's newspaper, as well as being a nice little earner, would have made him a pivotal player in national politics. Labour lost and Maxwell cynically folded the paper.

At the end of the eighties, casino capitalism was looking extremely fragile - by then Robert Maxwell was two billion pounds adrift and Rupert Murdoch was in hock for three. When Max Handley and I brainstormed this corporate madness we had a way of flipping into animated outrage, screaming, shouting and laughing at each other for having been so slow to understand what was happening.

On stage, when I started explaining the surrealism of the money markets to an audience, my performance re-inhabited the raving spirit of our discourse. Far from detracting from what I was saying, my attitude of mock outrage and bewilderment, 'what the fuck's going on?' coupled with a sort of wacky urgency and lateral thinking, 'I'll tell you what's going on', was actually appropriate and enhanced the message. A pertinent comment after a gig in 1992 was 'Jesus! Who let him out!' I immediately embraced it as a compliment. Of course I did.

I was no longer the cool raconteur, the low-key 'hook' I already had in the audience of disclosure - explaining the background to big news items and zeitgeist concepts was now wildly accentuated. I was now bursting with information that unhinged, disturbed and excited me. But it wasn't a hook based in anger or obvious confrontation. I had discovered something subtler than that - something unique and very personal. It felt sexy.

I'd always presented my extreme beliefs by quite calmly celebrating paradox. My new volatile attitude was far more appropriate. The clue had always been there, inherent in my best lines. The curl of my comic attitude embraces contradiction:

Me? I'm a militant agnostic - I don't know! I'll go further - I know I don't know!

She said, 'Sometimes your ego is bigger than your talent', and I thought, 'Hmm! That's some fuckin ego!'

There are 'no rules'. Therefore, there are no rules against making rules.

I also justify utopian ideals and advocate lateral solutions and ideas.

I reckon that the Bush People of the Kalahari should charge an evolution tax on the rest of humanity.

Junk mail. Are you plagued with this shit? What I do is this... I get all the pizza delivery fliers, the bumph from the electoral roll, the final demand on the television licence, the instalment book for the council tax! And all that roach material mini cab firms keep shoving through your letterbox - I mean you can't smoke that much dope, can you? Anyway, what I do, try it, is, I isolate the large Freepost envelopes, and stuff it all in, and then I send it all back to them.

If you take an infinite number of Elizabethan playwrights and place them in a controlled sub-tropical rainforest environment, sooner or later will one of them develop a primitive tool to get honey from a bees nest in a hollow log?

THE GRIM REAPO MAN IS AT THE DOOR

Cabbage Patch, Twickenham - July 11th 1990 - Transcript

Original script consultant and additional material Max Handley
Additional material Paul Durden. Additional material Sherry Tolpott
June 1990

Hello Twickenham! I nicked that line. But without plagiarism there is nothing new. I nicked that line as well. There is no such thing as an original idea. Well I bet the bloke that thought that up, has disappeared up his own fucking arse 'ole.

I always drink Guinness on stage. Guinness! Pure marketing genius. Average pint of wallop. Nah! It just colour-co-ordinates so well.

Ooo! If I can keep it all in my head tonight...

Any East Europeans in? No. No, they don't like to identify themselves. They get surrounded by hustlers trying to lay credit cards on 'em. They've had enough already. Imagine all the junk mail bunging up Poland's letterbox at the moment. Just for a laugh, after the gig, let's all go down to the Czechoslovak embassy and seek political asylum.

And the Romanians when they got rid of all the Ceausescus. The next government got really adventurous and announced they were going to give all the peasants an acre of land apiece. And I thought Ooo! I can't wait for all that freedom and democracy to get over here.

Ooo! If I had me own acre of land, I'd, er, I'd grow me own genetically engineered Mango plant, with fucking great giant mangos Ooo! And then I'd live inside it and eat my way out - self-sufficiency. No. Of course I wouldn't, that's silly! I'd grow dope and export! That's after I'd declared myself an independent sovereign state, but within the United Kingdom - so I could still get the sausage roll.

Thanks for coming. Last night it was half-empty in here. Yeah yeah alright. Half-full. But then I'm prone to walk outs so 'half-empty'. Anyway, I'm standing there up the back, watching the sporadic punterdom trickle in. And then it hit me. Hit me like a plate of warm porridge down the Y fronts. And I thought Ooo! Up a bit. No, down a bit. Ooo! Up a bit. No, sorry - wrong meeting... and I'm thinking, 'If you were to add up all the people that have ever lived on this planet, yeah? And I'm talking - yonks back, mega-yonks, when Cornwall was attached to Brazil - All right if you like clotted cream on your mangoes. Eh? Eh? No! That's wrong as it happens. Let's sort it out now. Cornwall was not attached to Brazil. That was comic license. Cornwall was attached to

Newfoundland. But mangoes are inherently funnier than maple syrup. Alright, what do we want? An accurate history of plate tectonics or good comedy? Both. Fair enough.

Anyway, If you add up all the people that have ever lived on this planet, it comes to 15 billion people. Half of them lived in the twentieth century, a third of them are alive today; and apparently (according to a recent report) that figure's going to double in the next two generations. And I'm standing there and I'm thinking, 'I can't wait that long to fill this fucking room.'

I spend a lot of my time touring round the country. In fact, I sold the flat to buy the camper van. The housing co-op are gonna go potty when they find out. Boom boom. Settle down. I've just done a few gigs in the North East - Sunderland, Stockton, Saltburn. I think it's very important for us comedians to play out there in the Third World. It was a joke! A joke that highlighted the North-South divide. Don't go and turn on me. So I'm driving back down the A1, and do you know those bastards? One minute they're pootling along the inside lane, doing about 30 mile an hour. 'Doot doot di doot', and for some reason or other they drift into the middle lane and they're still there doing 30. 'Doot doot di doot', and they're causing all sorts of problems for the juggernauts who don't know whether to overtake on the inside or chance it on the outside, so they stay legal and go steaming up behind them, beep-beep beeping away 'Get the fuck out the way!' And then, do you recognise this? They start slowing down, because now, they are driving with their elbows - because they're rolling a joint. 'Doot doot diddly doot'.

And then it gets really erratic - they've got a can of lager in one hand, a joint in the other and it's foot to boards. Do you know them bastards? 'Cut him in! Cut her in! Oh Roundabout? Never slow down for roundabouts vrom vrom vorooooom. Oh no, there's no excuse for boring driving.'

Do you know them bastards? Do you? Yeah? Well I'm one of them, right. Why did you laugh at that? Eh? Do you like it when someone takes out a bus queue pissed out of their head? Is that your idea of a good laugh, is it?

I'll tell you why you laughed at that. Tragedy. All comedy is based on tragedy. I don't actually believe that, but I can prove it, with a silly joke you probably know the answer to.

'Why do dogs lick their genitals?' Answer: 'Because they can'. OK simmer down. Now the tragedy there of course... is ours! Because we can't. Mind you, we've all tried, haven't we? 'Go on get down there. You can do it. I'm sure I read somewhere... or was it a dream...? Maybe if I lay sideways in the bath? No, too silly, and too dangerous. I know, I'll go to a back-street osteopath - get a couple of extra vertebrae put in. Then I'll be able to get down there...' Yeah, yeah, I know - it's Thursday night and you do not want oral sex rammed down your throat. All right, fair enough - there's some old ones in there with all the gems. Boom boom one that one.

Anyway, truth is, when I'm away on tour, a mate of mine flat sits for me, 'cos he's homeless. When I come back, I just kick him out on the streets again. See - tragedy. You love it, don't you?

But he does piss me off. What he does, yeah. He takes books out of my bookshelf and he puts them back in a different place. Now if that's not irritating enough, another thing, he folds them back on the spine so all the binding rips. But that's not it. What really pisses me off is - he tears off bits of the paperback cover to make roaches for joints. Is that the pits? I've got all these books and they're all ripped to shit. Shredded! I can't even read the titles. My bookcase looks like the prosecution evidence against Oliver North.

I've got The Whole Earth Cat., Littlewoods Cat., I've got Homage to Cat by George Or... I've got 198... by him as well.

First thing to happen when I arrive in Sunderland is the elastic in my braces snaps. One side's all saggy. ehuh! So I have to force myself to make an immediate decision . 'Get a new pair.' Because I could well go all eco-make-do and gather it up with a safety pin... 'They hold your trousers up on stage - get a new pair.'
See these twangers? They're for you.

Mr Big Boy Shopping Experience, Stockton on Tees. Everything for the young male. I managed to slip in and buy the braces. I give all the fashionable sportswear a miss. Sorely tempted by the two-tone quasi-lycra cycling shorts in lime green and puce, but no! It's not as if I go to a lot of warehouse parties.

I did go to one Warehouse party recently. Acid house it was. More like Valium bungalow. No, it was the drugs - the police had arrived early and confiscated them all. Which was a pity because I was all primed to party and up for it. What apparently happens at these do's is, the kids drop an 'E' - the drug - ecstasy, and then they have all these feelings of oneness and they're off, away with the fairies and they start dancing 'with God'. Now I don't know about you, but if I'm going to dance 'with God', then I want the sounds turned down. Cos I've got questions.

It's true, that. I only do the truth up here on stage. Obviously I omit details that I consider unimportant, and I include stuff that's irrelevant but might get a cheap laugh, and I'm highly selective and unavoidably subjective and I've got my own agenda. Plus, every now and again, just to keep you on your toes, I bung in a bit of information which is complete and abject bollocks. In fact, the truth you get from me is much the same as any truth you get.

You've probably noticed I've got plenty to say for meself, me. But the one thing that does for me, is when people say, 'Hello Tony, how are you?' and I think, 'How am I? I see, difficult ones first. How am I? Decision time. How am I?'

And you like to be positive in everything, don't you? Except the Aids blood test obviously... Aids. It's back to condoms now, isn't it. I hadn't used a condom since I was thirteen, and then it was just for throwing water bombs round the playground. 'Wheee! Splosh. I did that. Hee hee hee!'

I mean, you can't have a full frontal cathartic Reichian orgasm wearing a condom, can you? It'd melt, wouldn't it?

Men! Just the men in the room for a moment. You know men, in tantric sex? Yeah? You know when you go through peak orgasm and into valley orgasm, yeah? And you're like gently throbbing away on automatic and humming a mantra together and maybe supplementing that with a sort of meditative massage; more like stroking each other's auras yeah? And then you coast back into peak orgasm again. Yeah? And sustain it. Yeah? Yeah? No? No, there's a punchline to this. I just love looking at the women looking at blokes they're with. 'What's he on about? Well you can just go and ask him. ...And If you don't, I will.'

But sex can be very weird now, can't it? Especially if you're sleeping around, a bit cazsh. And you're a bit remiss with the condoms. It's as if there's a third presence in the bedroom with

you. Like a police sergeant standing in the corner of the room taking notes. Or a bunch of well-meaning people from the Terence Higgins trust all sitting round the bed observing, 'Oh, look what he's doing.' 'Look what she's doing.' 'Oh dear, they've done it.' Or a snooker commentator, 'I think he better play safe here Ted, what do you think? Well he's gone for it.'

A mate of mine died of Aids and we went to his funeral. He knew he was going to die and clearly got his head round it, cos he organised his own service. And it was very much about him and what he wanted. He was an opera buff and he arranged it so we all got to sing opera. I just la-lahed. But I participated. And after, some mates were telling me about some of the Aids funerals they had been to. The one I liked was the funeral story of a real OTT drag queen who organised a whole day of scripted events. And at the end of the actual service in the crematorium, just as the coffin was disappearing into the incinerator, right on cue, up pops a hand, wearing a black velvet glove, with a diamanté bracelet, and it starts waving goodbye to the tune of '...life is a cabaret old chum!' He wouldn't have minded you laughing at that, would he? He'd probably have liked me to have explained it a bit better, but...

About four years ago, just down the road from me, where I live, they opened the first Aids Hospice - The Lighthouse. Right next to a school. To start with there were big problems with the kids - they're all passing by on the other side of the road, hugging tight to the fence - making a big thing out it. And of course all the little kids are learning from the big kids, so it had to be addressed. The people from the Lighthouse go into the school assembly and invite the kids into the hospice. And they all back off and make more of a thing about it. But then, cos it was boys, it suddenly becomes a competitive thing - 'Yeah, I'll have a look.' 'Eh? Oh yeah, me too.' 'Yeah, me an' all.' And suddenly it becomes a bit of a 'dare' thing, and then they're all in there. And they're shaking hands with the residents and it doesn't fester up and they don't die. So it's alright with the kids.

Next thing is the uptight local residents. Now normally, where I live, if someone's on yer doorstep with a petition, it's usually alright. But I've got this geezer on me doorstep going, 'Sign here against the Aids Hospice.' 'Go on. Why's that then?' 'It'll bring down the house prices!' And they're right of course. You've got an Aids hospice in the street, it's gonna bring down house prices. Good! Let's have an Aids hospice in every street. If needs be.

I reckon Aids is the earth's immune system getting rid of a very dodgy life form. Us humans. We're screwed as a species.

I can't hold a relationship together. I'm fucking weird somewhere, me. You know that advert for heroin doing the rounds at the moment? I saw it at the flicks. Not 'for' heroin exactly - it's a Public Service film to warn kids off and scare the shit out of their parents. It's a before and after thing. The focus is this kid in her late teens, girl next door type, that's the hook. She's not too straight, not too crustie - fluffy hair, twinkle in her eye, provisional Equity card. It could be your kid! Could be your sister. Could be you. And the scenario is: the parents are away for the weekend and its party time and the kids are wrecking the place. She's there dancing with her mate having a good time - not a great time, but a good time. That's the 'before'. Then, she's lured into the back room, 'Go on Tracey, we've all tried it, you know you want to.' And they've got all the gear - they've got the heroin on the silver paper with the lighted match underneath and they're 'chasing the dragon'

and everyone in the cinema all learn how to do it. I'm there for a Marx Brothers double bill, me! I don't need to know this shit. Anyway, after she's had her blast of smack and she's back in the party, it all goes murky. 'After'. She's slumped in a corner on the floor and she's lost weight, her eyes are dark and hollow, hair's lank, bit of sneer playing round her top lip. And I'm looking at all this and my first response is... 'Ooo! I fancy her.' It's weird what turns you on, isn't it? Alright, it's weird what turns me on.

I think that bloke with the petition moved out of the area. I hope he got himself a nice little cottage in the country. Somewhere with a load of undeclared toxic landfill. We've won that, you know. I assume you are Anti-nuke. I certainly am. I'm working with these research journos doing this telly doc. Seems it's all over, bar a lot of shouting. There's whitecoats sitting in round-the-clock meetings now - as we speak, or as I speak. You shut up, working out how best to decommission the nuclear power plants. It's the waste see. There's nowhere they can put it. You can't just bung it in a pot and chuck it out the window like they did in the sixteenth century. And you can't just dump it on the beach at Brighton like they... like they do now.

I was listening to the World Service the other night. I listen to the World Service every night. I listen until five in the morning when it comes on in German, French and English all at the same time! I do wish they wouldn't do that. Why don't they just do the whole thing in Proto-Indo-European and have done with it. I don't know.

...And they were discussing Chernobyl. And some Danish scientist says that he reckons there's an 11,000 to one chance of another Chernobyl occurring in Europe, in the next ten years. And I'm listening. Then a British boffin comes on and says it's more like a million to one, and then an American says that it's probably more like two million to one. And I thought, 'Well, even at 11,000 to one, it's gotta be worth a fiver.'

So, just for the politics of it, understand, I get in touch with William Hill's Special Bets department. Mate of mine says he'll put up some money - cos if you can get a bet on, then they'll shorten the odds. Yeah. Price'll come down and then if you get another bet on, and they shorten de dat de dat de dat and it becomes an issue. Anyway, I ask the geezer, 'What's the odds on another Chernobyl occurring, in Europe, in the next ten years.' And he says, 'Hmm. I'm gonna have to get back to you on that one.' Next day, he rings me back and says, 'I'm afraid we can't take that bet, because it involves human suffering.' And I said, 'How 's that then? You were offering seven to four against the Tories winning the general election.'

Did you go on the Poll Tax demo? Huh! Oh really? I went on the Anti-Poll Tax demo. Nah nah n-na-ah! I knew it was going to be a big one because so many wacky groups were organising things around it.

One of my situationist mates er comrades, rang me up. Situationists? Ultra-leftist intellectuals with a nice turn of phrase. In the late sixties they were saying that capitalism would turn everything into either commodity or spectacle. Early eighties most of them went into advertising. Anyway, I get a call from the eloquent rump: 'We're storming the reality studios, Saturday. Be there or be hopelessly rhomboid.'

I thought, this one's gonna be interesting. I'll be there. I ain't got a mortgage. Have you got a mortgage? Some of my mates have and it's done for 'em. Mortgage - Death Debt. All they seem to want out of life now is their slippers and a mug of cocoa.

It's weird having a mortgage, yeah? It's like having a taxi cab parked permanently outside the front of your house with the meter running and the cabby just sitting there with his feet up, reading The Independent.. Yeah that's right. You heard - The Independent - the image did not require a stereotype.

I walked to the demo about 3 o'clock, straight after breakfast. Nah, I'm no longer on active service. I claimed 'observer status'.

About ten years ago a lot of anarchists got very bored with the demos. Mainly because they were organised by the Trots and the lefties. 'Meet in the park, march round to Trafalgar Square, listen to Tony Benn and go home.' 'That's not the revolution is it?' So the younger punkier elements, the 'class warriors', started disrupting demos. 'I don't spend all week finking up a slogan for me banner just for that. I wanna smash a copper over the 'ead wiv it or somefink.' So they started organising their own demos. Me? I found other ways of expressing meself.

Anarchists and Trotskyists are very different. They only ever get any publicity around demos, but they are very different political animals. You know that anarchists didn't organise the anti-poll tax demo - it started in the morning. I for one don't do mornings - I am not into a.m.

Although the police did concede that although the anarchists hadn't organised the demo, they were responsible for most of the trouble. The police issued a bulletin stating that there was a hard core of three an' half thousand anarchists. Three and half thousand? Immediately the anarchists issue a bulletin: 'We agree with the police. It's true. There's three an' half thousand of us. Available for actions, demos and revolutionary situations. No mornings.'

That's the major ideological difference I have with the Trots - their obsession with work. They are committed to getting the workers to identify with being workers. That's gotta be a flaw in the thinking, that.

I don't like work, me - never have done. All that digging holes and filling 'em in again. I mean, it's bad enough being born and bred working class. Now What? I've got to go to work? Oh-come-on! I am, as it 'appens, allergic to work - brings me out in a rash - yeuk! I am psychologically unsuitable for work. And anyway I'm a conscientious objector. I've always reasoned I've done nothing wrong. Why should I have to work?

So I walk to the demo in a mellow mood, through the parks - Kensington Park, Hyde Park, under the Corner, Green Park, St James' Park and Trafalgar Square. Mellow.

And I'm just walking through St Jame's Park, when I remember that Peru was refusing to pay their debt to the IMF - the International Monetary Fund. And if they are forced to pay, then they'll have to consider chopping down their rain forest. And I thought, Yeah! If I have to pay the Poll Tax, then I'll have to consider taking a chainsaw into St Jame's Park. P-parp p-parp parp parp p p p- Whiiiieeerrrrr!

Anyway, I get there - I more or less had to push me way through a police cordon to get in. And it is a big one. It is wild. There's a hotel on the corner of the Strand got the builders in - major construction job, and there's hundreds of comrades and scruffy street kids clambering up on the scaffolding. They're hanging up their banners and waving flags. And I thought, 'They won't get 'em out of there in a hurry - half of 'em are homeless.' Although they set fire to it a bit later so maybe not.

There's all sorts of stuff going on. Big role models them kids in front of the tanks in Tiananmen Square. Police are charging the crowds on horseback, and everyone who isn't dancing is pushing and shoving. So I thought. Nah! Observer status. And I climbed up the front of the National Gallery. I wasn't for looking trouble. I just wanted to watch some. Meet a few old mates and have a spliff. And opposite - Northumberland Avenue is chocka and there's a police barricade across stopping 'em coming into the Square. It's the tail end of the march - 4 o'clock and it's still coming in. 'Do you reckon we've missed Tony Benn?'

And then some kid climbs right to the top of this construction crane. And he gets to the top and people notice him and start cheering him. And he starts waving - careful. He's higher than Nelson's Column. He's up in the ozone layer. And then... he starts to climb out along the limb of the crane. And we're all watching him, but we're not cheering him so much. And this kid, bless him, he made my day. He climbs right the way to the end. And then he stands up - arms outstretched. And he goes 'Yeah!' And we all go 'Yeah!' And I thought, I bet he hasn't got a mortgage! You can tell, can't you? If he'd have jumped, then yes.

And he's going 'Yeah!' and we're all going, 'Yeah!' He should have had a mic - one of those cordless jobs like Tina Turner has - shape of a dildo. He could have said anything and we'd have loved it. 'It's brilliant up here!' 'Yeah!' He could have counted us all and disputed the police figures. 'One two three fo fi si... There's half a million of us!' 'Yeah!' 'That's right, half a million. Who are you gonna believe? Me? Or the bloke in the helicopter? He's from the West Midlands Serious Crime Squad. You gonna believe him?'

Then, and I had this pointed out to me by one of the Supreme Council of Class War, who I was sitting with, the police started using weapons and strategies that they'd learned in the laboratory - Northern Ireland. To me, it just looked like reckless driving on the pavement. But if they are using Northern Ireland as a testing ground for stuff, then why didn't they try out the Poll Tax in Northern Ireland? No, I don't think so. It might just unite the community. Eh?

They got 'em out of Trafalgar Square in the end. Good strategy? Hah! Thousands of 'em running riot round the West End all night. They were still chasing 'em on Sunday morning.

I did a little telly series recently. Yeah yeah. Babylon. I know -Television? Greatest breakthrough in anaesthetic since chloroform. But listen. I've been in the biz, yeah 'In the Biz' - this is biz talk, yeah. Apparently what with cable and satellite and shit, in a few years time, the wages in television, 'specially down the bottom end, is going to be the pits - average budget for an hour's telly? - four grand. Four grand? That's fuck all, that! That's chicken feed. Well, not chicken feed. Dead chickens is chicken feed. But four grand. What will that buy? Studio in a converted telephone box, cameraman with a glove puppet doing his own voice-overs. 'That's the way to do it!' We're talking Harry Corbet and Sooty on the cheap. Sooty gets through a few Harry Corbets, doesn't he?

So, a little learning process, in the belly of the beast, while they're still paying. That's my rationale anyway. I don't want British television to be the envy of the world. I want it to be crap. So I don't have an excuse for watching it.

I used to watch so much of it. Seriously hooked. I mean the opiates in Afghani black are bad enough, but when you're a media junkie, your stuff gets cut with real garbage. And I thought I could handle it. Just keep it to the important stuff - keep away from the quiz shows and soap

operas, just the in-depth news reports, heavy duty documentaries and the snooker. And the highlights of the snooker...

Old George Or in his book 198, he reckoned, that by the year 1984 on every living room wall, there'd be a telescreen blaring out trivia and government propaganda and every home would have one, because every home would have to have one, because it would be compulsory. 1984. Well, he got that wrong, didn't he? By 1962 everybody had volunteered.

The moment for me was - when I'm sat there watching an old film, and a mate comes round: 'Any Good?' and I hear myself say, 'Nah, I've seen it before - it's crap.' Reality check!

I had it bad - screen at the bottom of the bed. I watched the lot, channel hopping with the remote. Ooo! A costume drama about the Second World War. Blip! Ooo! A reappraisal of the Russian Revolution. Blip! Ooo! The one with old news footage and the vintage pop songs - Harold Wilson and 'I-can't-get-no-sat-is-fac-tion!' No, I'm videoing that one. Blip! 'And now, a re-appraisal of last week's news.' Aargh! Blip! 'A trawl through Yesterday. 'Blip!' Yesterday for beginners.' Blip! A repeat of 'All Our Yesterdays!'

Then I get the insight - unconsciously there's something quite profound going on - all these telly programmes, all geared to interpreting yesterday, and to re-writing the re-writing of history. So that it all dovetails neatly into this ludicrous conclusion that now, now - what the politi-cians refer to as 'this moment in time.' ...Now, we are somehow living at the finely tuned cutting-edge of progress! BOLLOCKS! When a civilisation dies, its whole life flashes before it. Blip! Blip! Blip! Blip!

So last year I decided to knock it on the head! No more telly. I lasted six months. Weird cold turkey. I never had the camera running on all that iconic stuff - The Berlin Wall, Tiananmen Square, Romania - nothing. BBC World Service - do your own pictures. Ceaucescu - Mr Punch. But I would have been watching that stuff twelve hours a day. So I reckon I've gained three months. But just before I packed up television, I thought, I'll have one last look at a few videos. And there was this beautiful French film I'd video'd on Channel 4, and you know, it was er, well, the only reason I'd video'd it was because there was some really very good horny bits in it. But when I re-played it, it wasn't there, I'd video'd over the top of it. I'd video'd Their Lordships' House. Yeah? Which became my favourite (for very different reasons). No, Their Lordships' House is so bi-zarre. It really is bi-zarre. It was the opening of Their Lordships' House and Quentin Hogg has got this long gown on, with lace doilies on his cuffs. He's got black stockings with garters, and little high -heel bootees with little buckles on the booties, and a big belt there, with a ceremonial buckle there, to match those buckles, and a real royal Ascot show stopper on 'is 'ead. And he's got a ceremonial staff, and there's three of them, and they're all dressed much the same and they're mincing in to the House of Lords. And I thought these people discussed clause 28, for fuck's sake. This is the highest Court in the land. This is the pinnacle of the British decision-making process. I'd like to take that video of Their Lordships' House. I'd like to take it up the Amazon. Where there's one of those tribes who, what they do all day is drink hallucinogenic nectar and dance around the camp fire and think up new ways to make love to each other in the communal hammock. Ooo! Oo! Oo!

I'm gonna write a book one day, called 'Tribes, Sub-Cultures and Ethnic Groups to Cite in Anarchist, Feminist, Utopian Arguments'. Well, it's needed, isn't it? It is, yes. You know what it's like. In the pub, late at night, and you're arguing. And you're pissed out of yer brains, and you're

coming out with a right load of old bollocks. 'And here's another load of low-flying dodgy logic I've just thought up...' Wouldn't it be so much easier to say, 'Hang on a second - moment...The Umbogie tribe of Papua New Guinea have got 73 words for love but NONE for property'. Thank-you-very-much!

Mind you. You can't just go citing any old tribe of primitives. In Papua New Guinea alone there are 700 tribes. Each with their own culture, their own language, as different from each other as... Well, there's one lot - totally unique - tall, serene with a life expectancy of 75...

The life expectancy in Chad is 26. 26 f'fucksake, 26? That means you go through mid-life crisis and puberty at the same time. 'I don't know what to do with my life, me. It's like I've done everything there is to do and Ooo! What's this Ooo! Ooo yes.'

But these people in Papua New Guinea. They're very dignified people and they're pacifist, and they're vegetarians. In fact they are frugivores - all they eat is the fruit that has fallen from the trees - they don't even pick it. And then they thank the tree. 'Thank you.' And they supplement their diet with a drop of yak's yogurt, and presumably they thank the yak. 'Thank you!' And what they do all day is: they re-birth wild flowers that they've trodden on while dancing - hiymm hiymm hiymm! Very elegant people.

A few valleys away, on the other side of the mountains, there is the polar opposite. You can't just go citing any ol' tribe of primitives. There's these cantankerous chunky macho little bastard carnivores - 'Grr! Nyah! Nyahh' - with some very odd courtship rituals. If a male fancies a female, and she's with another male, and they all are. What he has to do is confront the couple - 'Oi! You two!' and then he has to eat a bit of the other male. Grr! Nyahh! Nyah! Grr! Nyahh! Nyah! 'Oh! He'b sdolen my girl ad deaten myd ndose.' So you can't just go citing any ol' tribe.

In Polynesia when they go to sleep, they all dream together, and then go off flying together in their dreams. 'Not you Kevin, you had a nightmare last night and spoilt it for everyone.'

In North Western Australia, the Gagaju Aborigines, before their recent cocacolarisation with a dash of tequila. In forty thousand years of their culture they have never built a monument. But in all that time they had not changed their environment for the worse, one iota. That is their monument. I got that off a David Attenborough documentary. It's fucking brilliant, isn't it?

My mate's doing a research job on all this stuff. The tribes of Anthropologia - the Kogi, the Kyapo, the Yanomami and I'm mad for it! As you can tell. One lot in the Amazonian rainforest - I can't remember which - not the Yanomami - they're the poor sods had the misfortune to have their sacred burial grounds directly above one of the largest potential gold mines in Brazil. Is that a nightmare? First group of people they ever meet from the outside world is a full-on gold rush. Thousands of crazies steaming onto their lands, ignore them and dig the biggest hole they've ever seen. And after, when the Yanomami have been introduced to alcoholism, prostitution, and a range of diseases they had no immunity to, the owners of the goldmine company agree to fill in the hole and landscape the scenery back the way it was before. Digging holes and filling 'em in again. If only that was all it involved. Next time they discover some gold under someone's turnip patch, I reckon they should leave it there. Cos what happens to it, anyway? It only ends up in Switzerland or somesuch. 'As a measure of financial collateral'. In a bank vault deep in another hole in the ground. Let's just cut out the middlemen. Leave it deep in the ground where it's always been, and it belongs to the bank; it's theirs. It's safe, and this tribe will live on top of it forever. We have to

cut out all this digging holes and filling the fuckers in again. The fate of the Yanomami Indians - I really must letter-bomb my MP about that.

Where was I? Oh yes the Kyapos, is it? It's more than a rainforest to them. It's a sort of farm - these people have been casually farming the rainforest for generation upon generations. This is brilliant - they're just coming home from a bit of blowpipe practice, right? Wandering through the rainforest and they'll spot some particular plant on the path or in a clearing. 'Hang about everybody. Hang about. What's this doing here?' And they all stop and they start moving the plants around. They take certain plants and move them away and replant them deep in undergrowth way over there. This confuses the flies who lay their eggs on the leaves of that plant - 'Where's the plants gone?' They buzz buzz around - buzz buzz and eventually they find the plants way over there, and they lay their eggs. And the leaves fall to the ground and grubs emerge in the leaf mould. Then the little rodents who eat the grubs in the leaf mould - 'Where's all the grubs in the leaf mould?' And they pitter patter around - pitter patter, and eventually they find the leaf mould way over there and they eat the grubs. Then the hunter spiders who eat the little rodents - 'You seen any little rodents?' 'No. Not a pitter patter!' 'No, me neither - best do a recky then, eh?' 'I think so.' And the hunter spiders recky around recky recky and eventually they find the little rodents way over there and they kill them and eat them. And then the poisonous snakes who have a particular penchant for hunter spiders - 'Ooo! I do fancy a hunter spider. I haven't had hunter spider for yonks!' 'Nah me neither etc.' And they zig zag slither around zig zag slither slither and eventually they find the hunter spiders way over there, and they kill them and eat them. Meanwhile the kids play way over here. No fucking snakes! Nah! Nah! N-nah nah! And none of the paths through the rainforest has any of those plants Or any of those snakes.

And they know their plants - some varieties they cultivate and grow alongside other varieties: 'so-called companion plants which flourish in a symbiotic relationship with each other,' it says here. And all manner of exotica is bursting forth in fecundity - nuts bigger than coconuts, potatoes sweeter than sweet potatoes, and giant mangoes - Ooo! Which of course is just brilliant. Ooo! Ooo!

Meanwhile, they arrive back at the village laden with all these other plants, and seeds, and berries, and roots, and shit. And shit? Yeah, probably. And that's a whole range of stuff they've brought for the shaman. He runs a market garden and a drop-in pharmacy. Anytime they're ill or bitten by snakes, they go see the shaman. 'Wah Wah!' 'Ere, try this.' 'Oh, nice one.' And he's got potions for everything. It's just like the National Health Service 'cept you don't have to pay. Just bung him a leg o monkey occasionally. Oh no, they're not perfect. Vegetarians they are not. They're carnivores and so would you be if you lived in a rainforest environment where meat grew on trees. Hoocha hoocha hoocha!

Then, when it's right in the sky, they all meet for the feast of the full moon. Food, drink, di-dat di-dat di-dat! And after, they sing the news to each other.
'There's-a-tree-fallen-down-in-the-river.'
All together now -'There's-a-tree-fallen-down-in-the-river.'
And when they've all got it, they sing it one last time all together, followed by last month's news, and the previous month's news, and last year's and news going back generations, some of it now truncated to nuance - nu nuan, nu nuan, nu nuan. And they all know what it means, and they all

know what they're singing, which is great, and we don't, which is tough, but it's their gig. And then they relax with their drug of choice which can involve sucking the innards from roasted beetles. And then, before he retires for the night, a village elder chairs a public meeting.

'Right, minutes of last meeting?'

'We did that in the song?'

'Good. Yeah. Passed! Right! What's occurring?'

'I think we ought to do something about the tree that's fallen down in the river.'

'Good very good. Yes. Volunteers? You, you and you. Good. Anything else?'

'Yeah, a lot more fucking and a lot more moving the plants around.'

'All those in agreement?'

'Yeah!'

'Right! Any other business?'

'Yeah. Who's bogarting the roasted beetle?'

'Good point. Oi! Over here with that. Right. Is that everything?'

'Yeah!'

'Good. See yer next month. Happy hunting. Watch out for the snakes.'

I'd like to get that video of Their Lordships' House and show those people.

'Alright! One meeting, comrades! Stop all that fucking and moving the plants around. This here is a generator, and this is a video system, and this here is Their Lordships' House. See that? ...In civilised countries... that's how we make decisions.'

Ten years ago the anarchist tribes stopped going on the demos. And they started organising their own demos. There were the 'Bash the Rich' demos. Which I thought were a bit boys stuff, really. Okay, there was a Minnie the Minx role model in there alongside the Dennis the Menace role model. But not quite my style. And then there was the Stop the City demos. Now they were brilliant. Some group of tearaways create a diversion and then everybody else breaks the windows of the banks. Highly symbolic. One small problem with that - the profits of the Pilkington Glass Company went through the roof.

The Smokey Bears 'Free the Weed' demos got very playful, less people maybe, but more lateral thinkers. Big problem for the police escort. Usual scenario - meet at Hyde Park, but instead of marching round to Trafalgar Square, it was more of a shambolic stroll not through but across the West End, with a third of the participants never quite leaving the park. 'Trees - yeah neat.' The best one was 1987, I think, when they actually organised the chaos - oh yes, anarchists can organise when it's appropriate. The word was 'Selfridges' clock - split the demo'. 5000 people marching up Oxford street and at Selfridges' clock they split the demo, Selfridges' clock - split the demo, Selfridges' clock - split the demo. Brilliant, just left two old hippies with a Legalise Cannabis banner and the full police escort walking round to Trafalgar Square. 'What are we doing, Sarge?' 'Fuck knows but let's get it over with.'

Best of all, for me, was a few years back when some of them right-wing American evangelists decided to convert Britain to born again Christianity. A bunch of situationists launched the Can't Pray Won't Pray campaign. I really got into it - right laugh. We warmed up for it by heckling Lord Soper at Speakers' Corner, and Stuart the Balmy Baptist. Mind you, you only have to

ask him the time and he goes loopy - 'The end is nigh that's the time.' Then we got on Luis Pallau's case at QPR football ground. He was there for a whole week, so there were crowds of a few thousand each night - different congregation, bussed in from round the country. But we were there every night. We may have difficulty organising our own political movement but we certainly know how to disrupt other people's.

First day we just heckled, second day we played football - Devils v Angels. Some people got costumes together - horns, black cloaks - the whole bit. And we got thrown out and the papers called it 'rent a mob' so that's what it became. By the last night they had started to recognise us. So we arrived all bandaged up, on crutches; someone was trussed up in a strait-jacket. We sat up the front and got patronised and then right in the middle of the last hymn, we all jumped up. 'Praise the lord. It's a miracle!' It was corny but we liked it.

But my favourite was Billy Graham at Earls Court. Standing there with his suntan, light blue lounge suit, giving it guilt trip. Three of us heckled him at the same time but at different intellectual levels. 'Is God and Jesus the same person?' 'What's in it for me?' 'Who's your fucking tailor?'

See, the God squad, they KNOW God exists. They KNOW! It was then I sussed out that some of my comrades in the Can't Pray Won't Pray campaign were atheists. Fucking Atheists. They KNOW as well. They KNOW God doesn't exist. Everybody fucking KNOWS, don't they? Me? I'm a militant agnostic - I don't know. I'll go further. I KNOW I don't know. See, I'm capable of holding two opposing opinions on any given subject, plus a lateral third option and arguing all of them, at the same time, 'til the cows come home, to the meat-packing plant, that's after the ranchers have chopped down the rainforest. Now in any other walk of life, this would be seen as needing psychiatric help. Luckily I'm a creative artist so it's all right. Goodness knows what's gonna happen when the right hand side of me starts working.

An infinite complexity, that's the nature of things, isn't it? An infinite complexity. And now we've got chaos theory. Ooo! I do like chaos theory. Chaos theory's got its own computer-generated er manifestation of yer actual patterns of chaos - The Mandlebrot Set. Have you seen this? The more you look into it, the more infinitely complex, and the more you look into it, the more 'infinitely complex' - quick skin-up and clock this - 'infinitely complex'...it's like animated avant-garde paisley, this. 'Infinite complexity'. Mathematically simple, exquisitely beautiful, and infinitely complex.

I never liked Maths - I could do odds, but never Geometry. And this is 'fractal' geometry. Chaos theory can prove that change is the only constant. And as a result all the disciplines of science have gone chaotic - and I don't mean all the whitecoats are lurching round the laboratory knocking over the beakers and spilling gunk out of the test tubes. I mean yer actual scientific process of empiricism (dependant as it is on unchanging initial circumstances) is screwed. So we can dump that intellectual fascist Isaac Newton and start to inhabit our own century before it peters out.

Usually at this point in an argument I introduce Heisenberg's Uncertainty Principle. Heisenberg reckoned. In 1928 this was, I think. It's all just been stacked in my brain this, right. Bit o background - as told to me: take a lump of stuff, metal stuff, for the sake of argument, and you cut it in half, and then you cut it in half again. And you keep cutting it in half until you are only theoretically cutting it in half. What you are left with eventually is 'an atom'. 'Nature's building

block'. Isaac Newton said that. And the Pope, at the time, agreed with him. And the Pope's infalli-
ble - well actually he wasn't infallible at that particular time, but he was still fucking arrogant.
Anyway - both of their time, and both wrong. Now, if you want to look inside an atom? And an
atom's small. How small's an atom? Fucking small. Good. Yes thank you.

How small's an atom? If I had an amazing pair of tweezers, and I took an atom off my
thumb - nip. One, every second - Znip! Znip! Znip! Znip! I would have to've started at the beginning
of time Znip! Znip! Znip! Just to get that much! - Half a thumbs-worth! So they are... fucking small,
right? So if you want to see inside an atom, which is fucking small, what you have to do is put some
light on it. Click! Click! More light. Click! Click! More light. Click! Click! Click! Click! 'How much
more light?' 'A quantum of light!' 'A quantum of light? How much is that?' 'It's a fucking lot.'
'Okay.' Brrreeeieieizzzzzzz! Ah! But then, you change the nature of what you're looking at. Because
an atom is so fucking small and yer quantum of light is so whatever it is. You can't see fer the
lookin' of!' It's all different before yo.. You see, 'The act of observation changes the nature of what
is being observed'. Alright, an example for the slow ones. If an omnipotent being, right? Wanted to
see inside the er Biscuit Tin Cabaret, at the Cabbage Patch, Twickenham. Yeah? If he wanted to
have a little look. And instead of just coming through the door and up the stairs there and poking
his head in and saying: 'Oh, a nice little gig going on. Fair enough.' Instead of doing that, he was
to hover above the building with a ginormous great oxyacetylene burner of a lightning bolt and blitz
the roof off. Wheeeeeniiininin! We'd all be dead. Dead of severe burns. But that doesn't mean to
say that the cabaret club at the Cabbage Patch is always full of dead people with severe burns. The
act of observation changed the nature of what was being observed.

So too with the atom. You hit it with a quantum of light Wheeeeeniiininin! You change it.
When they are looking when they hit it with a bolt of light. What they see is...well, fuck all. Nothing!
Except a few flecks of energy - a tiny little nucleus with a few neutrons and protons buzzing round.
And a few electrons buzzing around that. But that's only when they are looking. When they're not
looking... anything could be going on. Anything - continuous repeats of the News at Ten. Anything.
The dance of the Gods? Anything! There's a tree fallen down in the river nunnan nunnan n n n.

Sub-atomic scientists at Cern in Switzerland have built a particle accelerator 9 miles...
never mind that in America, in Texas, where else, they're building a bigger one - a particle acceler-
ator 53 miles in circumference. Made up of tens of thousands of electro-magnets. And what they
do is, they chip off a little stream of protons - little protons, done fuck all to anybody. All a proton
does is go bip bip bip inside the nucleus of an atom - doesn't move very far - but it never stops -
never been on a 53 miles round trip - just bip bip bip! Inside a nucleus - never see a proton sitting
on a futon. Then suddenly they are sent whirring round the accelerator at the speed of light
Whirrrrreeee! Whirrrrreeee! Whirrrrreeee! Well you'd go at the speed of light with a laser beam up
your arse, wouldn't you? Whirrrrreeee! Yeah alright! Alright! And then they chip off another bunch
and they send them the other way - Whirrrrreeee! Whirrrrreeee! Whirrrrreeee! It's a bit like the M25,
only faster. And then they create a diversion and smash 'em in to each other - Whirrrrreeee! Smack!

And all the bits fly off. New bits. Bits they've never seen before. Bits that only last a
'moment'. Bits so insubstantial that they can go straight through you, without you even noticing -
bit like low-alcohol lager. And then all the scientists who have worked on the project, they all form
a queue and they get the bits named after them. And one of them cops for a Nobel Prize. And they

probably think I've got a silly job.

But they still won't have seen an atom, let alone the tiny bits it's made up of. All they will have is a record of an impulse, picked up by a detector and displayed on a computer screen. Very circumstantial evidence. Not even a signed confession taken down by the Surrey police. Nothing. And all that's costing 9 billion dollars. I bet they're not collecting it individually like they are the Poll Tax. Are they? 45 dollars, off every American...

'What we're collecting for here Mac is, we've recorded the existence of these minute specs or matter that only exist in a world of quantum mechanics and we're gonna name one of them after our head of the department. Cost of 9 billion dollars. Breaks down to 45 dollars apiece?

'Yeah, and fuck you too fella!'

Sometimes I go down very badly. What with half the references going over people's heads. I get these up-market punters - the sort of people who put Perrier water in the radiators of their BMWs, 'Make me laugh', or plebs who are too pissed - 'I'm not listening to this shit.' But, to be quite honest, I do this just for me. 'Fuck it', I think, 'Lenny Bruce finished his career out of his head on drugs, hassled by the police and dying in a toilet.' That's how I started off.

Then I get quite philosophical about it. What am I anyway? I'm this insignificant spec of life, clinging to the surface of an off-shore island on a piddley little planet, one of nine piddley little planets that is laboriously going round and round this star. Which is one of countless millions of stars. No. Billions of stars. Now, with the Hubble satellite, when they get the fucking telescope working, they reckon they can see all these 'dark stars'. So it's billions of stars.

And they comprise a small section of the Milky Way galaxy - that bit there on the Western spiral - which is, well there's as many galaxies out there as there are punters in China - a fuck of a lot of galaxies, right. And they make up a small part of the known universe... The known universe? Who 'knows' the universe? 'What? Me and the universe. Like that. Go out drinking regular.' ...the known universe, which is aimlessly expanding in a backwater of the cosmos. Doesn't matter if I go down badly or not, when you think about.

And in the next galaxy to ours... I'm doing it again. Our galaxy?

I'm always doing it. My country's another one. My country. England! England! Bollocks. My country? If this is my country, I want my three and a half acres NOW! Alright, I know it's only a couple of acres when you do the sums. But basic trade union negotiating strategy - always demand more than you're willing to accept. My Country! My bank's another one. I'm just popping down my bank. My bank? If it was 'my' bank, I'd be in there at the weekend, having a go on the mainframe. My bank. The bank! They sent me a letter the other day, the bastards! 'Dear Sir, You owe us nine pound! You are nine pound in debit. Do something about it, a bit lively. Get yourself a proper job. Ninin nin nnin - the manager.

Do you get them letters? I hate them letters. I never send 'them' a letter when I've got nine pound in there. Mind you, I should - Hello, I've got nine pound in your bank. I'm nine pound in front. Just thought you ought to know. Oh and by the way - I'm charging you twenty-five notes for sending you this letter. Na-Yah!

Nine pound - my problem. 900 pound it really would be my problem. If it was 9 thousand pound I'd be up shit creek without a methane gas extractor. If it was 9 million pound, it wouldn't

be my problem any more. It'd be the bank's problem. That's what I'm going for - under starter's orders. Friday night - with the cheque card - kite my way through the weekend. Get myself into as much debt as possible with the bank most likely to collapse. Then they'd probably lend me another million to help me get meself out of trouble - Here you are, invest wisely this time - shares in the family silver, property in northern France, diamonds yeah, Turkish kidneys - good mark up on them, invest wisely.

Robert Maxwell owes 2 billion to the banks; Rupert Murdoch now owes something like 4 billion to the banks. Not their problem - the bank's problem. When I first heard that, I thought, Rupert Murdoch 4 billion pound adrift. Me - nothing (I was solvent at the time). Then I sussed, hang about - Rupert Murdoch has got 4 billion pound 'less' than me. Ooo I did have a spring in my step when I sussed that out. Sproing sproing sproing! So how come I'm still skint? I don't understand this. But I'm getting an inkling...

There are no more rich people. There are only people that owe more than you. And if you know someone with a few bob, they're just working for someone who owes more than you can comprehend. And whose accountant exists on the fractal boundary between financial consultancy and conceptual art.

My mate sends me a cheque for sixty notes that he owed me and I put it in 'my' bank and it bounced - because he didn't have enough money in his account to cover. And then 'my' bank, 'My' fucking bank charged me six quid for bouncing a cheque in my account. They are doing that now. I thought, 'what's going on here then? How can we curl this?' Think laterally - yeah. Who shall we hang this one on? John Major. He's the Chancellor. What we do is, we find out John Major's bank account number, and everyone - I'm talking chain letters here - sends him a cheque for more money than we've got in our accounts. Then we'll see the interest rates start dancing.

We all owe money to the banks. The only difference between now and ten years ago is that we've all got loans, overdrafts and mortgages. 'Here you are. Here's a few bob - get yourself through the eighties.'

If you've got a mortgage, you probably won't be here at this time of night. Cos you've got to be up in the morning to get to work - rush down to the bus stop - check the taxi meter tic tic tic 'Oh dear, it's gaining on me.'

In a recession cabbies'll go 'South of the River', won't they? Give 'em ten quid plus their petrol money, they'll go south of the Yangtse!

It's not quite so cool to be in debt, nowadays. Everybody's in debt.

But you, me, Maxwell and Murdoch, are just the tip of a very big iceberg. At the start of the knocking nineties, everybody owes the banks. Little companies owe the banks; provincial English towns owe the banks. That's why they're all advertising on the telly. 'Come-to-Milton-Keynes-we're-potless.' And it doesn't stop there - large corporations, and entire countries owe the banks. America owes the banks. In fact, every country in the world owes the banks. And now even the banks owe the banks. 'Even the banks owe the banks? How can the banks owe the banks?' You see, they've exploited everything until there's nothing left to exploit. So now, they are exploiting the future.

Underwriting all of this is a sort of casino set in the future - the Futures Exchange - where all those who owe the most get to play Russian roulette with the life of the planet. In short: a tawdry short-term mortgage has been taken out 'on the future' using the Earth's dwindling resources as sole collateral. And yer actual money is not appropriate when gambling on the Futures Exchange.

If you have the 'confidence', the 'connections' and the 'know-how', you can join in the surrealism. You can buy, say, 3 tons of beef burgers, from Latin America, in say 1999. And then you just watch the way the dice fall... 'October beef - up 30. We're doing alright - Nugde! January beef - up 40. Nudge! Nudge! April beef down how much??? It can't be???'

And there's people topping themselves, slinging 'em selves off bridges, 'cos they've done their bollocks 'in the future'. The cows haven't even been born yet! They haven't grown the grass yet for the cows to eat! They haven't even chopped down the rainforest yet, to grow the grass.

The rainforest - the Kyapo Indians. I rather liked them. They've got their three and a half acres. They're self-sufficient. They've got their clean water and fresh air. And they've got abundance and diversity. They've probably got a cure for Aids in the pharmacy deep in the rainforest. P'raps I should be a hunter gatherer. Nah. Not on the Portobello Road. It wouldn't work, would it?

As one lot of tribes are forced to change and conform, then new tribes and sub-cultures evolve. I've just come back from Glastonbury. Thousands and thousands of crusties - new age travellers - gathered outside the festie and demanded to be let in. And they let them in - gave 'em three fields - crammed them into three fields. It was urban in those fields and it was wild. And some of the vehicles... I saw a big old post office van with a chimney, a Fire Engine with a stained-glass church window and a thatched roof. These people are artists. Very few of their vehicles had en suite bathrooms, but that's not the point. They believe in chaos; they believe if you throw it all up in the air, whatever way it shatters apart when it hits the deck, it must be better than the way it is now. Because they can't get the dole at the seaside, you can't be arsed with all the silly training schemes, then: 'No dole for you'. You're 16-18 and your parents have gotta find five hundred pound Poll Tax - easy solution, 'Out!' Mental problems? All sort of forms to fill in. Kids can't handle it. But there's safety in numbers - they're all joining the crusties. It's all down to Mrs Thatcher. She really doesn't like 'em, does she!

It's worth going on these big demos, you know. You might be the final addition that turns the mass critical.

There's an old heckler put-down line that goes...'Of all the millions of sperm that had to get through, it had to be... you.' A seemingly insignificant event. But had a different sperm 'got through' it's safe to say: that heckler would be a very different personality. And not just the heckler; everything else would have radically changed as well - the whole audience, the whole social infras- tructure - even the comedian and his patter would have altered. In the new scheme of things, he would just as likely be an oil-rig worker or an inmate of a Strangeways.

Had a different sperm managed to 'get through', our entire culture would be very differ- ent... A single flap of a butterfly's wing can create the vital eddy in the turbulent birth of a hurricane. The Butterfly effect - I've always understood it. Since I was seven. When I was a kid, I was crossing a main road, and changed me mind halfway. I suddenly got philosophical. I'm stood by the bollard, thinking, 'If I stop the traffic, they might miss getting in an accident down the road, but on the other hand... Age of seven I'm musing on the responsibility of derailing history onto a parallel universe. Bit later when I realised that everyone was at it, it didn't seem such a big deal. But it was and it is. 17 million deaths on the roads since the invention of the motor car.

But I've leapt ahead a bit...

Had a different sperm 'got through', a sperm like all the other millions of sperm in the running, all self-similar, all infinitesimally different, each with its own identity, its own unique DNA

structure; had one of them 'got through', a very different foetus would have formed, with a mother experiencing a very different pregnancy and giving birth at a different time - seconds, minutes, even days, weeks earlier or later. A fresh 'drop everything' journey of panic and celebration to hospital. Familiar riff of sirens re-arranging the traffic. Motorists checking their mirrors. Is it the police? Or is it an ambulance? Oh fair enough pull over. Pull back in lane again. Few seconds delay, just miss the lights. And they're resuming their journeys in a completely fresh matrix of time / space relationships - different drivers of different vehicles now involved in fresh dynamics and involved in new accidents; original accident victims, now experiencing safe journeys - possibly. Within hours the repercussions would spread virtually throughout the whole national roads system and social infrastructure, fundamentally changing the lives of millions.

Had a different sperm got through. Marc Bolan would still be alive man, if you'd been a different sperm. Yeah and hundreds of thousands of others would have lived too, to one day die in wholly other circumstances. We, all of us, are indirectly responsible for changing this and a whole bucket more, before we are even born. So go on the demos and be nice to each other and wipe that sneer off your face - it's counter-revolutionary! Where was I? Oh yes...

And in the next galaxy 'to the one we're in', a supernova has exploded - Puh-pow! And they're not sure yet... because they're still checking the neutrino pulse... Neutrinos! Neutrinos are something else. Yeah. Literally something else. Neutrinos are weird. The neutrino pulse contains the info. Get your head round this - we are being constantly bathed in great waves of neutrinos. Neutrinos are being emitted from the sun and distant stars and exploding super novas - Puh-pow! All the time. Endless streams of neutrinos are passing through us now. Neutrinos are so small and so fast that they go straight through 'our' planet and out the other side in a moment. They go through the ozone layer, which isn't difficult, they go through this thin crust where we live... Just here. With our banks and Poll Tax and nuclear power stations, the Kyapo are round here somewhere dancing round the campfire...through the h-hot bit in the middle - Australia - and out the other side. In a moment? How do they do that then? I asked this mate o mine who knows about these things. I said, 'How do they do that then?' Apparently they travel at the speed of light and they do a sub-atomic slalom round every atom in their path. Skidum skidum skidum. That's bollocks that! Who did the research on that? That can't be right. Can it! I'm not having that!

Anyway, they are just monitoring the neutrino pulse... and they're not sure yet - the whitecoats - whether this super-nova that's exploded is going to turn into pulsar. Bing bi-bing bi-bing spreading light, like a beacon, across the cosmos; or it could be a 'black hole!' A black hole. Them suckers are bad news. Shlurrrp! Shlurrrp! But it could be a pulsar, Boing! Boing! Spreading light, and light is life, and life is love, and won't-you-shine-your-little-love-light-on-me. But it could be a black hole. Shlurrrp! Bad news!

A bit of inter-stellar fog. Ooo I love a bit of inter-stellar Shlurrrp! A bit of detritus of an old planet. Ooo I love a bit detritus Shlurrrp! Bad News and we can't really blame that one on Mrs Thatcher and the Tories, can we? No.

If you've seen me before and you're thinking, 'Some of that's old material.' Well, and I think I've got this right - the information from that supernova exploding, travelling at the speed of light, has taken 151 million years to get here. So that's old material, isn't it. All power, much passion to you. See you again, yeah?

cartoon by Helen Cherry

Bibliography

Allen, Tony and Miles, John. *Rough Theatre Plays.* Open Head Press 1978

Billington, Sandra. *The Social History of the Fool.* The Harvester Press 1984

Byrom, Michael. *Punch and Judy.* Shiva Publications 1979

Charoux, Jac. *London Graffiti.* W H Allen 1980

The Comedy Store. Little Brown 2001

Complete Works of William Shakespeare. Abbey 1973

Cook, William. *Ha Bloody Ha.* Fourth Estate 1994

Double, Oliver. *Stand-up: On Being A Comedian.* Methuen 1997

Eric and Ernie. *The Autobiography of Morecambe and Wise.* W H Allen 1973.

Freud, Sigmund. *Jokes and their Relation to the Unconscious.* Penguin Books 1960

Griffiths, Trevor. *Comedians.* Faber and Faber 1979

Leach, Robert. *The Punch and Judy Show.* Batsford 1989

London Telephone Directory E-K 1979

Morton, A L. *World of the Ranters.* Laurence and Wishart 1970

Oxford Companion to the Theatre. Oxford University Press 1990

Penguin Dictionary of Modern Quotations. Penguin 1960

Penguin Dictionary of Quotations. Penguin 1971

Pickering, David. *Dictionary of Theatre.* Penguin 1998

Roget's Thesaurus. Longman 1962

Shorter Oxford English Dictionary. Clarenden Press 1973

Southworth, John. *Fools and Jesters at the English Court.* Sutton Publishing 1998

Thompson, Bonar. *Hyde Park Orator.* Jarrolds 1934

Welsford, Enid. *The Fool.* Faber and Faber 1935

Willeford, William. *The Fool and His Sceptre.* Edward Arnold 1969

Williams, Heathcote. *Whale Nation.* Jonathan Cape 1988

Sacred Elephant. Jonathan Cape 1989

Autogeddon. Jonathan Cape 1991

Wilmut, Roger. *Kindly Leave the Stage.* Methuen 1985

Didn't You Kill My Mother In Law. Methuen 1989

INDEX

187

Unwin, Stanley 48

Variety 63, 65, 67, 68, 70, 74, 81, 131
Vaudeville 62, 70
Village idiot xv, 53, 160
Vincent, Gene 67
Virginia Minstrels, The 61

Walcot Beano Club 94
Wall, Max 102
Ward, Don 96, 100, 105
Warrior Fools 54
Wear, Peter 101, 109
Weill, Kurt 134
Welfare State 78
Wells, Kim 118
Wells, Steven (Seething) 126
West London Theatre Workshop 75
West London Media Workshop 109
Whale Nation 126
Whitelaw, William 115
William the Conquerer 54
Williams, Heathcote 128, 95, 115, 126
Williams, Kenneth 47
Williams, Robin 81, 119
Wilson, Harold 160, 172
Wise, Ernie 68, 69, 154
Wit and Pun 25
Wogan, Terry 32
Wolmuth, Phillip vii, 56, 57
Working Men's club 93, 123, 125
Wow Show 102

Yorrick 57, 73

Zanni 55
Zephaniah, Benjamin 126